IN HUMBOLDT'S SHADOW

In Humboldt's Shadow

A TRAGIC HISTORY OF GERMAN ETHNOLOGY

H. Glenn Penny

PRINCETON UNIVERSITY PRESS

PRINCETON & OXFORD

Published by Princeton University Press
41 William Street, Princeton, New Jersey 08540
99 Banbury Road, Oxford OX2 6JX

press.princeton.edu

First paperback printing, 2025
Paperback ISBN 9780691216447

The Library of Congress has cataloged the cloth edition as follows:

Names: Penny, H. Glenn, author.
Title: In Humboldt's shadow : a tragic history of German ethnology / H. Glenn Penny.
Other titles: Im Schatten Humboldts. English
Description: Princeton, New Jersey : Princeton University Press, 2021. |
 Includes bibliographical references and index.
Identifiers: LCCN 2020049825 (print) | LCCN 2020049826 (ebook) |
 ISBN 9780691211145 (hardback) | ISBN 9780691216454 (ebook)
Subjects: LCSH: Ethnology—Germany—History. | Ethnologists—Germany—History. |
 Ethnological museums and collections—Germany—History. | Humboldt, Alexander von,
 1769–1859—Influence.
Classification: LCC GN308.3.G3 P4613 2021 (print) | LCC GN308.3.G3 (ebook) |
 DDC 305.800943—dc23
LC record available at https://lccn.loc.gov/2020049825
LC ebook record available at https://lccn.loc.gov/2020049826

British Library Cataloging-in-Publication Data is available

Editorial: Fred Appel and James Collier
Production Editorial: Kathleen Cioffi
Jacket/Cover Design: Amanda Weiss
Production: Erin Suydam
Publicity: Kate Hensley and Kathryn Stevens
Copyeditor: Anne Cherry

Jacket/Cover image: iStock

This book has been composed in Miller

Printed in the United States of America

CONTENTS

ILLUSTRATIONS

ACKNOWLEDGMENTS

THIS BOOK WAS not planned. I arrived at the Wissenschaftskolleg zu Berlin (Institute of Advanced Study) in fall 2017 with a completely different project in mind. Soon afterward, however, an overwhelming number of people—curators, journalists, museum directors, and numerous scholars—began contacting me as a result of the controversies swirling around the Humboldt Forum, a new exhibition venue in the heart of Berlin named after the brothers Alexander and Wilhelm von Humboldt, asking me to intervene. At first, I demurred, staying focused on questions of diaspora and emigration. After a few months, however, a number of people changed my mind. First and foremost, the indefatigable Sarah Ehlers went out of her way to bring me up-to-date on the public debates about colonialism, cosmopolitanism, and ethnology, keeping me abreast of the latest interventions and protests against the efforts to draw collections from multiple museums, and particularly the Berlin Ethnological Museum, into the Humboldt Forum. She was incredibly encouraging and wise. Daniel Schönpflug instructed me on the virtues of writing for a general audience, the best way to intervene in such debates, and he introduced me to my agent, Barbara Wenner, who made this book possible. She immediately saw the importance of the project and went to great lengths to help me transform my tortured academic prose into something palatable for lay readers. She also introduced me to Detlef Felken, my editor at C. H. Beck, who shared her enthusiasm and quickly took on the project. That was a formidable group of backers, and the combination of their efforts and support made this a relatively easy and incredibly rewarding book to write. My greatest thanks, however, are due to my wife, Beatrice Curio-Penny, a biologist, who never tired of reminding me that the stories of the people I had long thought about would interest a broad audience—if I would make the effort to write for them. I was able to do that, in large part, by writing for and with her. She read the entire manuscript multiple times, pointing out the references that were too obscure, the examples that were too many, and the need for details about people and places that I too often assumed readers would know. Working with her on this project made it one of the most rewarding of my career.

In the end, however, it was really my longtime friend Greg Johnson, whom I met when we were graduate students in Berlin, who was the

catalyst that led me to write this book. In the fall of 2017, he asked me to attend a meeting at the Berlin Ethnological Museum. That meeting ultimately spurred me to wade into the complexities unleashed by the debates around the Humboldt Forum, and I remain grateful for that experience and for his inspiration. Any inaccuracies or limitations in the book, however, are my responsibility alone.

Fred Appel, my editor at Princeton University Press, was also inspirational. He saw the virtues of pursuing an English-language version of the book and gave me the chance to help update it as well. His guidance has been impressive and essential. I am grateful to him for his efforts and for the recommendations of the anonymous readers.

IN HUMBOLDT'S SHADOW

Kihawahine

THE FUTURE IN THE PAST

KIHAWAHINE, A STATUE of the mother goddess, a high-ranking Hawaiian deity, is one of some five hundred objects that Eduard Arning, a German physician, collected while studying leprosy in Hawai'i in the mid-1880s. Upon his return, he gave the collection to the Berlin Museum für Völkerkunde, now the Berlin Ethnological Museum. About two feet high and carefully carved out of indigenous kou wood, *Kihawahine* spent many years secluded on the rocky coastline of Hāmākua, Hawai'i, an area accessible only by swimming. She was secreted in a hole lined with stones, covered by a flat stone slab, hidden together with a hermaphrodite god and a human skull. When local villagers first discovered the gods and brought them to the nearby Waimanu valley, disease spread among the people, leading to the gods' quick return to the stone-lined hole. Shortly thereafter, they became part of Arning's collection. There is some mystery about how Arning obtained *Kihawahine*, but there is no question that she came from a burial site.

Greg Johnson brought *Kihawahine* and the rest of the Arning collection to my attention in the fall of 2017. At that time, Greg was a professor of religious studies at the University of Colorado, as well as a close friend. He has spent his career focused on American Indian and Hawaiian encounters with United States and international legal systems. He was traveling to Germany that fall because the state of Saxony was poised to return Hawaiian ancestral remains housed in Dresden to an impressive team of cultural practitioners and repatriation experts, led by Halealoha Ayau, with whom Greg had collaborated for years.[1] Greg had made him aware of the *iwi kūpuna* (ancestral Hawaiian skeletal remains), *moepū*

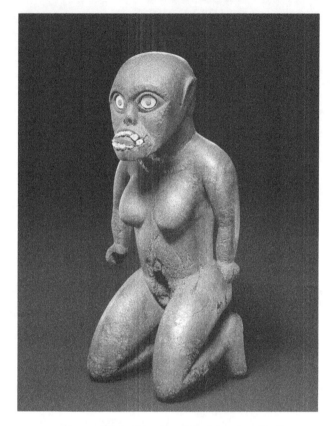

FIGURE I.1. *Kihawahine.* Staatliche Museen zu Berlin.
Ethnologisches Museum (VI 8375). Photo: Claudia Obrocki.

(funerary possessions) and *mea kapu* (sacred objects) in Berlin's museums. Halealoha Ayau invited him to attend a repatriation ceremony in Dresden and to help support their discussions with the Berlin museums.

After twenty-six years of negotiations, the Museum für Völkerkunde in Dresden returned four *iwi kūpuna* taken from Hawaiian graves between 1896 and 1902. Halealoha Ayau's team of native cultural practitioners, acting together with the Office of Hawaiian Affairs, received the remains from Saxon state officials during a public ceremony in October 2017.[2] Nanette Snoep, director of Saxony's three ethnological museums, called it "perhaps one of the most important days of our museum history." It marked the first time a Saxon museum had repatriated human remains back to the place from which they originated. For Halealoha Ayau, who had struggled for twenty-six years to "find the right words" to gain permission to "bring our family back together," it was more than that. It was a highly emotional moment of closure, the completion of a morally imperative act.

The exchange also signaled a new beginning. Amid the ceremonial sign-ing of documents and ritual chants, he and the others graciously praised the museum's action as one of "ultimate humility." They also characterized it as "a sea change" in the relationships between German museums and indigenous people. It marked, they noted, the beginning of an enduring relationship in the place of previously fraught political tensions.

After completing their work in Dresden, Greg Johnson, Halealoha Ayau, and their colleagues traveled to Berlin to continue their work there. The Berlin Ethnological Museum is one of the largest and most impor-tant ethnological museums in the world. It contains more than 500,000 objects, including one of the most significant historical collections of Hawaiian artifacts outside Hawai'i. Much of those Hawaiian collections came from Eduard Arning. When Arning presented his collection to the Berlin Anthropological Society at the Museum für Völkerkunde in Feb-ruary 1887, Adolf Bastian, the father of modern German ethnology and the museum's director, lauded the "treasures" in the collection and argued that Arning's singular gift had transformed their assorted Hawaiian items into a collection that was literally "one of a kind." He also congratulated Arning for the exacting information he had accumulated about the arti-facts. He explained to the audience that Arning's collection demonstrated what could be achieved with "seriousness and efforts and the sensible implementation of both," even "within an almost hopeless field." Similarly, Rudolf Virchow, renowned pathologist, founder of the Berlin Anthropo-logical Society, and liberal member of the Reichstag, praised Arning while introducing his lecture on the ethnological collection. Then he noted, "To the rich collection of skulls, which he brought us at the same time, and to the exquisite photographic images of indigenous people [*Eingeborenen*], which he mostly created himself, we will return another time."[3]

Arning was not an ethnologist; he was a dermatologist. He traveled to Hawai'i in 1883 to work for the Hawaiian government because the Hawai-ian prime minister, Murray Gibson, needed help in understanding the spread of leprosy on the islands. Yet, when Arning arrived in Honolulu that November, he not only moved into the professional circles around King Kalākaua but also entered a crossroads of Polynesian trade. He saw circulating in markets artifacts brought by ships' captains from the Carolines, the Solomon Islands, and other ports in the Pacific. He also encountered other Europeans there, such as Prince Oscar of Sweden and Swedish archaeologist Hjälmar Stolpe, who arrived in Hawai'i soon after Arning and attempted, with little success, to collect archaeological and ethnographic objects.

FIGURE I.2. *Kihawahine* with other objects collected by Arning in Hawai'i. From
Adrienne L. Kaeppler, Markus Schindlbeck, and Gisela E. Speidel. eds., *Old Hawai'i:
An Ethnography of Hawai'i in the 1880s Based on the Research and Collections of
Eduard Arning in the Ethnologisches Museum Berlin* (Berlin, 2008), p. 41 © Staatliche
Museen zu Berlin, Ethnologisches Museum.

At Kalākaua's court, however, Arning moved among officials and
royalty who possessed things from past generations—clothing, religious
objects, tools, and weapons. The king himself was an avid collector. His
own collections, in fact, are now in Hawai'i's Bishop Museum. As a physi-
cian, Arning also had contact with men and women of all classes, including
fishermen. Their fish gods taught him that Christianity had not completely
obliterated the old religion on the islands. Some of the more conservative
noble families taught him that as well. Many earlier beliefs and practices
were simply privately and quietly pursued.

Arning had access, in other words, to many levels of Hawaiian culture
and society. He used that access to take part in what for him and many
others was one of the most exciting scientific pursuits of his time: a vast
ethnographic project meant to create what Adolf Bastian termed "a uni-
versal archive of humanity," which he believed was the key to revealing a
total history of humanity.

When Arning realized that despite reports to the contrary, it was still
possible to collect historical artifacts in Hawai'i, he wrote excitedly to
physiologist Émil du Bois-Reymond in Berlin suggesting that he could
acquire a collection for Bastian's museum. His suggestion was forwarded

to Bastian along with greetings from King Kalākaua. Bastian, not surprisingly, had been to Hawai'i during his fifth major scientific voyage (1878–80), and had already met the king. As a result of that encounter, he had produced *The Sacred Legend of the Polynesians* (*Die heilige Sage der Polynesier*) around his translations of the Kumulipo, a prayer chant of the Hawaiian king's genealogy and divine origins, loaned to him by King Kalākaua. Bastian was delighted by Arning's assessment. He also was happy to include him among the hundreds of people who, by the middle of the 1880s, were enthusiastically collecting for him all over the world. By the end of the century, that number had grown into the thousands.

Bastian's Museum

Bastian's enthusiasm was infectious. He spent twenty-five years of his life traveling abroad, incessant, impatient, moving quickly from one experience to the next. Time, for Bastian, was always fleeting; he hated miscalculations or setbacks that might cause him to lose any of it. As a young man, he had a shock of dark hair and a modestly trimmed beard that matched his unassuming dress. As his hair grew first gray and then white, he became increasingly gaunt; yet age made him no less energetic or focused. He only became more harried, more aware of time passing and windows of opportunity closing. Personally, he was reticent despite his ever-increasing notoriety. In fact, as his reputation grew he found that notoriety uncomfortable, and he often made a point of disappearing during celebrations in his honor. Despite that, he was an enthusiastic and convincing speaker. His force of will and the perseverance that allowed him to overcome a wide range of challenges while abroad animated the reports of his travels and his arguments for pursuing a total history of humanity. It was that will, that enthusiasm, and those arguments that allowed him to win over many collaborators and also enticed people such as Arning to seek him out and to volunteer.

Bastian was born in 1826 into one of Bremen's more wealthy merchant families. That wealth allowed him to travel unencumbered throughout his lifetime. Growing up among overseas merchants also made those travels second nature. He had a neohumanist education in Bremen, and by the time he left school, he had not only mastered Greek and Latin but also was fluent in English and French. He was, he later realized, particularly adept at language learning. As a result, he was able to speak the language of most places he visited. He quickly became conversant in new languages as he moved around, and he studied some intensely when he thought it necessary. That talent would not have surprised his teachers, who had reported to his parents that his intellect was excellent, even if his work was often "hasty."

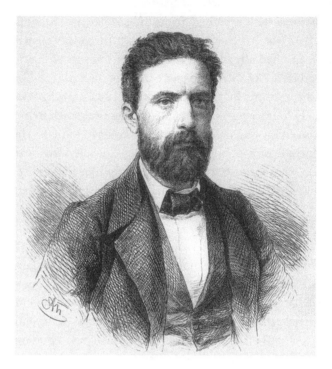

FIGURE I.3. Bastian as a young man. *Illustrirte Zeitung* (1860).
© bpk-Bildagentur / Ethnologisches Museum der Staatlichen
Museen zu Berlin / Art Resource, NY.

Bastian became enamored with the natural sciences while in school, and he continued to study them at universities. He completed his doctorate in medicine under the renowned pathologist Rudolf Virchow, who later became his close colleague and friend. Yet the most important part of his education followed the model set out by his hero Alexander von Humboldt: a frantic pursuit of *Bildung* (self-edification) through travel and inquiry all over the globe.

Bastian first left Europe as a ship's physician in 1850. Over the next eight years he traveled to Africa, Australia, the South Seas, South and North America, and South Asia. Those voyages whetted his appetite for more. In the early 1860s he returned for five years to South and Southeast Asia, traveling first to India, and then to Burma (Myanmar), Siam (Thailand), Cambodia, Annam (Vietnam), Indonesia, the Philippines, China, Mongolia, and the Caucasus. Burma was the highlight of the trip. He spent half a year in the royal residences of Mandalay studying Buddhism and debating religious texts with local princes, scholars, and the king; in 1873 he traveled to the Loango coast in West Africa; in 1875–76 to Central and South America;

from 1878 to 1880 he traveled from Persia to India, Indonesia, Australia, and Polynesia before returning to South America; at the end of the 1880s, he spent three years traveling from Russia, to Asia Minor, into Egypt and East Africa, and then across to India, down to Australia, and through Oceania again; in his seventieth year (1896), he embarked on yet another two-year excursion to Java, Bali, and Lombok, where he once again pursued an intensive study of Buddhism; from 1901 through 1903 he continued those studies in India and Ceylon (Sri Lanka), two of his favorite places. From 1903 to 1905 he traveled to the West Indies, and he died in Trinidad.

In many ways, Bastian was a loner. He never traveled with friends, groups, or as an expedition leader. Rather, he traveled lightly and quickly, with guides and sometimes porters who often taught him local languages and offered him windows into their communities' worldviews. His needs were few while under way. He was just as content sleeping outdoors with his guides and porters as in the homes of German merchants, officials, or in various hotels. The latter, he thought, slowed him down, even if they offered him opportunities for sharing his vision and recruiting more people to his cause.

Convinced by Alexander von Humboldt that the natural sciences offered a means for understanding the cosmic harmony of the world, Bastian returned from his first set of voyages eager to harness Humdoldt's scientific methods to explore the total history of humanity. He began with the premise of a unitary humanity—one people in one world. Human cultures in all their multiplicity were, he believed, simply variations on a common theme, differences within a psychic unity shared by all peoples across space and time. The *Weltanschauungen* (worldviews) of any culture, he was convinced, expressed the commonalities and variations one could observe among cultures. His first goal was thus to understand that commonality in all its variations across space and time; his end goal was to use that information to fashion a total history of humanity. He never thought, however, that he could achieve those goals on his own. Nor did he expect them to be achieved during his lifetime. Yet he was convinced it could be done, and thus he dedicated himself to pursuing a vast ethnographic project that would bring together all the data necessary for this effort, and he committed himself to convincing as many people as possible to join the cause.

The first step in his project was to collect as much information as he could about all the peoples of the world. Part of that information could be gained through discussions, observations, and written records. He explored them all during his first voyages. Yet, because so much of the

world had always been and still was illiterate, Bastian soon turned to the analysis and collection of material culture—to all of the things people make and use, from their great monuments and highest art to their most simple crafts and everyday things. He was particularly concerned with prioritizing the cultural material produced by illiterate societies, because for those people, he argued, the things they produced and left behind were the only records of their relationships with the surrounding world and the history of their cultures as they developed over time.

For Bastian, then, the objects a group of people produced and used were first and foremost "impressions of that people's spirit [*Volksgeist*]," and consequently the vast majority of his publications were concerned less with the things he and others collected for his museum than with what those things could tell him about people's customs, ethics, practices, and religious ideas. In short, he used the objects to understand the formation of the ideas behind them, and he used the ideas behind the objects to understand the emergence of those people's worldviews. His hope was that he and those who joined him would be able to do that for people everywhere. Thus he brought tens of thousands, and ultimately hundreds of thousands, of such objects together in the museum he directed in Berlin in order to engage in a vast, comparative analysis of those worldviews. That was the whole point of the museum. That is why it and the collections are there.

This was, in fact, a much different kind of collecting and display than had been common in the past. Bastian was not interested in focusing on trophies; he was not keen to fill his museum with exceptional things. He saw little value in that. As he argued again and again, anyone the museum sent abroad, or anyone who, like Eduard Arning, chose to join his cause, "would be strongly advised not to allow themselves to be blinded by the exceptional showpieces, which, following the earlier style of the curiosity cabinet, would seem suitable to display as trophies." Rather, what they needed to do was "contemplate the typically average character of ethnic life in each moment and collect the corresponding tools and implements with all of the associated detail (from the different stages of the manufacturing process) to the last differential."[4] Those objects, and the differentiated information surrounding them, would provide ethnologists with the data they needed to achieve their goals, to reveal a total human history. That was the vision.

There were, of course, other anthropologists and ethnologists in the Americas and Europe during the middle of the nineteenth century engaged in studying human cultures, collecting material culture, writing

human histories, and filling museums. Yet Bastian's ethnographic project, and thus the ethnology that channeled and shaped the ethnological museums that sprang up throughout the German-speaking lands during the second half of the nineteenth century, was different. Unlike their counterparts in most of Europe and the United States, German ethnologists did not use objects simply to confirm or illustrate theories of human development; nor did they seek to use them to legitimate cultural or racial hierarchies. Rather, they began with a rejection of race science and an assumption that there were no inherent mental differences among people. Bastian, Virchow, and their colleagues believed that nature had endowed all humans equally; no group had inherent genetic advantages or disadvantages. Thus they created their museums as spaces for the study of human cultures and histories in all their variations, not to support or illustrate politically useful theories of human difference.

Their greatest challenge was locating and acquiring the objects, those records of human cultures and histories, and bringing them together in their museums. That challenge also seemed to increase with each day. That is why Bastian became so harried and his work remained "hasty." For, just as the nineteenth-century's growing industrialization rapidly eased Europeans' transport and travel to faraway lands, it also increased disparities of power, leading to wider-ranging and quicker conquests. In turn, those conquests transformed many non-European societies, reducing cultural differences, eradicating older forms of production, and eliminating the material culture produced by earlier generations and along with it the records of their history before the conquests. Similarly, just as the increasingly global competition for territory and power might facilitate Bastian's scientific collecting, it also made that collecting competitive, as his counterparts in other countries tried to acquire objects first or control the acquisition of objects within their domains. These factors undermined Bastian's ability to travel where he wanted and to collect where he found it most imperative. Time, in other words, seemed more fleeting with each passing year, leading him and his counterparts to engage in a series of compromises and Faustian bargains with government officials, military forces, and patrons that later undermined his project.

Yet his successes were many: by the time Bastian returned from his first trip in 1858, he had dedicated himself to pursuing a total history of humanity, and he quickly became the leader of German ethnology—the study of human cultures in all their variations. Over the next forty-five years (1860–1905), Bastian built the world's largest and most important ethnological museum; he shaped the science of ethnology in the

German-speaking world; he inspired generations of scientists to join him; and he fashioned a vision of ethnology that drew thousands of Germans around the world into his networks of acquisition and collecting. Eduard Arning was only one of many. Between the late 1860s and World War I, their joint effort filled his museum until it overflowed with objects from every corner of the globe and threatened to burst at the seams. That success astounded Bastian's counterparts and his competitors in other countries, who regarded it with envy, and left his coworkers and those who followed him with both a wealth of material and an array of challenges. His is a controversial legacy.

For not everything ended well. Bastian knew the power of objects. He also knew that knowledge, science, and display should not be divided. He knew that his museum had to be more than a municipal or national display, more than a statement of grandeur—static, didactic, and, to his mind, boring. The central point of drawing together those hundreds of thousands of objects was to allow them to interact through juxtapositions that would be dynamic, active, enlightening. The point was to have the objects teach us to see, to have them teach us about the areas of human history for which there are few or no written records. The point was to use the visual displays to help locate the consistencies that cut across the endless variations in humanity. The value of the objects never lay merely in their possession, and their purpose was never to be used as simple illustrations in didactic *Schausammlungen* (public displays; literally, show collections), which, he thought, were a poor use of museums. Ethnological museums, as he made clear in his instructions to collectors and his criticisms of the old *Kunstkammern* where these objects were displayed, should be first and foremost laboratories, places for the production of knowledge, not its mere articulation.

Yet that is what they became after his death. In part, bureaucracy and politics began undercutting Bastian's vision already during his lifetime, and they overwhelmed it after his death in 1905. While his success at inspiring people and growing his collections impressed, many challenges undermined his project: his museum lacked the space needed to display all of his ever-expanding collections and put them to use; its budget was too small to support enough assistants; and those assistants grew increasingly frustrated with the conditions. The youngest ones, eager to make careers, searched for alternatives to working in the collections made chaotic by the limited funds and space.

At the same time, just as Bastian's life was nearing its end, Wilhelm von Bode, an art historian who became general director of the Royal

Museums during the year of Bastian's death, began lobbying for conformity among museums. He had his own vision, and Bastian's project had no place in it. As general director, Bode consistently channeled funds away from the sciences and into the arts, and he tried for decades to make Bastian's museum conform to the other museums under his auspices. He tried to force Bastian's followers to transform the very character of the institution by making it a place more pleasing to the public, by reducing its total number of collections, by moving the vast majority of objects behind closed doors, and by following a didactic aesthetic of display meant to entertain and teach.

Already in 1911, Bode issued a report that sought to reduce the Museum für Völkerkunde to a focus only on *Naturvölker*, or "natural peoples," not on all the peoples of the world. He also demanded a "reasonable reduction" of the museum's collections through donation, sale, or trade. Most of all, Bode wanted the museum converted into spacious halls filled with representative objects, precisely the kinds of didactic *Schausammlungen* Bastian abhorred. In 1926, just three years before his own death, he finally got them.

We lost a great deal as a result. We lost the recognition that Völkerkunde museums were unlike art museums. They were never meant to articulate, demonstrate, or illustrate. They were built to be workshops in which data could be assembled and knowledge produced. Over time, we also all but forgot that nineteenth-century German ethnology, or *Völkerkunde*, was incredibly pluralistic, characterized by its practitioners' refusal to entertain unproven racial hierarchies and by their quest to analyze and understand the great diversity of a unitary humanity across space and time—a quest that set German ethnology apart from its counterparts in America, Britain, France, and much of the rest of Europe. Yet that too was forgotten, and with that moment of forgetting we lost as well the understanding that these museums, as houses of human history, were never meant to be sites for the exhibition of exotic others. They were meant to be locations for helping people better understand the human condition, and thus themselves.

The twentieth century, however, changed all that. At first, those younger generations of ethnologists looking for career opportunities began working with Bode and others to develop didactic displays. Increasingly, those exhibits were meant to tell tales that fit the needs of national politics rather than Humboldtian science. They began leaning toward discussions of cultural hierarchies that could justify colonial systems. Then the Nazis transformed the German cultural sciences into racial sciences; they recast the associations, the institutions, and even the meanings of

their names. It took decades after World War II for those academic disciplines, their associations, and their institutions to recover. Perhaps they never did. Völkerkunde today is only a cipher of what it once was. Even the name has gone out of fashion, forever tainted by Nazi misuse. Meanwhile, the collections Bastian and his counterparts painstakingly assembled over generations have been largely frozen in time for over a century—waiting to share their secrets with the world.

The central argument of this book is that it is time to release those objects and put them to work. In many ways the debates around the Humboldt Forum in Berlin since the summer of 2017 have made that possible. The arguments about building a modern version of the old Prussian Palace in central Berlin and the decision to place a fraction of the collections from the Berlin Ethnological Museum in that edifice together with collections from the Asian Art Museum, Humboldt University, and a display devoted to the history of the city have been heated.

Driven by a kind of *Vergangenheitsbewältigung*—a painful reckoning with the past common to all areas of German history—those debates have been animated by tensions between voices that emphasize the cosmopolitan visions epitomized in Alexander von Humboldt's writings, which inspired Bastian and his counterparts to create and fill the largest collecting museums in the world, and those voices that wish to underscore the roles (whether inadvertent or intentional) such scientists and institutions played in the crimes of the nineteenth and twentieth centuries, particularly the legacies of colonial and Nazi violence. Those voices make completely different arguments about *Kihawahine*'s journey to Berlin and about her future. The first group emphasizes her value in the totality of the collections, the second underscores the questionable means of her acquisition and her place in Hawai'i today.

In part, global efforts, driven largely by indigenous activists such as Halealoha Ayau's team of native cultural practitioners, who have been working transnationally to "decolonize" historical institutions for decades, have also fueled the debates. Over the last three decades, such activists—arguing for sovereignty, human rights, and protections for their cultures, languages, and religions—have had tremendous success on the world stage: before the United Nations and the World Court, and in the media. They have also been winning victories regarding land rights, based often on religious arguments, in national courts, particularly in Australia, Brazil, Canada, New Zealand, and the United States. The field of indigenous studies, led by indigenous scholars like those who accompanied Halealoha Ayau, is also booming, and many of the activists today are highly educated

and politically savvy. Those activists and their supporters in Europe and the United States have focused considerable attention on institutions that contain the funeral objects and physical remains of non-Europeans, and much like Halealoha Ayau and his team in Dresden in the fall of 2017, they have been achieving striking successes globally during the last decades as they have called for repatriation of these objects.

The best thing about the debates around the Humboldt Forum in Berlin is that they have pulled German ethnology out of the shadows and placed it on a public stage where it can be scrutinized, argued about, and, if we are lucky, saved. I wrote this book to remind people about the value of the collections in Berlin's Ethnological Museum and the other ethnological museums in German-speaking lands because, if there is one thing that most disturbs me about the debates of the last decade, it is the degree to which the original purposes behind the creation of the collections and the value inherent in the objects has been overlooked and remains lost.

The most heated question raised during the debates around the Humboldt Forum has been about the repatriation of objects such as *Kihawahine*. The heat has come from further accusations that Germans have been far too slow to come to terms with their colonial pasts, and that the Humboldt Forum, through the combination of the building's imperial façade, its nationalist symbolism, and the decision to display state collections of non-European objects within that edifice, demonstrates that Germans still have a long way to go before a reckoning can take place.

Yet the question we should be asking is not repatriation yes or no. The question that most needs to be answered is, what should we do with these collections today? Repatriation is only part of the answer, and it is my contention that we cannot answer that question fully without a clear understanding of the objects' histories and Bastian's purpose. The basic point is that if we do not understand the history of the collections and the origins of the objects, we cannot understand what Bastian knew long ago: ethnological museums are filled with historical traces, material objects that contain vast amounts of information about human history. And they are more than that: as Halealoha Ayau and his colleagues made crystal clear in Dresden and Berlin, objects like *Kihawahine* have much to teach us about different ontologies—different ways of being in the world and relating to the world as human beings. At the most basic level, they have much to teach us about human difference and about ourselves as people in the world.

We should let them do that. But the collections cannot do anything in their current conditions. For most of the last century, the majority of the

collections have been locked away in depots, separated from the didactic and entertaining Schausammlungen. Meanwhile these Schausammlungen, the kinds of displays Bastian never wanted and would never have tolerated, have come to dominate these museums to such a degree that many have forgotten the museums' original purposes. Indeed, for most people, even those who work in museums, these permanent public displays seem so natural, so essential, so fundamental to what any museum should be. Most people have long forgotten why Bastian and the thousands who joined him dedicated so much energy to creating these institutions in the first place. It is time to remember, time to free the objects, time to return German ethnological museums to their original purpose: the production of knowledge about human cultures and human histories.

Hawaiian Feather Cloaks and Mayan Sculptures

COLLECTING ORIGINS

IN 1828, LONG before he became the head of one of the most powerful trading houses in Hamburg, Wilhelm Oswald visited Hawai'i as a young cargo officer on the Prussian merchant ship *Prinzessin Louise*. Filled with Prussian cloth, linens, finished clothing, glassware, textiles, and other trade goods, this sailing vessel stopped at what Europeans still called the Sandwich Islands on its way between the Americas and China. Hawai'i was only one of many ports along a four-year route meant to help Prussia establish trade connections throughout the world, an ambitious venture in an age of imperial competition for territory and trade. Less than two decades after a devastating defeat by Napoleonic forces, when Prussia's very survival had hung in the balance, this state had no real navy, no fleet worthy of note. It could hardly compete with even the Hansa cities, such as Bremen and Hamburg, whose transoceanic trade networks had been active for centuries. By the time the *Prinzessin Louise* passed though the dangerous and daunting (as it still is) Strait of Magellan while rounding the tip of South America, those cities already had merchant houses and consuls in many of the ports it visited. Meanwhile, the major sea powers, England, France, and increasingly the United States, dominated the Pacific.

Still, as American and European ships visited the islands, they brought rumors of Prussian military prowess to Hawai'i, and Oswald soon found himself drawn into the Hawaiian Royal Court and pressed for information by King Kamehameha III. Although still a teenager, he had been ruling

there for three years. The young king eagerly listened to Oswald's tales of European warfare. He wanted to know more about Prussian exploits, about Frederick the Great's many wars and Field Marshal Blücher's heroic role in Napoleon's defeat. Oswald's stories spurred the Hawaiian ruler to ask about the Prussian king, Friedrich Wilhelm III, and these led him to make comparisons between Field Marshal Blücher and his father, Kamehameha I, who had been a formidable warrior, uniting the Hawaiian Islands through force of arms.

While Kamehameha III could appreciate the military and political importance of Oswald's tales, it was difficult for him to imagine the hundreds of thousands of soldiers mobilized in Europe's wars. The numbers were so big. By that time, the entire population of native Hawaiians numbered only about 150,000 people. How were these large armies organized, supplied, and transported? How could leaders such as Blücher control their movements or orchestrate a cavalry's charge? These questions fascinated him, and he frequently visited the *Prinzessin Louise* to speak with Oswald about them. The Prussian ship always celebrated the king's arrival, greeting him with a royal salvo from their cannon, which the harbor fort consistently echoed with its own guns. Over time, the information he gathered caused Kamehameha III to regard his homeland as poor in comparison to the industrial states that manufactured the goods flowing into his islands from ever-greater numbers of ships crisscrossing the Pacific.[1]

In early March 1828, when the *Prinzessin Louise* was ready to leave the islands, the Hawaiian ruler came to the ship with a brilliant red-and-yellow cloak, painstakingly made from the feathers of local birds. Such feather cloaks were among the most prized possessions of the Hawaiian nobility, and his father had worn this one frequently. Before Europeans began arriving in the islands in 1778, and for several decades afterward, such cloaks were visual symbols of military power and political might. Only ranking male chiefs could possess them, and they wore them only in battle or on state occasions. They were often taken as war prizes from losing chiefs, and so, powerful chiefs and a king such as Kamehameha I might have many. These cloaks were handwoven by men of high rank from feathers collected as part of the commoners' taxes. The largest of these scrupulously produced cloaks might require millions of feathers.

By the time of Oswald's visit, however, Hawaiians had given away substantial numbers of these cloaks to ships' captains. Very few were left in Hawai'i by 1854, the last year of King Kamehameha III's reign. In fact, by the time of his death, far more were in European museums than in Hawai'i. In part, that is because so many were given away, but it was also

FIGURE 1.1. King Kamehameha's feather cloak. Staatliche Museen zu Berlin,
Ethnologisches Museum (VI 366). Photo: Martin Franken.

because times had drastically changed. The king's elder brother, Kame-
hameha II, during his short reign (1819–24), had destroyed the islands'
ancient *kapu* system, the social code of religious laws/taboos. To solidify
his power, he put an end to the social class of priests and eradicated idols,
images, and temples across Hawai'i.[2]

Until Europeans began arriving in large numbers, chiefs had occu-
pied themselves with the production of weapons, war cloaks, and helmets
under the auspices of kapu. However, as they became acquainted with
European commerce, money economies, and learned to read and write,
the ruling classes shifted their occupations. Gunpowder, not clubs, knives,
and spears, increasingly drove Hawaiian battles of unification and con-
solidation. Consequently, in 1899, William T. Bingham, the director of the
Bishop Museum in Honolulu, could locate only five feather cloaks on the
islands. Yet there were hundreds in museums and private collections in
Europe and North America.[3]

That history, however, did not diminish the moment in March 1828
when King Kamehameha III presented the cloak to Oswald. It was a
poignant act of diplomacy, a gift from one sovereign to another, meant

to initiate relations. The cloak and the king's letter to Friedrich Wilhelm III traveled around much of the globe before arriving in Berlin in September 1829. The Prussian sovereign and his court were impressed by the cloak's beauty—its delicate feel, the colors, and the painstaking labor that produced it. It was magnificent. They also recognized its diplomatic significance.

Friedrich Wilhelm III first encountered the cloak during a presentation of goods and artifacts gathered during the voyage: ivories, lacquer work, lamps from China, porcelains, sandalwood boxes, silks. and teas, as well as a variety of minerals, plants, and products of nature that would eventually make their way into Berlin's Natural History Museum. The feather cloak, however, was special. Kamehameha III's letter, which stressed that the cloak was one of the finest things his islands had to offer, moved the Prussian king. He instructed his ministers to notify him if another of his ships were to venture to the Sandwich Islands, so that he could arrange for a commensurate gift for Kamehameha III.

Thus, when the *Prinzessin Louise* returned to Hawaii in 1830, it took with it a saddle and riding equipment complete with pistols in holsters, a guard's uniform like the one Friedrich Wilhelm III often wore, oil paintings of himself and Field Marshal Blücher, a map of Prussia, drawings of important buildings of state, metal busts of European leaders and military men, and various products of Prussian industry, ranging from clothing to jewelry to porcelains. The Prussian sovereign detailed these items and their uses in a personal letter to the Hawaiian king, affirming their shared nobility. The gracious tone of Kamehameha III's response underscored his delight with the gifts.

After the initial viewings, the feather cloak was separated from the natural curiosities and trade items. Prussian ministers placed it in the Kunstkammer in the Royal Palace, in the section devoted to "non-European rarities." There it took its place among an eclectic assembly of a few thousand things, many collected over centuries to satisfy Prussian rulers' curiosity about other cultures. Some Chinese, Indian, and Japanese items had been among the collections since the time of Great Elector Friedrich Wilhelm (1620–88), although the French seized most of those when Napoleon occupied Berlin in 1806.

The feather cloak entered a somewhat smaller collection of "non-European rarities" than existed at the end of the eighteenth century. Nevertheless, the collections were quite varied. They even included other items from Polynesia. Prussian officials had brought some back from the Pacific; others had purchased, at London auctions, objects collected during James Cook's famous worldwide voyages. There were also objects from

Asia, Brazil, Mexico, and New Zealand, gifted to the royal collections by private individuals and state employees.

By 1851, the Royal Ethnographic Collection boasted some 5,192 items, and after 1856, after the Kunstkammer was dissolved and its holdings redistributed into the state's growing complex of museums, the collection became independent. In 1859, the feather cloak and the rest of the collections were presented to the public in three large halls in the New Museum, the second classical museum building erected on Museum Island, just north of the Old Museum and the Lustgarten in central Berlin. There, as part of a "universal museum" with scientific pretensions, they joined the collections of plaster casts, copies of statues ranging from ancient Greece and Rome through to Gothic and Renaissance Europe. These arrived together with the collections that became the basis for the Egyptian Museum, the Collection of Copper Engravings, and the Museum of Early and Prehistory. On the top floor of the building, one could also find odds and ends from the Kunstkammer, such as architectural models and small art works from the Middle Ages and the Renaissance, which later found their way into the Kunstgewerbemuseum (Arts and Crafts Museum) when it opened in 1875. The New Museum offered visitors a window into the arts and cultures of the world.

Since 1844, the objects in the ethnographic collections had been organized geographically and systematically. They retained that scientific order in their new locations surrounded by polished marble, under the brightly colored ceiling of the *Flachkuppelsaal* (flat-dome hall), and near the Dorian columns. They were arranged according to the continents of America, Australia (including Polynesia), Africa, and Asia. More than half the objects came from Asia, and many of them caught the viewer's eye through their "tasteful and even artistic implementation."[4] These were delightful wonders from around the world in an eminently fashionable setting.

These were not simply cabinets full of aesthetically pleasing items. Many things were larger and stranger than the feather cloak. An eight-foot tall painted leather tipi from North America, for example, stood in the middle of one hall near a semicircular window niche. There was also information: to help orient visitors, each object had a numbered label, color-coded according to its continent, with details about the object and the collector. In addition, in 1861, the guide meant to help visitors negotiate the displays listed these objects individually. Within those regional groupings, there were also hierarchical orders.[5] Like most museums in Europe and the Americas at this time, they offered visitors evolutionary trajectories by displaying objects in a linear progression, from less- to more-advanced technologies.

Weltanschauungen

Almost everything changed after Adolf Bastian became directorial assistant of the ethnological collections in 1869, and then took over as director in 1876. The geographic arrangement of objects continued to dominate Berlin's ethnological displays right through the twentieth century, and some objects, like the feather cloak and the tipi, continue to be counted among the collection's highlights even today. Yet Bastian brought a radically different vision to the collections. Unlike his predecessors, he had spent years traveling the world; he had extensive experience living among non-Europeans, and he added to those experiences over the course of his life. As a result, he was not interested in simply curating a collection of noteworthy objects. He was interested in using them to expose and compare Weltanschauungen—worldviews.

Much like the English natural scientist Charles Darwin, who became famous for his extensive travels and his contributions to the science of evolution during the middle of the nineteenth century, Bastian left Europe on his first voyage in 1850 with Alexander von Humboldt's writings on his mind. As he crisscrossed the globe over a period of eight years, encountering an astoundingly diverse mix of cultures, languages, and religions, Bastian thought about Humboldt's desire to write a total history of the cosmos, drawing on all areas of knowledge and all the fields of science. He thought too about the harmony Humboldt had glimpsed: the interconnection of all things, revealed through patterns in nature across space and time.

Bastian returned from that first set of voyages in 1858 with a passion for one area of Humboldt's cosmos: the history of humanity. For Bastian, that meant the history of the human mind. Within two years of his return, his enthusiasm and his restless energy drove him to publish his first major work, the three-volume *The Human in History: Toward the Founding of a Psychological Worldview (Der Mensch in der Geschichte: Zur Begründung einer psychologischen Weltanschauung*, 1860).[6] In it, he argued that all the components of human thought coursed through the minds of the great varieties of people he had encountered. There were harmonious patterns in that thought as well, which he believed extended across space and time. "Far from Europe, and for a long time limited in linguistic intercourse," he exclaimed, "the ideas laid down here germinated under the perception of the manifold circumstances in which the people of the globe live together. In the quiet of the deserts, on the lonely mountains, across wide oceans, in the sublime nature of the south, they gestated over the years and joined together in a harmonious tableau."[7]

Bastian dedicated his work to Humboldt, who passed away in May 1859, just as Bastian was finishing his text. Humboldt, Bastian wrote, had not only inspired him to travel but also provided him with a research method. Bastian became a staunch advocate of inductive science: Humboldt had trekked through deserts and forests and climbed volcanoes in Central and South America making empirical observations. He went to see everything nature would show him—animals, birds, insects, vegetation, ocean currents, mountain ranges—recording the properties of all he observed, and allowing the systems of interconnections to emerge into view. Bastian made observations as well: his focus, however, was on people, their ideas, their thoughts, and the things they produced: languages, religions, and so many objects.

As he traveled worldwide, he saw consistencies and differences; he too watched for patterns. He was particularly interested in the interplay between people and nature; notions of black and white magic; the roles of gods in religions and priests in politics; modes of communicating with gods and the roles objects and fetishes play in that process; the place of the learned versus the priests; the emergence and characteristics of traditional symbols; conceptions of the soul, the afterlife, ghosts, and the place of graves and altars in that balance between the physical world and the metaphysical. Bastian looked for the overlaps in those beliefs among the people he encountered and where individual groups differed and developed unique elements in their own worldviews. Then he sought to ascertain what historical processes had led to the differences within the similarities.

Like Humboldt, Bastian placed theories to the side. He refused to force his observations into preconceived notions or jump to conclusions. This was his chief problem with Darwin's *On the Origin of Species* (1859) and especially *The Descent of Man* (1871), which applied Darwin's evolutionary theories to human beings and speculated on the history of what he called the different human races and the roles natural selection had played in human evolution before the rise of industrial civilizations. Impressed by Darwin's research and travels, Bastian found Darwin's theories interesting; but he knew they were unproven. As a result, he argued that Darwin had published too early, as if his theories were based on irrefutable facts. That, he lamented, was essentially bad science. Quickly publishing unfounded conclusions might close off inquiry and mislead researchers. Bastian wanted to avoid that.

Bastian expected the natural laws that governed human thought and interactions to emerge from his patiently collected data—but he had no idea when that would happen. Nor did that uncertainty trouble him. Perhaps that was because Bastian had been convinced by his travels that

ethnology was the critical science of his age. Events even seemed to be making it imperative: "All of us," he wrote, "are children of the times that call us into life."[8] And his "epoch," he explained, was one of rapid flux driven by science and technology and the commerce and exchange they facilitated. That flux not only led to cultural, social, and political transformations, so obvious in island locations such as Hawai'i. There were also mental transformations, new notions of time and space, new relationships with nature, new ways to encounter and think about the entire world. That, he argued, had advantages: "In our motorized world system, we no longer know of a sky that revolves around the earth, for us the horizon of the firmament dissolves into the infinity of eternal harmonies."[9] His generation, he believed, more than any before it, could glimpse those totalities as Humboldt had done; yet they could also harness modern technologies to pursue them globally in a way that Humboldt never could. That was a call to action.

Bastian wanted to seize that moment of mobility and quickening change, engage in a vast comparative analysis, and fashion a total history of humanity by focusing on the human mind. The tool, he argued, would be a new psychology, one that "not only pursues the development of the individual but also that of humanity, moving across the foundation of history." It was, he believed, "the science of the future." It alone, he argued, "is able to arbitrate the ever-increasing gap between faith and knowledge in order to seal the foundation of a unified worldview." The natural sciences, he was convinced, had shown the way. They set a precedent that could be extended to the human sciences: "what chemistry and physics have delivered to the foundation of the inorganic, what plant and animal physiology have done for the organic, that is the task of psychology in the metaphysical areas of thought."[10]

It must have been odd, decades later, for his students and some of his frustrated assistants to read Bastian's first books, written by a young man with few accomplishments but a clear vision that great change and possibilities were in the offing. By the end of the century, so many of those young ethnologists would rebel against the hold this old man seemed to have on the field. Yet, in 1860, the young Bastian could still write, "We young men often resent the tenacity with which the dignified graybeards of the previous generation strive for progress." That, he quipped, was typical of youth. Yet his epoch was indeed different, and older scholars, those who did not feel its motion, could not understand the implications of the recent changes in science and technology, or the importance of Humboldt's method: "only in our present time has a general overview of the whole of the world been spatially and temporally mediated, and now it is

only necessary to have a statistical arrangement of all the details before we may proceed to draw conclusions, once the compensatory formulas are found."[11]

Bastian's era, in other words, had to be an era of data collecting. He retained that conviction through the rest of his life. Moreover, he argued that it must be properly pursued. Good science must show the way. Anything else was frustrating; anything else might derail the entire project.

For Bastian, practicing good science meant it was not enough to place observations before theories; a researcher must also be self-reflective. Most important, one must not allow subjectivities to undercut objective observations. Bastian had learned this from Humboldt, but he had also seen it confirmed elsewhere in the world: "Buddhism may have freed itself the most from these mistakes and preserved the principle of the infinite series as much as possible, and in this way, in its spiraling expansions, where it in fact avoids the concept of eternity through the accumulation of immeasurable numbers, which it quasi-attempts to calculate, it can, with the aid of this well-known operation, move from popular representation into philosophy without neck-breaking leaps of speculation."[12]

Bastian confessed, at the outset of *The Human in History*, that these three volumes were only the first step in his journey. He had written them to communicate to readers the focus of his inquiries and his future research goals, to explain his realization that far from Europe "ideas germinated" under "manifold circumstances, in which the people of the globe live together," and which he was convinced tied them all together in a "harmonious tableau."

The way to an understanding of the character of those "germinating ideas" and the implications of that "harmonious tableau" was the creation of a *Gedankenstatistik*, a systematic tabulation of ideas, which would allow him and those who would join him, to dig deep into the mental worlds of different peoples methodologically and pursue a comparative analysis of them. "What wonderful revelations," he wrote, "must not be provided by a Gedankenstatistik, which showed the same mathematical number of psychological original elements flowing in a uniform regular circulation through the minds of all people, across all time and histories." Such a method, he argued, was essential. "When all our thinking is based only on relative estimates of reciprocity, we can only allocate a thought to its position in the world as a whole, which has now become possible to survey geographically and historically, as a unity, and also to anticipate astronomically, if we have recognized it in its relation to the environment."[13]

Applying methods of the natural sciences to the study of human beings, and particularly to human thought, the goal would be to break that

thought down into its basic components and then observe where and how those parts combined among the peoples of the world. While he acknowledged that the creation of the earth might have been "random," Bastian was convinced that its development, like all of nature, nevertheless had followed natural laws. That, he argued, was true for human beings as well, and he was certain that such natural-science methods would allow him to locate those laws.

While traveling the world, Bastian had seen patterns among people's actions and their creations. He saw, for example, the emergence of priestly classes worldwide, similar uses of fetishes in religions in different parts of the world, similar needs among vastly different peoples to erect monuments to gods, to ancestors, or as expressions of self. He believed that the consistencies and differences in such patterns offered him ways to get at fundamental modes of thought; basic, elementary ideas shared by all people across time and space. There was, he continually argued, a number of "psychological original elements" that coursed through "the heads of all peoples, in all times and history." He was adamant about their existence. Moreover, by "all peoples" he meant literally *everyone,* Europeans as well as all the other peoples of the world, all possessing the same essential mental faculties: "In the most incidental afterthoughts of narratives, nursery tales, and conversations, we encounter the same ideas, in England as in Abyssinia, in India as in Scandinavia, in Spain as in Tahiti, in Mexico as in Greece; the same thought, which, upon close inspection, leaps everywhere from its hiding-place of national popularity and documents itself as the incomprehensible thought of humanity, incomprehensible, if not understood in the harmony of the cosmos."[14]

Collecting Ideas

For readers in the twenty-first century, many of whom have sought solace in yoga classes and embraced the call for mindfulness, it might seem logical that Bastian's next set of travels (1861–65) were focused on East Asia, and that much of his time was spent studying Buddhism. His arguments about elementary ideas, self-reflection, and subjectivities make it seem almost foreordained, and he was clearly already a fan of the religion. Yet, as anyone who has traveled widely or has ever simply missed a plane connection is well aware, travels do not always go as planned.

Bastian observed and recorded across a huge territory during his second set of travels: he returned to India, Burma, Siam, Cambodia, and Vietnam, and he made his first visits to China, Indonesia, Mongolia, and

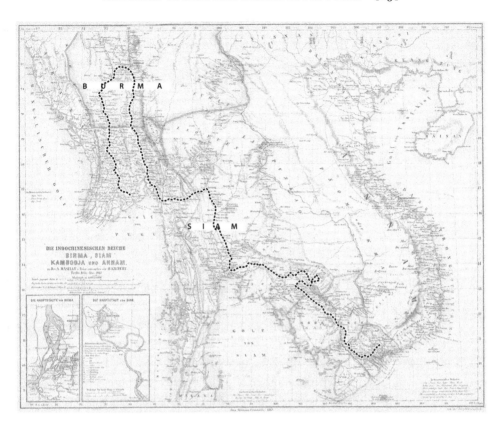

FIGURE 1.2. Map of Bastian's travels in Southeast Asia, in what he termed the
Indochinese empires of Burma, Siam, Cambodia, and Annam. He also included
enlargements of the capital cities of Mandalay and Bangkok. Adolf Bastian,
Reisen in Saim im Jahre 1863 (Berlin, 1867) © Bayerische Staatsbibliothek München,
177–3, p. 541 (Anlage Karte).

the Philippines. There were, in fact, many firsts on this trip: he became
the first German to journey through all the countries of Eastern and
Southeastern Asia and document them in detail; he was the first to travel
through Burma; he was one of the first Europeans to detail the temple
complexes of Angkor Wat and Angkor Thom in Cambodia. He was, it
turns out, one of the first to use the term *Indonesia* to refer to the islands
of the archipelago; he was also one of the first to describe those islands
and their peoples in great detail, as he went from one island to the next,
one tribe to the next, collecting information and creating dictionaries.
He was one of the scholars who made the name *Indonesia* stick, and he
became the founder of German research on Indonesia.

Yet Bastian did not set out on his venture with that list of accomplish-
ments in his pocket, hoping to check them off as he traveled along. Rather,

he went seeking more data for his Gedankenstatistik, collecting more points of comparison for his emerging ethnographic project. As he did so, he followed his nose.

The first months of 1861 went as planned. He traveled easily along European trade networks to Madras in southern India and from there he sailed to Rangoon in Burma. Then he spent seven weeks in a boat propelled by four men with oars working his way up the Irrawaddy River from Rangoon to Mandalay. He produced an arresting account of life along the river while gathering his observations and, at the outset of this travel narrative, he established a pattern that became consistent in many of his accounts: he mixed a deep political and religious history of the area with glimpses of the everyday and close descriptions of his own experiences. He told readers what it was like to approach land in partial darkness; to notice the shifting colors of the water that, "well known to the experienced seaman," indicate a river mouth and its shallows; to negotiate the vegetation, the trees and bushes reaching into water; to approach fires lit for guidance while glimpsing fishing boats tied to bamboo stakes driven into the earth; to dimly make out the short huts in the cornfields and the landings sheltered by straw roofs leading into villages.

In addition to such general descriptions, he collected moments, stunning moments, which could later prove useful. For example, the many Burmese and Chinese holiday celebrations he witnessed in Rangoon, with their strings of bright lanterns; the musicians with round drums, flutes, and bamboo sticks; the colorful turbans and high straw hats; and the dancers who began at a moderate pace and then accelerated in ever broader and quicker movements with astounding flexibility—all these he recorded in his notebook. Then he placed them unaltered in his narrative's appendix: "because then the first impression will be preserved better than if I would change it according to later acquired understanding of more such scenes and designations which at that time were still strange to me."[15]

Bastian's travels took place against the backdrop of European imperialism, in which the British and French empires competed for influence and territory in Southeast Asia with all of the advantages in transport and weaponry brought on by the industrial revolution. The Burmese Empire, powerful and expanding for three-quarters of a century, was brought to heel by the first Anglo-Burmese War, which ended in 1826. The Burmese not only lost territory and were forced to pay the British a crushing indemnity of a million pounds, they were also obliged to sign a commercial treaty. That expanded the British East India Company's influence and markets significantly, which also effectively undercut French influence

and trade in the area. Bastian arrived less than a decade after the Second Anglo-Burmese War, in 1852. That war had led to further annexations and the creation of a British-controlled Lower Burma, which he traveled through on his way to Mandalay. The palace coup at the end of the war also brought King Mindon to power. He was Bastian's main interlocutor in Mandalay and the man who transformed the city into the capital Bastian experienced while there. In 1885, seven years after King Mindon's death, the Third Anglo-Burmese War eliminated Burmese independence and sovereignty, transforming it into a province of British India, a much different place than the one Bastian had known.

As a Prussian subject, Bastian moved with a degree of privilege through these worlds that were being reshaped by competition and conflicts between European and non-European powers. He always had to work within the rules and regulations of local authorities. Yet, as a European physician and scholar who carried letters of introduction from Prussian authorities, he often could count on other Europeans' assistance and support while abroad. Prussia was no threat to either British or French imperialist goals. Nor could it threaten the sovereignty of Burma, Siam, or the other states he visited. This worked to his advantage. Moreover, the rulers of those states, while wary of any European encroachment, were also curious about Europe. Most were eager to learn more about their adversaries from a European who posed no threat. The majority also valued his erudition, as did many of the European colonial officers Bastian encountered along the way.

Thus, just as British colonial authorities guaranteed his safety in their dominions and assisted his efforts to gain entrance to monasteries and temples along the Irrawaddy River, rulers such as King Mindon of Burma and the kings of Cambodia and Siam valued their discussions with this European who took the time to learn their languages, expressed a genuine interest in everything about their lands and peoples, posed no threat to them, and possessed a wealth of information they might put to use. As a result, they too guaranteed his safe passage, hosted him in their courts, and gave him access to their sacred sites and state archives.

Bastian spent much of October 1861 in Rangoon preparing for his trip up the Irrawaddy River. While there, in a characteristic move, he hired a tutor to help him begin learning Burmese. He also devoted a good deal of time gathering information about what to expect in Mandalay. As he noted at the outset of his narrative: "my previous experiences had often shown me that the days lost by careful consideration at the point of departure are subsequently harvested through months." So, he carefully chose

his companions and prepared his travel "despite the daily impatience to enter the new."[16] Hiring a Burmese cook for the boat trip, for example, accomplished two goals: it kept him and the boatmen well fed and provided him with the means to practice the language he would need in Mandalay while he worked his way up the river.

Bastian negotiated the Irrawaddy in an open wooden boat with six men: his cook, the four men rowing, and another seated on a tall stool, controlling the rudder. There was a small shelter as well, which Bastian had altered so he could stand under its roof. As he set off, he anticipated visiting monasteries and temples. He expected to see small pagodas (temples) in villages and large ones inhabited by monks, many of which offered stunning views to the traveler who dared to scale their steps. He also hoped to delve into the region's Buddhist and Hindu pasts; some temples lay in ruins, surrounded only by fields, while in many cases new ones had been built up next to those that toppled. There was a deep human history contained in all of these edifices—those standing and those in piles on the ground. Such histories, he would come to realize, were in all of the things people created.

Bastian sometimes visited these places alone, and other times was accompanied by British officials who shared his interests or by the monks left in charge of the temples. Some monasteries even offered him access to historical and religious texts in a flowing Burmese script he taught himself to read. He transcribed some of those texts into his notebooks, and he recorded other historical and religious tales he found inscribed on monuments and other structures. Many of those found their way into his travel narratives as well.

As he crossed the border into the Burmese kingdom, leaving the protection of British authorities behind, he unpacked his revolver and rifle, understanding that he alone could ensure his safety there; yet he faced no challenges as he passed the customs house on the river, and, aside from crocodiles, his daily efforts to bathe went unchallenged as well. As he entered Minhla, the seat of the regional governor, the men powering his boat became worried: coming from the British-held territories, they felt insecure; his cook, for example, was afraid to go into the markets. Still, the governor, who pressed him for medicines when he learned Bastian was a physician, gave him papers permitting further travels. Those travels were inconvenienced by the official and religious restrictions against killing animals, which made meat and even eggs hard to acquire in a mostly vegetarian world. He was often hungry. The temples, however, only increased in number as he followed the river, feeding his intellect and preparing him, in a way, for the temple city of Pagan.

He approached Pagan's pagodas on the slow-moving river through morning mists, gazing across "a scrubland dominated by countless clusters of domes: 'countless, like the temples of Pagan,' according to the Burmese proverb." When he entered this temple landscape, he encountered intricately carved wooden doors, golden figures, statues of Buddha, some sleeping, some sitting, and walls painted with historic and religious scenes, which seemed to have accumulated over the last thousand years. He wandered from one to another; each offered different plays on familiar scenes: "In Ananda-phaya, built on the model of Nanda-Tsee-Goon by five Rahandas of Hemawonda under King Kyan-zeetha, the front door leads directly to the recess, in which Ananda's colossal image stands. The high vaults, in which the recitative of the evening service was wonderfully solemn, cross each other and the walls are cut out everywhere in niches containing a great variety of different figures."[17] For Bastian, whose interest in Buddhism had led him up this river, Pagan was satisfyingly overwhelming.

As he moved on to Mandalay, the capital of Burma, he achieved yet another first: he was the only German ever to spend half a year confined in King Mindon's palace. Bastian later described the palace as located in the center of a "military town, which corresponds to the Manchu District in Beijing, and is surrounded on the outside by a deep moat." Its fortification and location above the river was a response to the British threat. Around those fortifications lay the unprotected remainder of the city, where business and trade took place. Everything struck Bastian as hastily assembled, disturbingly fresh. The movement of people animated the center, and he took note of the orders and ranks, identified even by their umbrellas: only the king was allowed a white one; others, depending on rank, carried red or gold. In essence, he detailed everything he observed, from the animal figures on the gateways and the pilgrims purchasing prayer flags and lights before visiting temples, to the huge colony of chickens under the king's protection. "For a while, every day," he explained, the king had purchased a hundred birds that would have been slaughtered and had them delivered to this "holy asylum." There, porters brought them baskets of rice and corn, making them "thick and fat"; they produced such quantities of eggs that "nearby a colony of dogs has settled in to consume the superfluous ones."[18] He captured many other everyday moments in his journals as well: a divorce ceremony, the pride of the Chinese residents in their temple, puppet shows, processions of white elephants accompanied by music, the workings of witches and medicine men, the Burmese zodiac, the lives of resident Armenians, and festivals of the moon.

His initial apartment became well known because he was a German physician—many people sought out his assistance. Consequently, his

efforts to retain some anonymity failed, and his desire to quietly travel the old road north into China to learn about Buddhism away from these centers aroused governmental suspicion. Those areas were closed to foreigners, and after a point they were open only to Chinese. Moreover, few Europeans came to the city, and none who did lived in the village outskirts observing people; they sought an audience with the king. Since King Mindon was well aware of the activities in his city and always wary of the British, Bastian's actions began to convince him that this foreigner was a conspirator or a spy. Thus, when Bastian tried to move away from the city, Burmese officials summoned him back—back to the city, and to the court of the king.

In the precariously formal world of King Mindon's court, Bastian explained his interests in other lands, languages, and religions, and particularly his desire to study Buddhism in Burma, where, he argued, "it had remained most pure." Initially dubious of this stranger, the king was delighted by this revelation—and for a moment Bastian sensed success. Yet when he explained that for exactly this reason he wished to travel to Tagaung, "the ancestral seat of the Burmese royal family," and the northern provinces, the king soured. He did not understand the argument, and he quipped that one can either study or travel, but not both. Bastian feared he had made a misstep; but his concern for his fate was immediately relieved when the king made a suggestion: "for the study of Buddhism, there is no better country than Burma, no better place in Burma than Mandalay, and no better place in Mandalay than in my palace. An apartment stands ready in my palace; there Buddhism can be studied; I will take care of teachers and books and deliver everything necessary. Is that all right or not?" Dumbfounded, Bastian equivocated for only a moment, just long enough to sense that King Mindon was unused to waiting for answers. Then he retorted: "Yes!" As tensions eased, the king responded: "I myself will be interested in these studies and watch their progress."[19]

Transformed from an anonymous traveling scientist to an object of Mindon's curiosity, Bastian negotiated his move into a prince's quarters while absorbing the rules and regulations of the palace, learning a more refined version of the Burmese language, and then diving into Buddhist texts. As all travelers do, he made mistakes. While unpacking his things in his apartment he was horrified to see his umbrella included—umbrellas were forbidden in the palace–and he immediately conspired with his servant to have it spirited away. One fountain, he learned, produced water for bathing the king's feet, not for him. Meanwhile, when he was sleeping, his feet must always be pointed in a particular direction, "where the

golden-footed man himself sleeps. In the whole palace, however, everyone must lie in bed with their feet turned away from the palace, which was to be taken *ad notam*."[20] He dared not move his bed.

Priests and princes made amends for Bastian's ignorance of palace etiquette, while offering their new student a wealth of information about the land, its politics, and its religion. These were lifetimes of knowledge, and he gleaned much more from them than he ever could have gathered on his own. Initially, the king appeared to have a life plan for Bastian, fashioning a training program that would slowly progress from language to religion to mastery, in a manner reminiscent of that followed by monastic students—except that Bastian's studies were led by princes and teachers assigned by the court.

As he gained the trust of those princes and teachers during his first months of study, however, Bastian was able to transform that program into a schooling that accommodated his needs and provided him with detailed information about Burma that would offer him a basis for the comparative analysis he pursued after he left the palace—from arts, astrology, history, music, and philosophy, to cultural codes and social norms, to the skills of handworkers, painters, tailors, and the training of soldiers and the use of slaves. Buddhism, of course, was the focus of his studies, and he recorded his understanding of it in his notebooks and later in his travel narrative. Yet his interests and observations included this all.

He recorded also the tensions that emerged when he resolutely defended his position as a resident scholar while the king tried to transform him into a court physician. That led to weeks of isolation, and even his servants and tutors abandoned him until the king's position softened. Then his studies continued.

After the court grew to trust him, after the king came to regard him as neither spy nor threat, he was allowed, after a series of festivals and a parting ceremony that left him with a ruby ring from the king and many other gifts, to continue his journey beyond Mandalay. At first, he set off north to those territories he had intended to visit when he arrived in the city. Protected by the king's documents of permission, he worked his way up to the Chinese border before making his way back into southern Burma and then, traveling mostly by elephant, into Siam. In the cities, he later noted, there were structures set up to help travelers mount the elephants; many had them at their homes. He was able to sit or even lie on top a platform fixed to his elephant's back as it swayed through the wooded paths, stepping over fallen trees, or shoving them to the side. In the forests, however, without the help of a guide or a ladder, he had to learn to get his mount to

kneel down, use its leg as a step, and move up past the ears. Once in Bang-kok, this king, too, greeted him as a visiting scholar; Bastian wrote exact-ing accounts of the city; and he dove into the language and religion with even more enthusiasm than he had into elephant mounting and riding.

That elaborate, exacting, and intense pattern of locating people and places with concentrations of knowledge, collecting details of history, reli-gion, and everyday culture from locals and their surroundings, and record-ing them for later inclusion in his Gedankenstatistik, was Bastian's pri-mary methodology. It must have been exhausting as well as exhaustive. Yet he continued to use it over the next four years of travels through South-east Asia, across the islands of Indonesia, and, after his return to Europe, through Mongolia and Siberia, as well as over the next four decades of his life. That is how he pursued the total histories he envisioned.

Between 1866 and 1871, Bastian published his six-volume *The Peoples of East Asia*, a stunning achievement for any scholar. It was a report on his experiences and an extensive account of what he had collected: details of people, places, and things; explanations of their cultural codes, political structures, and religions; descriptions of cities, towns, villages, and every-thing he saw in them. He even produced short bilingual Burmese-German and Vietnamese-German dictionaries.

Yet he appears almost to have written those volumes on the side. After taking up residence in Berlin in 1866, Bastian also quickly completed his Habilitation (the postdoctoral qualification required of professors) at Friedrich-Wilhelm University in Berlin. The next year, he was appointed an extraordinarius (nontenured professor) at the university, and he also assumed the presidency of the Geographical Society. In 1869 he became a cofounder with Rudolf Virchow and other leading scholars of the Berlin Society for Anthropology, Ethnology, and Prehistory as well as its journal, *Zeitschrift für Ethnologie*. As if that were not enough, he also took up his position as assistant to the director of the Ethnographic Collection[s] in the Royal Museums. There, his collecting interests quickly extended to an obsession with things.

The Fisher of Souls

Bastian is a controversial character. By the end of the century, old rivals and a younger generation of ethnologists were eager to point out the limitations in his later work, to mock the overcrowding in his museum, and to challenge his emphasis on method over theories. In fact, theories of cultural diffusion were gaining champions among young ethnologists

by that time, and as Bastian's life came to an end, a revolt of sorts was under way. Yet grudging respect, even admiration, remained among coworkers and opponents alike. It was hard to deny Bastian's leading role in shaping the field of ethnology or to admire his commitment to it. As one of his directorial assistants, Karl von den Steinen, reminded the crowds at Bastian's funeral in 1905, "no German scholar has traveled more, none has read more, none has written more."[21] Bastian's publications, he exclaimed, "are a library," and "surveying it exceeds the powers of a mortal."

In part, he argued, Bastian's record stemmed from the fact that he "traveled a free man, out of his own resources, and there was no one to whom he had to give an accounting." Consequently, he could travel further and longer than others. Yet it was not simply a question of how much he traveled, but how he did it: "He went, asked, asked, wrote and collected. He studied the people outside, just as he did his books at home, and his life at home was just another, sedentary mode of traveling through the printed world of the mind."[22]

Among Bastian's many writings, Steinen singled out *The Peoples of East Asia* as Bastian's most "valuable travel account." The depth of inquiry and detail of description, he noted, was stunning, and the experiences captured within it also prepared Bastian to produce a series of "ethnopsychological publications" after he assumed his position as directorial assistant in the museum. In those works, he began to systematically sketch out links between ethnology and psychology, between individuals and groups. That became the basis for his mature arguments about human history, based on his notions of elementary ideas, folk ideas, and geographical provinces, which emerged in the 1880s.

It was only in 1875, however, that Bastian's collecting extended from ideas to people and things. It happened during his fourth journey, which took him over the course of a year and a half to the western coast of South America, to Central America, and then through the United States and the Antilles. That trip was fundamentally different than his previous journeys. It was funded directly by the Royal Museums just two years after the Prussian king had agreed to support the expansion of the ethnographic collections with an independent, self-standing institution: Bastian's museum. Moreover, its goal was to fill in gaps in the ethnographic collections, which Bastian and members of the Berlin Society for Anthropology, Ethnology, and Prehistory had lamented as they petitioned in 1872 for a new kind of museum, one that could assemble the material traces of human history from all over the world. Thus, Bastian left Berlin with a budget for

purchasing objects, and he targeted collectors, potential collections, and places where one might find archaeological artifacts.

He returned with important collections, but in many ways, it was the connections he built, the people he won over to his cause, that mattered most. As Steinen knew from personal experience, Bastian was a kind of "*Seelenfischer*," a fisher of souls, who developed a pattern in his collecting ventures:

> He sought out the authorities that had been familiar with the natives for years, and who had worked through material in their manuscripts or collections that the alien, fleeting visitor would never have been able to bring together: Bastian appeared wherever they were hidden, and these men, who all too often saw themselves as prophets in their own country, and now suddenly found the deepest understanding of their quiet work and their ideals among the far-traveled, they were glad to learn from him and to give to him.[23]

Steinen underscored Bastian's success with this method: "He immediately conquered people by giving them high, rare tasks with trust, with a confidence that one literally felt growing within himself." This worked, because Bastian appealed to their "best instincts, and possessed no others himself."[24] Steinen had experienced this personally, and he empathized with those men whom Bastian caught while on his expeditions. During a random encounter in Honolulu, Hawai'i, in 1880, he himself "hopelessly became enslaved by the Seelenfischer," and it changed the course of his life. He went from traveling for pleasure to collecting for Bastian and then to a position in the museum.

Consequently, Bastian's three-volume work, *The Cultural Lands of Ancient America*, is not only replete with examples of his developing ideas but also contains a compilation of the contacts he developed with Germans and non-Germans living on the western side of the continent, from Valparaiso, Chile, in South America to Guatemala in the North. Those contacts reacted to Bastian just as Steinen describes: they helped him locate archaeological objects, collections, and other collectors. They helped him understand the international market in material culture in each of these locations. Many of them went out of their way to secure him collections while he was there, and quite a few continued to create collections for him during the decades that followed. In many ways, these were the beginnings of the global collecting networks Bastian fashioned over the next three decades. To a large degree, those drew on German-speaking communities abroad to fill his museum.

Bastian left Liverpool bound for Latin America on May 5, 1875. Yellow fever made a stop in Brazil unthinkable. Consequently, as they neared the coast on May 23, the captain sent a small boat to exchange postal packages, but he refused to allow anyone onshore. A few days later, as they worked their way down the coast, they saw "the rocky mountain peaks, which are so varied in their picturesque magnificence" marking the Bay of Rio de Janeiro.[25] Yet here, too, Bastian and the other passengers had to be satisfied with their view from the ship and with "a walk in the Campiña hills of Macaque Island," where the shipping company had its coal depot. Despite those precautions, when their ship made its first real stop in Montevideo, Uruguay, the fear of yellow fever was so pervasive that disembarking passengers had to wait in quarantine on the rocky Isla de Flores before entering the city.

As the ship took Bastian through the Strait of Magellan, he experienced it through a unique mixture of aesthetics, history, geology, and science. He scribbled out, "When on 21 October 1520, Magellan's eyes took in this promontory, the question of whether the problem of circumnavigating the earth would be solved was dependent on the answer of yes or no," for previous reports, he noted, "had been contradictory." Bastian savored that critical moment in world history, before reflecting on how, after that initial success, the pressing question became how quickly the passage could be navigated, and how safely. Bastian noted the milestones for his readers—the names, the dates, the number of days—and reflected on the changes he had experienced.

His was neither a sailing vessel from the sixteenth century, nor one akin to the first ship he took through this passage; yet there was still danger. Steamships also sank in this majestic place. He thought about those accidents and mused about the skeletal vessels below them left from such failures. Mostly, however, he contemplated the books written by Darwin and other traveling scientists, which revealed their own first views of La Cordillera descending into the sea. No one, no matter how objective or focused on the geology, can avoid remarking on its formidable stark beauty. As his ship was caught in the first rays of dawn near la Calle Larga, he too had to write about it: "wildly torn rock massives chased westward in multiform, opposing peaks, while on the left a wall was formed by island-like slashed lumpy rock masses, with Cape Upright protruding, the opening of Sea Reach, where the swell begins to be noticeable."[26]

Bastian made quick work of Chile. After rounding the tip of the continent and heading north, he got off in Valparaiso, where, much as Steinen described decades later, he went straight to the German trading house

Zahn and Co., where a Herr Elvers put him in contact with the German consul. He, in turn, provided Bastian with "an interesting acquisition" from Easter Island before placing him in touch with more Germans, who helped him as well. Then Bastian hurried inland by train to the capital of Santiago, where he met with Federico Philippi, professor at the University of Chile and director of the National Museum of Natural History. Philippi already knew Bastian, and had known he was coming. He was a corresponding member of both the Berlin Society for Anthropology, Ethnology, and Prehistory and the Geographical Society in Berlin. He quickly put Bastian in contact with other faculty and scientists in the city, and they organized an exchange of objects between their museums. Then Bastian left. He hurried back to the coast and hopped a British steamer north to Peru.

That trip was anything but romantic. Bastian was irritated that he had to waste some of his funding on a bribe to get on board, and despite paying that additional fee, what followed was unpleasant: "there was a cross-swell on some parts of the coast," and their ship "had been loaded with several hundred oxen, which with every vacillation skidded here and there in their stalls [and] caused an infernal noise."[27]

While suffering the trip along this picturesque coastline speckled with cactus and topped with a chain of snowcapped mountains, he stopped in a series of small towns. He found one German after the other eager to work for him. In the port of Caldera, for example, the German consul happily received him and helped get him on a train to the inland silver mining town of Copiapó, where another German consul took him into his home, refusing to let him stay in a hotel. Bastian was entertained by the consul's family, drank bottled German beer with the consul in the German Club, and met many more Germans, including a trader who showed him his collections of mummies, clay pots, copper knives, tools, and other objects found along the nearby "Inca road." The consul's brother agreed to excavate more objects like those and send the results to Bastian in Berlin. The consul sent some of his own collection as well.[28]

Further up the coast in the Iquique, where the port had long been filled with ships exporting saltpeter around the world, Bastian had breakfast with yet another German Consul and other "German compatriots," many of whom were "employees in the German trading house Gildemeister & Co." That company became one of his most important contacts in Peru. The Gildemeisters, like Bastian, originated in Bremen, and the contacts he created between that family and the museum far outlived Bastian. The museum received donations of objects from them as late as 1995.[29]

When Bastian reached Lima, his evening with the German Imperial resident minister and his first days in the city forced him to change his plans. The wealth of the saltpeter years had made Lima into a place of opulence and excess in which, among other things, "the display of antiquities seemed to be a thing of fashion, and as they were under constant demand, they were retained on all sides."[30] Local collectors were passionate, unwilling to sell, and even when they were willing, the prices were far too high for his budget. He convinced some collectors to engage in an exchange of duplicates with his museum, but purchases were difficult. Even with tens of thousands of marks at his disposal, he could not compete in this market for relics.

So Bastian left the city. He traveled with a German trader to the interior, to internationally known ruins such as those in Pativilca, and to many smaller sites in between. Yet these were so well picked over, so much was strewn about, the opportunities were so limited, and the costs so high that Bastian soon chose to retreat altogether, return to Lima, and head north to Ecuador. He wanted to quickly get away from the city he thought "gives the impression of a pestilence covered with false makeup, which attracts all the juices of the body politic and decomposes them into harmful slurry, which would best be removed as soon as possible so as not to cause any further damage."[31] Alexander von Humboldt had disliked Lima as well. Wealth had corrupted it rather than enhanced it, and Bastian thought its future precarious as the mining production was slowing and the market in saltpeter would one day fail. Yet it had not been a waste of time. Some collections from the Gildemeisters and from Minister Luerssen found their way to Berlin, one from Luerssen arriving decades later, in 1904. Moreover, Bastian had learned a great deal about the challenges ahead.

Arriving in the harbor of Guayaquil, Ecuador, at the end of July, he was again greeted by a German consul who, much like his counterparts in other Latin American cities, took Bastian into his home. Bastian began immediately fishing for contacts and collectors among the many Germans working in the city's trading houses. Within days, however, he and his servant were traveling by mule to Quito, where he was immediately presented to Ecuador's president, Gabriel García Moreno, just a day before his assassination on August 4, 1875. His death undercut Bastian's plans for state-supported excavations, and it threw the government and Bastian's itinerary into chaos. He had to move quickly to free his servant from prison—he had a connection to the now toppled government. Once he was released, they quickly fled the city.

As they moved away from Quito and settled into a more measured pace, they crossed some of Humboldt's paths through the open grass country. With reverence, they approached the mountain that had spurred Humboldt to draw together his ideas about the natural world: this was where he realized nature was a web of interconnected life; where, from high upon the volcano, he saw the totality of nature spread out before him; where he was inspired to sketch out the *Naturgemälde*, his representation of the whole of nature.

"When we reached the last twist of the path, which would reveal the great spectacle," Bastian recalled, "I involuntarily pulled on the reins of the mule for a moment to prepare myself for the first sight of Chimborazo, which lay before us in all its majesty." It was as aesthetically impressive in real life as it had been historically significant: "at the opening moment, the gaze wanders to distant mountain humps, laid out in colorations of different cultivation, and behind them, on the ridge of a jagged mountain range, rose the mighty snow cone." Riding down the thin gravel paths at its sides into a plush green canopy, he could not help but take in the contrasts, the plays of colors, about which Humboldt had written. He noted how "the emerald glow of the green meadows, the dazzling way of the snowfields, the azure blue of the sky, combine to create a wonderfully overwhelming color effect in the golden light of the sun."[32]

While Bastian covered vast distances by mule, he often reflected on the scientists who preceded him. Their accounts, in many ways, were his travel guides. Not only Humboldt but also other naturalists had traveled widely in the area.[33] Their studies helped him negotiate the histories and the geographies and select his destinations. So too did the information from his contacts in the cities, who set him looking, among other things, for a collection of some three thousand bronze axe heads that were rumored to have been recently unearthed and to be completely anomalous for the area. He asked about them as he traveled, and his search for them helped guide his choices about where to go, but he also discovered things on his own.

Many ruins had disappeared, he noted, because the stones were taken away and used for modern buildings. Many Christian churches, in fact, were built with heathen stones. Other items became playthings for children, or people transformed them into decorations. At one point, in a hut occupied by local Indians, or "Gente de Bayeta," at the foot of El Panecillo, he was, as he so often did while traveling, practicing the local dialect with the other patrons when, while lighting a cigarette, he noticed "between the cooking utensils a vessel of a somewhat different shape, which, on closer inspection, was indeed found to be antique," and when

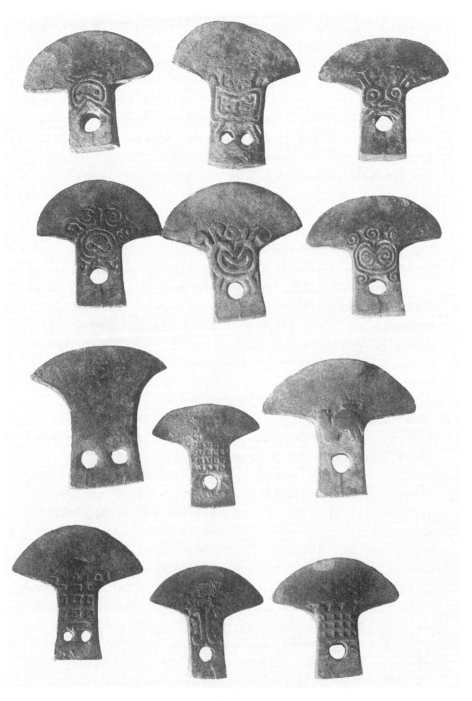

FIGURE 1.3. Axe Heads. From Adolf Bastian, *Nachträge und Ergänzungen aus den Sammlungen des Ethnologischen Museums* (*Die Culturländer des Alten America*, Vol. 3) (Berlin, 1889). © Bayerische Staatsbibliothek München.

he "rubbed off the dirt it also revealed ornamentation."[34] When he asked where they had found it, they directed him to a potato patch, where he noted for future researchers the location of a temple he had no time to excavate.

Ultimately, he found some of the bronze axe heads, and his efforts have since become a part of Bastian lore. Though three thousand of these axe heads were originally discovered during an excavation in the district of Azogues, their whereabouts were unknown by the time Bastian arrived in Ecuador. He had seen a few of them in the capital, and a few more in Guayaquil. A German collector gave him one of the three in his possession, but others demanded prices he simply could not pay. Many suspected that the rest had been sold for the value of the bronze, melted down and transformed into something else. That was entirely possible. Bastian often purchased silver objects from jewelers and blacksmiths who had bought them from treasure hunters for the weight of the silver; he prevented those objects from being transformed into bars and coins. Many of the axe heads were ornamented, making them all the more valuable, and eventually his inquires in the Azogues district at the home of a trader, Vincent Aguilar, led him to a large box in the office of a man who dealt in metals. It contained three hundred of the axe heads, from which he was able to acquire sixty-one (forty-three are still in the museum today).[35]

Acquisition was one thing, getting the axe heads back to Berlin was another. At one point, the sack in which he was transporting them broke open, strewing them about. He obtained a box, but feared he might lose it in one of the many river crossings. He did not. It traveled with him to Piura, where he spent time with the German teachers hired by the city fathers to run their school; he schlepped them through snowdrifts, in which his mules sank to their bellies; he carried them across desert landscapes filled with bandits. And he toted them as he negotiated for private collections near the ruins of Chan Chan and the town of Virú, and they were among the items he loaded onto a boat in Naranjal, the harbor town of Cuenca, which was supposed to take him back to Guayaquil. It did, but it almost sank along the way, and, as the panicked crew and passengers scurried about looking for things to toss off the overburdened vessel, he sat menacingly on his box of axe heads with his revolver and refused to let them near it. As a result of his vigilance, when he finally returned to Guayaquil after forty-one days, those axe heads, along with many other things he had acquired along the way, were collected and shipped to Berlin.

After several more excursions along the coast, Bastian returned to Lima, where letters awaiting him from Germany made it plain that he had to return much earlier than planned. That caused him to rethink

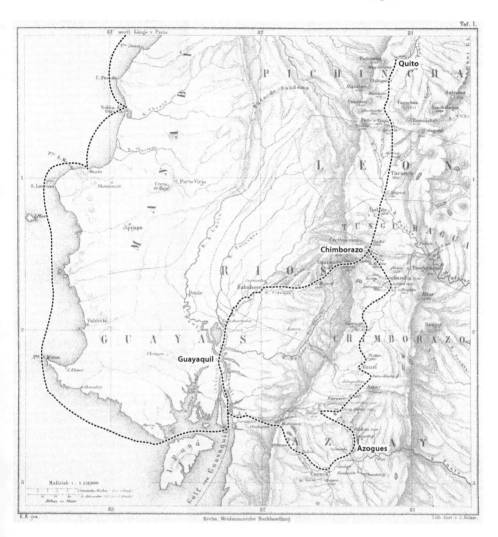

FIGURE 1.4. Map of Bastian's travels in Ecuador, including his visits to Chimborazo and Azogues. A. Bastian, *Ein Jahr auf Reisen: Kreuzfahrten; Zum Sammelbehuf auf Transatlantischen Feldern der Ethnologie* (*Die Culturländer des Alten America*, Vol. 1) (Berlin, 1878). © Bayerische Staatsbibliothek München.

his itinerary and his interests in returning south and plan instead a trip through Colombia, Central America, and the United States. In Colombia, his patterns of collecting people and things continued amid the further mishaps and challenges that were common when traveling in remote areas that were tropical (and often fever ridden) or simply sparse and isolated, with little infrastructure. On one steep, muddy trail, one of his mules lost its footing and took a nasty fall. The mule was injured and some of the clay objects he had collected were destroyed. He was irritated both by the losses and by the loss of time.[36] Bastian hated losing time.

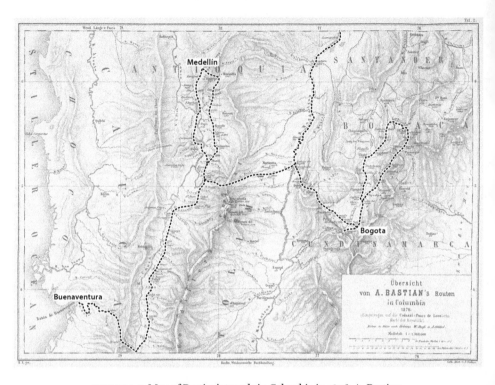

FIGURE 1.5. Map of Bastian's travels in Colombia in 1876. A. Bastian,
*Ein Jahr auf Reisen: Kreuzfahrten; Zum Sammelbehuf auf Transatlantischen
Feldern der Ethnologie (Die Culturländer des Alten America*, Vol. 1) (Berlin, 1878).
© Bayerische Staatsbibliothek München.

Sometimes collecting was easy. On his way to Filadelphia, in the Caldas
Department of Colombia, he and his servant found themselves on the so-
called Camino Real, or "real street," "whose name one understands better after
comparisons." They had a delightful breakfast with a local physician, Dr. Ale-
jandro Londoñez, who was interested in Bastian's endeavors, and he helped
spread the word about them. As a result, "in the afternoon, as I again was
walking down the previous street, people with antiquities, who had collected
them in the meantime, came to me from different houses. Others promised
to bring theirs to Manisales."[37] The Seelenfischer was acquiring many souls.

Not everything, however, went so smoothly. His notes are filled with
accounts of bare huts, aggressive insects, muddy paths, and inclement
weather. Reliable food was hard to come by as well. For that, Bastian had
a strategy many travelers can still appreciate today:

> To sustain the body, far less is necessary than one usually thinks, and
> the necessities will usually be found in one way or another among the
> common foods, and in the South American countries best through

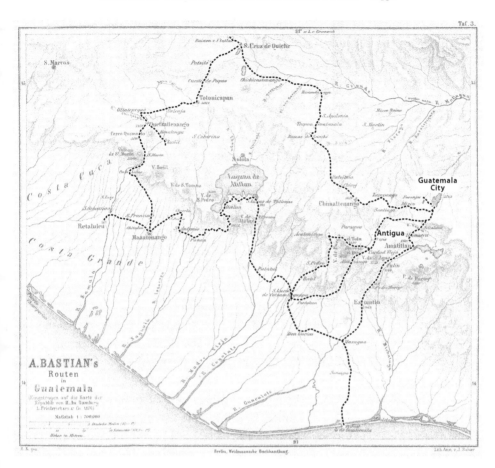

FIGURE 1.6. Map of Bastian's travels in Guatemala. A. Bastian, *Ein Jahr auf Reisen: Kreuzfahrten; Zum Sammelbehuf auf Transatlantischen Feldern der Ethnologie* (*Die Culturländer des Alten America*, Vol. 1) (Berlin, 1878). © Bayerische Staatsbibliothek München.

chocolate. From that one may exist for weeks and months, that is, if it is to be had with boiled eggs in the shell (since another, and every artificial preparation is questionable from various points of view), or occasionally a mazamorra, a kind of grits, of which gourmets, of course, offer no variation, but which are nutritious.[38]

This grim menu held together with chocolate also led him to reflect on how different his travels had been in Asia, and to dream during some Colombian evenings of the light, fresh meals of vegetables and fish that had sustained him for years on the other side of the Pacific.

In stark contrast to those villages and towns with their questionable inns, Bogotá was a place of fine meals and plush hotels. It was also another

place inhabited by many Germans well placed in industry, trade, teaching, and other professions. Here too they helped him secure collections, both while he was in town and for many years after. There were also libraries, filled with the smell of the old, dusty books that he immediately scoured for historical manuscripts, and there were goldsmiths serving the wealthy, from whom he rescued more objects, including "a few emeralds found in tombs." For "the cult of the green stones found in American archaeology," he noted, "significant gemstones of the richest quantity were taken from the mines of the Muzos already in ancient times."[39] Hence the jewelers' interests in tombs.

In Bogotá, too, he successfully fished for souls. One notable success followed a passionate lecture Bastian gave on the future and the importance of archaeology and ethnology. Afterward, philologist Rufino José Cuervo approached him. Earlier in the week, he had resisted all of Bastian's requests to purchase his collection of archaeological relics, but he had been so moved by Bastian's lecture about the scientific value of such things, that he now offered to send his collection to the Berlin museum as a gift. He did, and, as Bastian later remarked in his travel account, "because in the meantime they have arrived, in the main, safe and sound, they remain secured for science."[40]

This pattern of collecting people and things continued during his comparatively short excursions into Central America, and especially in Guatemala, where he had an unprecedented success. Like most German and non-German scientists who have arrived in Guatemala during the last two centuries, he was immediately drawn to the picturesque colonial capital of Antigua, where, "when we left in the morning (21 May), we saw in front of us in their exhilaratingly refreshing and inspiring atmosphere the pointed Vulcan de Agua (3,753 meters) next to the double-pointed Vulcan del Fuego (4,001 meters), covered with snow" and curving up before a distinct mountain range. From this city of ruins left destroyed by a devastating earthquake on the Feast Day of Santa Maria (July 29) 1773, he traveled to the slowly modernizing capital, Guatemala City, where Germans came out in droves to meet him. The passenger list from his ship had preceded him by telegraph, and he soon found himself whisked away by locals into their German Club. Those Germans eagerly helped him learn about the archaeological relics, which "had found their way into private hands." They also helped him gain provisions, lent him a revolver (his had been accidently left behind in Colombia) and he set off toward Santa Cruz de Quiché, where culinary conditions were so dire he felt it best "to return to the earlier diet of chocolate."[41]

Guatemala's coffee plantations became a crossroads for scientific travelers from the middle of the nineteenth century well into the twentieth. Bastian visited many. The food was better there, the information good, and support forthcoming, especially on those owned or managed by Germans. Moreover, they were often close to archaeological sites because plantation workers frequently uncovered sculptures and remains of settlements or towns as they converted lush forests into farms for the production of coffee and other commodities. Somewhat like Humboldt's condemnations of Spanish slavery in its colonies, Bastian was critical of labor practices in Guatemala. He wrote with concern about feudalism around the plantations, but he also wrote with great curiosity about witchcraft in the cathedrals, the women sitting between the rows of pews with candles, alcohol, and offerings chanting in one or another Mayan language to spirits not captured in the chapel's mosaics. He also was one of the earliest German scientists to explore the vast archaeological site around the Chocolá plantation (*finca*), which later became a base camp of sorts for archaeologists and ethnologists.

The site that most interested him, however, was near Santa Lucía Cotzumalguapa. An Austrian had told Bastian about it during a visit in Berlin, and Juan Gavarrete, an archivist for the Sociedad Económica, who had helped produce a governmental report on the site, had told him about it as well. When Bastian arrived in Guatemala City, he was surprised the report could not be found. When he arrived in Santa Lucía, however, the sculptures were still there. The local commandant, Pedro de Anda, took him to the sites. Some pieces had been moved to private properties, others were in their original locations, still others, he suspected, were just under the cover of the vegetation and the ground.

Bastian was taken aback by these sculptures, because of both their importance and their obvious neglect: "It took me some time in Santa Lucía to recover from my amazement at these wonderful works of art, and to understand the obliviousness in which, though only a few days' journey from the capital of the country, they are still buried." The government had no interest in these objects; it did nothing with the report it commissioned, and it disregarded Pedro de Anda's letters about them. Yet their presence spoke volumes to Bastian: "one can see how much is still to be discovered here, when such a piece of antiquity can be casually picked up along the way as if it were so much rubbish."[42]

As a result, Bastian quickly negotiated a purchase price, made agreements for further excavations, and arranged the transportation of these stone objects (the contract excluded any gold they might find) to the harbor, and eventually to Berlin—although one of the carved stone slabs was

broken during transport in Liverpool and the "Eagle Stone" was lost when one of the haul lines severed while it was being loaded onto the transport ship and it plunged into the sea. Still, it was worth the effort. Ethnologist Manuela Fischer has called this collection of unique stone sculptures one of the "outstanding displays in the exhibition of Mesoamerican cultures in the Ethnological Museum Berlin."[43]

Bastian's Museum

Soon after Bastian returned to Berlin in August 1876 he was made director of the ethnological and prehistoric collections, he immediately returned to campaigning for the quick completion of their new building while reminding administrators, architects, and government officials alike that they were building a fundamentally new kind of institution. They did not need a bigger version of a Kunstkammer, and their goal was not simply to locate more space for the ethnological and prehistoric collections so that they could have a bigger version of what had been in Berlin's New Museum. Space was certainly at a premium. In 1870, they had between 7,000 and 8,000 items in their ethnological collections; that number had tripled to 22,000 by 1876. Only three years later, it would double again, so that by 1880 there were some 40,000 objects in the collections (250 European; 12,500 Asian; 3,500 African; 21,000 American, and 2,500 from the South Seas and Australia).

The conditions were frustrating. The rooms were overflowing, and it had become impossible to display many of their new acquisitions. Bastian also had trouble getting city and museum administrators to understand his goals. The point was not merely to accommodate a general public by making things easier for visitors to see. Their self-standing museum, he wrote in June 1877, could not be like an art museum, designed merely for public displays. It was more akin to natural history museums, in which space was imperative for their "study purposes." As he had repeatedly explained while lobbying for this new institution over the previous decade, and as he would continue to explain while defending it during the following ones, their goal was to create a "reading room [*Lesehalle*] for the inductive study of the science of humanity." He wanted a place where they could secure for science the kinds of materials he saw fading with time as he completed his last journey. He wanted a place in which the material traces of human history could be subject to a vast comparative analysis. He wanted the physical embodiment of his Gedankenstatistik.

There was, however, a different tone to his arguments after his return. Bastian was deeply troubled, and his arguments were more insistent. Foreboding drove his urgency. For if his age was indeed the age of collecting, it was clearly a fleeting moment—it could not last forever. Already during his last trip, he felt time slipping away: he was convinced he had arrived too late in Peru; so much already had been lost—melted down, torn apart, dispersed by markets—and his return trip from Central America through the United States reminded him that although his American counterparts were collecting systematically, building their museums, it was perhaps too late. There, as in so many other places around the world, indigenous groups, tribes of American Indians most Germans had first read about as children and continued to read about as adults, were vanishing "like snow before the rising sun of civilization." Because the great varieties of human cultures that were just recently flourishing around the globe were falling victim to the homogenizing powers of that so-called "civilization," ethnologists, he argued, had to move quickly. They had to save their material culture—the only historical records produced by people without written languages, and the only records left by many past civilizations. They had to act before those records vanished, before the vast ethnographic project Bastian envisioned became impossible to complete.

Moreover, as his last trip had made all too clear, Bastian could not do it alone. While he had successfully built up networks of collectors that would supply his museum for decades, he had managed to bring back only 1,748 objects. There was so much he had not located. There was so much he had been forced to leave behind. Who knew how long it would remain? Who knew when his age of collecting might end?

Consequently, as Steinen noted during his 1905 memorial address for Bastian, and as everyone around him had learned over the preceding four decades, Adolf Bastian's mantra became: "the last moment has come, the twelfth hour is here! Documents of immeasurable, irreplaceable value for human history are being destroyed. Save them! Save them! before it is too late!"[44]

The Haida Crest Pole and the Nootka Eagle Mask

HYPERCOLLECTING

JOHAN ADRIAN JACOBSEN was worried. Adolf Bastian sent the Norwegian collector to the Pacific coast of Canada in the summer of 1881 with thousands of marks and a clear goal: to collect as much as possible from the Northwest Coast tribes (especially the Haida) living between Alaska and Vancouver. It seemed like a straightforward task. He arrived in San Francisco in late August, organized his funding, and set off north. He gleaned advice from other collectors, and he gained assistance from the Hudson Bay Company and from a missionary and trader—who even sold him things, beautiful things. By early September, Jacobsen was successfully collecting in British Columbia, acquiring a lot. Yet, as he sat in the Tsimshian community of Port Essington, British Columbia, just a few weeks later, he was overcome by doubt. Bastian had told him where to collect; but he had not told him exactly what to get or how best to get it. Moreover, no one had prepared him for the seller's market.

Northwest Coast tribes had been trading with Europeans since the age of the Cook voyages (1768–79), and during the century before Jacobsen arrived, the number and variety of traders had increased with each decade. As a result, Jacobsen found himself competing with private collectors, a representative of the Smithsonian Institution in Washington, DC, and tourists—hordes of them—who came in the summers to the port cities, towns, and even some villages. Consequently, everything was more expensive than he imagined. He was always unsure if he was paying too much, and he was concerned that his funding might run out before he

could cover the entire area. The people he met in these coastal villages were already integrated into money economies. Many knew the value of their possessions on the international market of material culture far better than he did. To make matters worse, they also sensed his insecurity and urgency, and that gave them an advantage.

Writing in broken German from Port Essington, Jacobsen explained his predicament to Bastian and the members of the committee that financed his trip.[1] He assured them that he already had acquired quite a few "handsome" and "beautiful" items, but he emphasized repeatedly, "it all costs much money. Everything," he lamented, "is very expensive in this Land . . . even the Indians are moneymen. . . . In summer many tourists come here and they happily buy such things." Moreover, he was being outmaneuvered. The Haida he sought out in one village, he reported, were particularly "spoiled with the prices," because "a certain Dr. Paul was here who collected everything that was to be had and already sought out the best pieces."[2] Anything that was left behind had risen considerably in cost.

Still, there was some good news. "It is not the Haida alone, who have carved house posts—one also finds them in villages on Vancouver Island." Moreover, if the prices were high, the supply had not played out; as he went door-to-door in villages, he found many people with beautiful and fascinating things to sell. Some were very old—he favored the oldest things because they were unique, irreplaceable. He knew that. Over time, he also realized that the tourist trade was not all bad. In some villages he purchased lovely miniatures of items, such as totem poles, clearly meant for the tourist trade, while in others, he found people willing to reproduce objects he could not buy. One notable example was a beautifully carved and painted "Chief's Seat" that caught his attention in a Bella Bella village. The owner refused to sell it, but Jacobsen was able to commission a similar one from a man he termed the "best carver in the village." With the help of the Hudson Bay Company, he had it shipped to Berlin. It arrived with an equally stunning canoe made by the same artisan, and after Bastian's new museum building finally opened in 1886, that canoe had pride of place in the North American section.[3]

Christianity also had its virtues. Though widespread conversion combined with industrialized fishing and encroaching money economies meant that people had stopped producing many tools and religious objects in the old style, it also meant that many of these items had lost much of their practical or spiritual value in some communities. As a result, Jacobsen encountered people who were happy to part with things once dear to

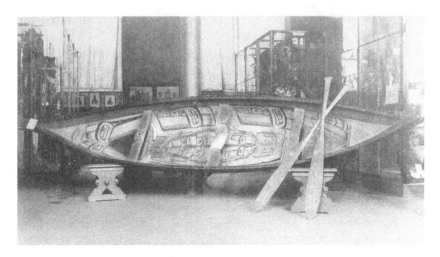

FIGURE 2.1. The canoe in the Berlin Museum für Völkerkunde, 1894.
Staatliche Museen zu Berlin, Ethnologisches Museum.

their families—if the price was right. A Haida crest pole, which became a focal point in the atrium of Bastian's museum from its 1886 opening until World War II, came from the Haida village of Masset, in the Queen Charlotte Islands. Jacobsen purchased it from a man who had converted to Christianity and was known as Captain Jim or Stilta. By his account, he no longer needed the crest pole, and he was happy to sell it to the museum.[4] Indirectly, he also supplied the museum with some of its history and meaning, and he gave them the name of the sculptor who carved it: Albert Edward Edenshaw.[5] The fact that few collectors had managed to acquire one of these poles, and that it came with such detailed information, made it exceptional even within this extraordinary collection.

Still, Jacobsen continued to worry. "Maybe," he wrote to Bastian in October, "I am buying too much—it is like that, however, when one first starts to trade. Then one wants to acquire everything that looks interesting." That was perhaps especially true in British Columbia. Almost everything produced there of ethnological interest, from charms and fishhooks to boats and masks, was ornamented in ways that made them appealing to the collector. They all caught his eye, and since Bastian's instructions had been so general—collect as much as possible—Jacobsen followed his instincts and his aesthetics, paying particular attention to beautiful and older things. Basically, he bought wildly, like a shopper at an end-of-year sale, and hoped that he was choosing wisely. "I am so curious," he added toward the end of his letter, "how the things will be received in Berlin when they finally arrive. Hopefully good."[6]

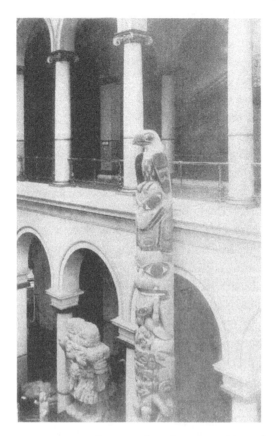

FIGURE 2.2. The crest pole in the atrium of the
Berlin Museum für Völkerkunde, 1894. Staatliche
Museen zu Berlin, Ethnologisches Museum.

Jacobsen's anxiety lessened as he continued collecting. He gained a
better sense of the market, and he retained the assistance of George Hunt,
a twenty-seven-year-old son of an English father and Tlingit mother
who had been raised among the Kwakiutl. Hunt sailed with Jacobsen
to Kwakiutl villages throughout the territory around Fort Ruper and
acquired more rare items for the collection, including several stunning
cedar bark blankets.

Moreover, as Jacobsen pressed further north, away from the tourist
ports and beyond the circuits of other collectors, he found ever-greater
opportunities. In some areas, he wrote in January 1882, where the men
were engaged in seal hunting and the furs commanded high prices, they
could earn as much as thirty dollars a day. That made it unnecessary for
them to part with anything, and as a result they were often quite "bash-
ful" about selling to him. Yet that was not always the case. As he came to

discover, their work was seasonal. During the winter, after a few months away from that steady income, they were more interested in dealing with him. Things got even better further inland.

As he collected into 1882, business continued to improve. He wrote Bastian that Alaska was "the true Eldorado." Later he would remark, in his autobiographical musings, that he "found in every village treasures purer or more unaltered than ethnology has seldom preserved."[7] At the time, he wrote cheerfully about his success and speculated on the potential of pushing north: "I have spoken with many people who know Alaska, and one tells me that there are many curiosities there, and much cheaper than anywhere in British Columbia and Canada." An old Alaskan trader even told him that fifteen years earlier he could have filled "a schooner with curiosities" for just one hundred dollars. Though that was no longer possible, there was still much to acquire.[8]

As he turned south, sailing back toward California, he wrote to Bastian with further tales of northern treasures and reported that other collectors, American and European, were on their way there. His instincts told him to go back for more. But he remained unsure: would Bastian agree?

He did: animated by the news of "the true Eldorado," Bastian raised more money for acquisitions from private donors he recruited to his cause in Berlin and instructed Jacobsen to return. Days after arriving in San Francisco in March 1882, Jacobsen found himself heading back to Alaska for a trip that became much longer than he had expected. With the assistance of Rudolf Neumann, a German-American agent of the Alaska Commercial Company, Jacobsen spent the better part of the next year assembling a collection of more than four thousand items from Inupiaq and Yup'ik communities.

Neumann's trade networks greatly facilitated that process, but winter in the Yukon was not without peril. Jacobsen traveled at times by boat, and sometimes by dogsled. He reported on a pair of Europeans losing their feet to frostbite, and of another trader drowning in a kayaking accident. For him, however, it felt like home. As the son of a Norwegian fisherman with little education but plenty of experience with harsh working conditions, the climate suited him. He was born on the island of Risö, above the Arctic Circle, and Jacobsen knew how to move between islands, hunting across ice and snow. He also was comfortable with these people. Close working and living conditions sometimes irritated him, and he clashed with some. In general, however, he found them similar to the people he had come to know in Greenland and on the other side of Canada, in Labrador, and his collecting generally went well despite the cold, the vast distances, and a

nasty bout of snow blindness. His chief lament was that Edward Nelson, a collector from the Smithsonian Institution, had beaten him to many villages. Some of the locals regretted that, too. Many who already had sold all their bone and stone implements to Nelson were irritated when they learned that Jacobsen was paying higher prices.[9]

Hypercollecting

Jacobsen's trip was part of a larger plan. Bastian was hypercollecting— attempting to get as much as possible as fast as possible. Systematic collecting ventures like this one were part of that plan. When Bastian completed his fifth major journey in late 1880, he not only passed through Hawai'i, where he worked with King Kalākaua's texts and prepared the way for Eduard Arning's efforts there a few years later, he also traveled east across the Pacific to Portland, Oregon. Nearby, he witnessed Europeans' devastating impact on tribes indigenous to the Columbia River region, and he became aware of the dramatic transformations taking place in British Columbia as well. He was convinced that the Northwest Coast had particular importance for ethnology. His conversations with W. H. Dall, a naturalist at the Smithsonian Institution and one of the earliest explorers in the region, confirmed that. The Pacific Northwest was a meeting point of two great continents, and the cultural history of their meeting easily could be wiped out with the transformation of the cultures indigenous to the coast. Bastian was anxious about that loss. He was keenly aware that, like most collections in Europe and the United States, Berlin's ethnological collections had next to nothing from those areas. If they did not act quickly, they never would.

And it was not just the cultural transformations under way that had him concerned. He also knew that the competition for those unique items from the past, those objects that contained the historical records he sought for his Gedankenstatistik, was increasing everywhere as museums across the Western world sent out collectors or expeditions of their own, and as nation-states, such as Canada and the United States, began to lay claim to all such things within their territories. As the value of these objects for science and politics rose, so too did their commercial value, and that increased the numbers of people who wanted to acquire them. As Jacobsen had quickly learned, demand also made those objects harder to get, and made the ones he could get more costly. Bastian feared that, given these circumstances, he would soon be unable to obtain ethnographic objects from many parts of the world.

Bastian was thinking a lot about such challenges while he completed his arguments for how ethnographic collections from around the world could be put to use in his museum. He laid out his most essential ideas in the text he was near finishing in 1880 on the importance of folk ideas for the construction of a science of humanity and their foundation in ethnological collections.[10] In this text, he explained the connections between what he called elementary ideas, folk ideas, and geographical provinces and the ways in which ethnological collections, geographically arranged, could become critical mechanisms for his Gedankenstatistik. Extensive ethnological collections could help him determine how *folk ideas*, or different cultural and ethnical manifestations of thought, grew out of *elementary ideas*, basic patterns of thought, as people adapted to environments and specific historical developments within particular geographies. Gaping holes in the collection would undermine those goals.

At the same time, Bastain was communicating with the General Administration of the Royal Museums about his vision for the museum, emphasizing his revelations during his latest trips—from the devastation in Peru to the current threat in Canada. In June 1881, he summed up his concerns in a long report on the state of his collections, emphasizing the need to increase them dramatically by collecting broadly and quickly. He explained that his own trips had been incredibly important for increasing their holdings, both through his direct acquisitions and through his successful efforts at creating and using contacts abroad—but he also emphasized that he could not continue to do this alone. Therefore, he argued in his report that their primary goal should be "to win through correspondence in the various parts of the earth such promoters who are prepared to use their local expertise in accordance" with the instructions he was preparing for them. However, where this kind of helper could not be found, or where time was of the essence, their mission should be "to send travelers on our own initiative to the locations that, from the point of view of the museum, are most urgently in need of research and collecting."[11]

Bastian, in other words, was scheming, trying to develop a global network of associates who could supply the museum with collections as well as a system for quick, pointed expeditions to crisis areas—where cultures were undergoing immediate, radical transformations. The only thing lacking was the funding—the museum's budget was limited and not particularly flexible at a time when the building was far from complete and financial problems had already delayed it several times. He solved that problem by lobbying a group of friends and supporters. Together with Albert von Le Coq, Isidor Richter, Valentin Weisbach, and other wealthy men in

Berlin, he founded the Hilfs-Comité, a group dedicated to helping increase the size of the museum's collections.[12] The idea was simple: they would bankroll urgently needed expeditions; those would generate collections; the museum would later buy the collections; the committee would regain its money and use the profits to fund more, similar actions. Ultimately, this committee supported Jacobsen's trip with more than twenty thousand marks, and it paid off: his success legitimated their support, and eventually the support of the museum administration, for more such efforts.

The other reason Bastian's plans worked so well at this precise moment in time was Jacobsen himself. In 1881, Bastian did not have a large number of assistants who could be sent abroad. That would change quickly over the next decade, but in the summer of 1881, Jacobsen was the obvious choice: he had lived abroad, working in Chile on docks and ships; he also had collected for the Hamburg Zoo owner and impresario Carl Hagenbeck—traveling to Greenland to recruit Inuit for his first *Völkerschau*—a public display of non-Europeans hired to publicly perform their lifeways and cultures—and it was a tremendous success in Germany. Jacobsen recruited these people with money and promises of adventure: traveling to their communities, negotiating contracts, ensuring they had adequate costumes and everyday materials to put on display, such as clothing, tools, kayaks, a sled, and even the dogs to pull it. A group of Laplanders followed the next season with equal success. Their third effort, however, ended in tragedy, when all the participants he brought from Labrador died of smallpox. Hagenbeck was devastated and unwilling to recruit another troupe.

Consequently, Jacobsen too was scheming during the spring of 1881, and looking for employment. Bastian had already purchased collections from Jacobsen's various Völkerschauen, so Jacobsen approached him in May 1881 with a plan for a global expedition, based on an idea he had developed with Hagenbeck. He offered to captain a ship that would collect for Bastian around the world over the next several years. Initially, Bastian liked the idea. He began to organize the funding, and Jacobsen began outfitting a ship. But, as Bastian's thoughts turned to pointed actions, and as he and the Hilfs-Comité heard rumors that other researchers might be organizing expeditions to the Northwest Coast, Bastian shifted his support from that long-term project to a more focused excursion. That was fine for Jacobsen. It secured him an income, endeared him to the museum, and he felt certain he would gain future assignments if this one went well. That hope, in fact, fueled much of his anxiety at the outset of his venture. He desperately wanted to succeed.

FIGURE 2.3. Objects from Jacobsen's venture. Adolf Bastian,
*Amerikas Nordwest-Küste. Neuste Ergebnisse ethnologisher Reisen
Aus Den Sammlungen der Königlichen. Museen zu Berlin*
(Berlin, 1883). Source: Digital Library Greifswald.

As it turned out, Jacobsen chose well. His first shipments from British
Columbia sent delight through the museum employees as they examined
the objects: the curiously carved animals on the small totem poles painted
with striking reds and greens; the cedar cannibal mask in the shape of
a crane's head with a movable jaw, painted red, green, white, and black,
and adorned with black feathers and four tiny wooden skulls; the painted,
woven, conical hat with "a fantastic animal figure" portrayed in red, black,
and blue on its delicate curve; the stunning fringed blanket woven from

mountain-goat wool and adorned with similar images; the small carvings of animals, birds, and people; the hand rattles and drums, all so intricately detailed, yet with thick proportions in the lips, eyes, ears; none of them had ever seen anything like this. Bastian hurried out a special publication on the initial acquisitions that, because of the overcrowding in the New Museum, could not yet be displayed; several positive appraisals followed in German scientific journals. The rest of the materials—close to seven thousand objects in total from the Northwest Coast and another four thousand from Alaska—received equal enthusiasm.

The venture was a fantastic success. Jacobsen even experienced a brief moment of celebrity after returning from Alaska in March 1884. Eager to show off their treasures, Bastian and his assistants moved the collections to the old stock exchange building in Berlin for a special exhibition, while Jacobsen completed a book with a ghostwriter (someone needed to tame his German) about his adventures. German newspapers contacted the museum asking for accounts, and the entire city seemed to know of the venture. When the gala opening took place at the end of the month, Bastian and Jacobsen, the Seelenfischer and the fisherman's son, walked Crown Prince Friedrich and the Prussian minister of culture through the displays.

Then they built on their momentum. The Berlin Society for Anthropology, Ethnology, and Prehistory wrote to the director of the General Administration of the Royal Museums exclaiming that Jacobsen had proven himself to be "an exceptionally talented collector and observer."[13] Cataloging his successes, they asked, as Jacobsen had hoped, for further funding to send him on another trip. The director thought it a good idea, and he argued further up the institutional hierarchy until Jacobsen was funded for his second venture.[14] He left for Russia and Siberia at the end of the month, where he assembled another collection of some three thousand items.

Still, at the outset of the process, and in contrast to all the praise, Bastian also received a missive from Paul Schulze, the German American director of the North West Trading Company in Portland, Oregon. Bastian had met him during his trip to Oregon the previous year, where the Seelenfischer had recruited him to his cause. Schulze later gifted the museum a collection he had assembled of some seventy objects from Alaska and the Northwest Coast. In September 1881, however, Schulze was responding to Bastian's request for aid. Schulze wrote that he was happy to support Bastian's collector, but he wondered, "Is Mr. Jacobsen a scholar or what we in America would call 'a practical man'? If the latter is the case, then I

consider your mission absolutely wrong." In his opinion, their goals could not be achieved "with collections alone; these should be organized only by scholars who, by virtue of their knowledge, are able to explain the collected objects by studying the language, customs, and mores of the tribes concerned, thereby making them truly valuable for ethnological studies."[15] That warning was prescient.

Hierarchies of Collections

Not everyone was completely happy with Jacobsen's collections. Over time, other ethnologists began to find flaws in his collecting methods. Franz Boas, who later became one of the leaders of American anthropology, was the most famous of Jacobsen's critics. To a large degree, the impact on the international world of ethnology of Jacobsen's Northwest Coast expedition was due to the criticism Boas brought to them.

If there were heroes in the history of anthropology and ethnology, Boas would be at the top of the list. He grew up in a middle-class German Jewish family in Minden, Westphalia, with well-educated, assimilated, politically liberal parents who taught him to mistrust political dogmas and embrace the notion of Bildung—an important German tradition of self-cultivation through study, travel, and self-criticism, meant to allow people to increase the harmonization of their hearts and minds and gain greater personal freedom through higher forms of self-reflection. He loved reading travel narratives as a child, and he was fascinated with the natural sciences from an early age. He eagerly consumed Alexander von Humboldt's work as a student, and he went on to study geography and physics in the late 1870s and early 1880s. Later he worked with Rudolf Virchow and Adolf Bastian in Berlin.

Boas also immersed himself in the culture of the *Bürgertum*, the German middle classes, including the fraternities at the universities. Later in life, the man who became known as the father of American anthropology always insisted that any photographs of him, particularly any portraits, be made from his left side, where it was more difficult to see the dueling scars he had received from his fraternity brothers, or the droop in his smile caused by the resulting nerve damage. Despite his youthful indiscretions, Boas, following his parents, hated the close-mindedness of conservative nationalism.

Boas is best known for his promotion of cultural anthropology and his opposition to race science—the idea that race is a biological concept and that human behavior and mental faculty can be explained with racial

categories or typologies. Like his mentors Bastian and Virchow, Boas opposed those positions throughout his entire career. He refuted them with his own studies of skulls, which demonstrated that due to nutritional and other external factors there were more variations in skeletal structures within groups of people than between different groups of people—which undermined the most fundamental arguments behind race science. He also joined Virchow's opposition to what they both regarded as unfounded, facile evolutionary theories that assumed there were clear hierarchies of more and less evolved human beings. Boas argued throughout his career that differences in human behavior were largely cultural, acquired through social learning, not the result of inherent biological characteristics. For Boas, then, culture became the critical concept for describing and understanding human differences. To that end, he, much like Bastian and Virchow, was committed to a careful accumulation of data about the great variety of people and their cultures around the world. Scholars credit him with transforming American anthropology and essentially shaping the cultural anthropology that continues to be pursued at universities today.

Boas first worked as a temporary assistant in Bastian's museum in the fall of 1885, and he gained much of his inspiration for becoming an ethnologist while working with Jacobsen's collection in 1885 and with a Bella Coola troupe from British Columbia that Jacobsen recruited for a Hagenbeck Völkerschau on his way back to Germany from Siberia. They arrived with Jacobsen in Bremen in January 1886, and whenever they were in Berlin, Boas spent all of his free time with them. Later he published a small essay about it in the American journal *Science*, followed by much more work on Northwest Coast tribes over the next decade.[16]

While Boas initially found Jacobsen's collection inspirational, it also began to frustrate him. Many of the objects lacked the detailed information about their cultural functions—how they were made, what purposes they served, their stories, their songs. Jacobsen had been left on his own to acquire objects as he could, with few instructions about how to collect. The Haida crest pole came with exacting information because it was acquired from a man who had turned to Christianity and away from the traditions that produced it. In addition, someone else was able to collect much of that information for Jacobsen a year later—after he realized he needed it.

The Nootka Eagle mask, however, is a different story. It too is an exceptional piece, appealing, even beautiful. There are good reasons the Berlin Ethnological Museum has repeatedly used its image for catalogs and advertisements. First of all, it is striking. Like much of the collection,

however, it arrived in Berlin with few details besides the date and place of its acquisition. We know it came from Barkley Sound, because Jacobsen scribbled that location on a small cardboard tag he attached to it. We also know that the shape and moving wings are different than most masks from the area. The profile too is unique: but we do not know why. Because Jacobsen failed to ask, we may never know.

Boas spent considerable energy traveling to British Columbia in search of more information about the objects in Jacobsen's collection. He published a number of essays on the topic, offering "corrections" for many of Jacobsen's descriptions of objects in his collection, and he cornered Bella Coola participants in the 1893 Chicago World's Fair with drawings and photographs of objects in the Berlin collection for the same purpose. He wrote extensively about the process in his correspondence with other ethnologists he had come to know in Berlin, such as Eduard Seler and Felix von Luschan, who were beginning careers in Bastian's museum around the same time Boas was there.[17] In 1886, just before the opening of the new building for the Museum für Völkerkunde, Boas wrote to Luschan from British Columbia that there were lifetimes of work for ethnologists to do there; he also underscored the need to do it right: "Heaven forgive the sins of earlier collectors. The masks for which one did not immediately collect histories will remain in large part misunderstood."[18] Jacobsen's ears must have been burning.

After Boas's public efforts, a clear hierarchy of collections emerged in the international world of anthropology and ethnology: the more information obtained about an object's origins and cultural functions, the greater the object's value. Scholars working in the history of anthropology have often characterized Boas's work as exceptional. From the perspective of the German ethnology that produced him, however, there was actually nothing exceptional about his methods or goals. To a large degree, they stemmed directly from his mentors, Bastian and Virchow and their arguments about what constituted good science. They also were shared by most of the German ethnologists of his generation who he first came to know and respect in Bastian's museum.

Professional German Ethnology

The late nineteenth century was a precarious age to work for museums. Just as there were no clear rules about collecting at the outset of the 1880s, there was no agreed-upon set of credentials needed to obtain an established position. Worse still, for most of the people working in and

around Bastian's museum, there was little job security. All that was in flux. Jacobsen, for example, was initially a smashing success even though he was poorly educated and made up most of his collecting rules as he went along. He became more exacting about collecting information together with objects during each subsequent trip, and he hoped that his improved methods would help secure him a permanent position in the museum. He tried for the better part of a decade. Yet those small shifts were not enough. Many of his goals, in fact, proved to be moving targets: one day's unprecedented collection might be a later day's bad example; excellent qualifications for collecting in one context might quickly be deemed inadequate in another. As for work in the museums: the process of professionalization quickly left him behind while he was abroad, and no amount of publication in popular or scientific journals could change that.

Established professionals such as Bastian and his assistants, who initially lauded Jacobsen's collections, deemed him useful as labor, essential for organizing the collections he obtained for Berlin, and ideal for presenting them to their patrons. The Norwegian son of a fisherman was, after all, a colorful character. Yet Bastian and his coworkers quickly judged him unsuited for administration and science. He may have been no less qualified for museum management than some of the men who had directed ethnological museums in Germany a decade earlier. Yet, by the time he returned from North America, Siberia, and his third trip for the Berlin Museum to Indonesia (1887–88), that window was closed. The fact that by the end of the 1880s he had procured more than a fifth of the objects in the museum's collections also did not matter.

The competition on the museum job market was simply too keen. By the end of the decade, men like Eduard Arning who volunteered to collect for Bastian in Hawai'i were producing a different kind of collection, the type lauded by Bastian and Boas, who, in turn, called for more. During his own collecting ventures, Boas learned to spend time in communities before negotiating for objects, and he continued collecting information about them after he completed a purchase or a trade. Boas, however, was only one of the intelligent, promising, and talented young men that the Seelenfischer captured while Jacobsen was out collecting.

The concentration of talent Bastian brought into his museum boggles the mind. There was, of course, Karl von den Steinen, whom Bastian had hooked in Hawai'i, and who became especially well known for his work on the art of the Marquesas Islands in French Polynesia and his studies of Indian cultures in central Brazil. Among other things, he led two major expeditions into the Amazon during the 1880s, the second sponsored by

the Hilfs-Comité, and he later became director of the American section in the museum and a professor at Berlin University. In the mid-1880s, however, he was still a relatively small fish. Albert Grünwedel, however, was not. By 1883, he was one of Bastian's four directorial assistants, and his knowledge of Buddhism and of Central Asian cultures rivaled Bastian's own. He became especially well known for his work on Buddhist art, Central Asian archaeology, and Himalayan languages. Eventually he was made a professor of Oriental languages at Berlin University. Wilhelm Grube, another of Bastian's directorial assistants since 1883, was an exacting linguist and Sinologist, highly regarded for his work on ancient and extinct Asian languages, particularly in the Amur region. The third of Bastian's directorial assistants, Felix von Luschan, was a polymath. He became a leading anthropologist, archaeologist, and ethnologist, with wide-ranging interests across those and other fields. He eventually held the first chaired position in anthropology at Berlin University. Orientalist F.W.K. Müller was another small fish—but only in the 1880s. Like Steinen, he later grew to dominate the pond. He became a scientific assistant at the museum in 1887, where he worked in languages ranging from Japanese and Korean to Malay and Samoan. He eventually became director of the museum's East Asian section and a leading member of the Prussian Academy of Sciences. Similarly, Eduard Seler, another scientific assistant since 1884, became one of the world's leading scholars of Central America, a professor of American languages at the Berlin University, director of the American section of the museum in 1903, and also a member of the Prussian Academy of Sciences. It is no wonder that Jacobsen could never gain a permanent position in a museum, fell out of favor even for collecting, and ended up managing a hotel.

Bastian, in other words, packed his museum with well-educated young scholars who were passionate about their work and willing to do it for modest salaries. With the exception of Albert Voss, who had been Bastian's directorial assistant and director of the Prehistory section since Bastian took over the ethnological collections in 1876, these men were also similar to Boas in age. Consequently, for much of his life, they remained a fundamental part of his intellectual community.

If Boas ultimately outshone his Berlin counterparts in the annals of anthropology and ethnology, it had a great deal to do with his move to the United States. America in the late 1880s and early 1890s was a comparatively open field. As Boas championed Bastian's notion of geographical provenances in his debates with Americans, arguing in favor of inductive science, he took on positions that, while exceptional in the United States at

that time, would have been predictable in Germany. For that reason, after riding a wave of scholarly successes that culminated with his almost unanimous election to the National Academy of Sciences in 1900, Boas wrote to his mother that she should not think him "great." It was, he explained, "very easy to be one of the first among anthropologists over here."[19]

The Ethnologists' Workshop

Bastian's museum was the first major museum building devoted to anthropology and ethnology in Germany, and Bastian was unashamed about its scientific purposes. That made it exceptional as well. It is hard to imagine a contemporary guidebook to an ethnological museum with an introduction like this one from 1887:

> The purpose of the collections is to make visible through the facts of vivid materializations the growth process of a spiritual organism, as it has flourished in the thought-creations of the human species on the planet Earth. A series of foundational elementary ideas are revealed, recurring in immutable similarity across all continents, as well as the variegated diversity under which they differ in their anthropological provinces according to geographical environment, while the range of these oscillates within an ethnic horizon, whose ongoing periphery is inscribed by the circle of historical movement (as far as one, that is, according to the conditions of the location, may have proven to be introduced).[20]

The guidebook was a scientific manifesto for an educated public. It offered a glimpse into the hopes and methods of Bastian's team, and it explained how the collection should work: the "emphasis" for this ethnographic project had to be on the "collections from natural tribes." For people without a written language, the things they produced in the past and the present—what scholars today would call their material culture—were particularly essential: "since the only accessible documents are exhausted in technical-artistic products." As the only records of their history, these objects had incredible value.

In addition, Bastian stressed to his visitors that it also was the task of ethnology, and thus of his museum, to engage collections from "the cultural peoples of East Asia who have not to date been included in world history." He included China, India, Indochina, Japan, and Korea, as well as the ancient civilizations in the Americas, especially those "which were destroyed by the European discovery, and which will presently be

reconstructed from the monumental remnants, the sayings of the indigenous peoples, and in part the explanations provided by them."

World history as Europeans had written it, in other words, had left out most of the world. It had focused overwhelmingly on people with written languages, and it had overlooked many of those. So, for Bastian, another chief goal of the museum was to reintegrate those places and their peoples into Germans' and other Europeans' knowledge base and then allow a new, total history to emerge. Visitors were invited to join that process.

At the same time, and this is a point too often left out of contemporary discussions of Berlin's Ethnological Museum, the entire ground floor of the building was devoted to "European (and especially fatherland) prehistory." That had a number of virtues, not the least of which was the mutually informative comparisons of similar objects produced by Europeans and non-Europeans at different moments in time. In many cases, he explained, those comparisons had already led to "previously silent witnesses" among the archaeological artifacts being brought "to speak." It had led to a deeper understanding of European history from a time for which there were no written records.

Taken together, Bastian explained to visitors, these three divisions within the ethnological collections—from natural peoples, from cultural peoples, and from ancient history around the globe—"constitute one of the most important instruments for ethnology's tasks, by presenting a comparative overview of ethnic modalities and by gathering them together from their distribution over the earth's surface as the preparatory building blocks for an inductive approach to the study of humanity."[21] Combined, he believed, they would allow him to create a world history that was not dependent on the cultures that stemmed from the Mediterranean.

The 1886 opening of the new Völkerkunde Museum was set in its atrium amid palms and other tropical plants, framed by statues from Java, Laos, and Siam, with an ancient Indian gateway and bright gold Chinese banners behind the stage, and hanging above the entire scene, a large Prussian flag. Diplomats and ministers made a series of speeches from the carpeted podium to the royals and dignitaries who had gathered for this day. As they spoke, they consistently lauded the character of the museum and praised its benefactors and founders.

This moment, however, was long in coming, and it is hard not to wonder where that ministerial excitement had been over the previous fifteen years. The guide Bastian created for the ethnological collections a decade earlier, in 1877, had already championed many of the same intellectual goals and needs as the ones advocated for the newly opened Museum für Völkerkunde: the need to collect, the importance of maintaining a

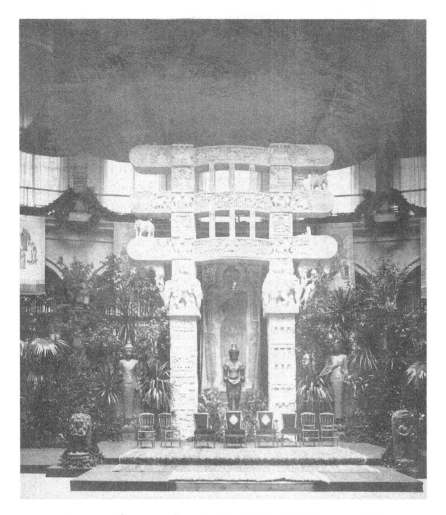

FIGURE 2.4. The museum's opening in 1886. Staatliche Museen zu Berlin, Ethnologisches Museum.

geographical organization of the collections, and the desire to use the collections and displays as scientific tools that would expand their understanding of human history. In 1877, however, none of that could be achieved because of the grim conditions in the New Museum. Already in 1872, the "small catalog" Bastian's predecessor had issued underscored the lack of space and bad lighting, which made useful displays difficult to create. By 1877, Bastian's guide had to acknowledge that displays of the sort he envisioned were completely impossible to create or maintain, but he also wrote with determination about the collection's potential and what could be done if sufficient "space and light were available."[22]

He never imagined it would take more than a decade to gain more "space and light" in a new building. Fights over potential locations, debates with the fire marshals, never-ending problems with funding: they repeatedly brought construction and planning to a standstill. Every time he went abroad between 1877 and 1886, he returned dismayed by the lack of progress. In December 1879, for example, an exasperated Bastian wrote from Batavia to the General Administration of the Royal Museums asking if it was really true that the new museum building "still is not started?"[23] Agonizing over lost opportunities while negotiating with recalcitrant officials, he had delayed his trip for months in order to ensure that they would get started. Yet they did not, and when he returned to Berlin in the spring with a vision of the Northwest Coast in his head, scheming to develop a viable plan of action, he found that the museum he expected to be almost completed "still had not even begun." His dismay is understandable: as a result of those conditions, almost all of the collections he and others had obtained for the museum over a fifteen-year period remained in limbo, "stored unpacked in the basement," where they could not be put to use.[24]

Despite the long road to completion, the rush into the building also took much longer than anticipated. There were tens of thousands of objects! Not everything could be moved, unpacked, cataloged, and displayed in such a short period. As a result, the 1887 guide produced by Bastian, Voss, and their young assistants, was only partial, offering visitors an introduction to what they had managed to set up on the first two floors.

Still, the holdings were impressive and the displays well thought out. When visitors entered the museum through the vestibule, they had three options. To the right was the extensive Heinrich Schliemann collection from Troy, which Schliemann excavated near Hisarlik, Turkey, between 1871 and 1882, and donated to the state. He had set up the displays himself. To the left were the prehistory collections from Brandenburg that, if visitors chose that direction, took them clockwise around the central courtyard through a sequence of halls filled with objects from northern to southern Germany, then into a room with items from non-German Europe, and then into the halls filled by Schliemann's collection. A small corner room along the way held the gold and silver objects from the German lands' distant past. Starting on the right, with the Schliemann collection, reversed the experience.

Most visitors, however, would have been drawn through magnificent columns directly into the atrium, which contained the largest objects in the collections from East and Southeast Asia, the Americas, and the Pacific. It was a kind of potpourri of big and heavy things, a hint of what

FIGURE 2.5. The entryway through the vestibule and into the new Berlin Museum für Völkerkunde. Photo: akg-images.

was upstairs. Directly through the central pillars stood the "eastern stone gateway from Satnschi," with gilded wooden Buddhas from Rangoon positioned on each side of it, a copy of a statue of a Siamese king who opposed Buddhism in front of it, and stone tablets from "the temples of Buddhagaya" set around it. The Haida crest pole stood across from the "left entryway." Nearby was a kayak from "Eskimos," a painted boat of the Bil Nalla people, a sleigh, and a dogsled. On the right side of the room stood a tipi from the North American Plains, a "sailboat with an outrigger" from the Marshall Islands, and stone figures from Hawai'i. The massive stone sculptures from Santa Lucía Cotzumalguapa were in the "stairway of the museum." Visitors could read in their guide the entire story of how Bastian acquired them.

On the floor above were the displays from Africa, America, and "Oceania," which included Melanesia, Micronesia, and Polynesia. One could choose to begin on the left with Africa, as the guidebook did, or on the right with America and proceed through the collections. Either way, the objects were arrayed geographically, grouped according to place of origin with details about the peoples who produced the objects, the regions,

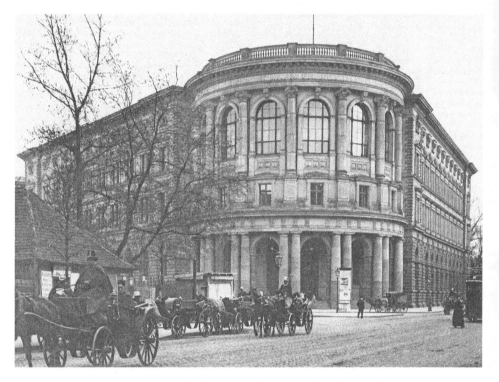

FIGURE 2.6. Outside the new Berlin Museum für Völkerkunde.
Landesarchiv Berlin, F Rep. 290 (05) Nr. 0028404 / Photo: Pulkrabeck.

and frequently the collectors—especially if they had donated the objects
to the museum. There were maps to help orient people, numbered tags
with brief explanations for each object, and almost everything stood in
cases made of glass and steel. As they walked among the objects, viewing
them from many angles, visitors moved across continents or, in the case
of Oceania, across island groupings, and the organization of the displays
mimicked the geographical proximity of the peoples who had produced
the things on display.

Descriptions often pointed out how objects were created and used, and
the guide underscored anomalies. For example, the "sabre-like slashing
weapon" of the Monbuttu (Mangbetu) people, in case eleven along the
interior wall of the first African hall, had an "actual concave outstretched
handle" that was not on the lower but rather the upper end of the weapon,
"while the lower end usually offers a clublike thickening, which serves for
occasional parrying."

Similarly, Bastian's team took the time to stress at the outset of the
Oceania section that many of the objects there had been collected before

ethnology emerged as a science, but that they could "now be integrated into the current methodically initiated study." Despite being collected without the guidance of those methods, many of these objects were some of the only remnants of cultures now vanished, which gave them immense value. Others, they explained, like Kamehameha's feather cloak, were well studied, and visitors were offered details about its feathers, its construction, and its place in a culture of ranks and taboos.

The discussion of ancient America was equally extensive, especially the history of "Old Mexico," its political, religious, and social history. Its mythology, visitors learned, informed so much of what appeared on the stone sculptures in the stairwell and many of the glass and steel cabinets. That history, for example, was the context in which the wooden tiger acquired by Alexander von Humboldt, encrusted with bits of black stone, mother-of-pearl, and turquoise, made sense. It glared at visitors from inside a case but it was tied to all the things around it.

Looking across the collections of bone, shell, and wooden objects, as well as the textiles and earthenware vessels extending past the stone sculptures, the challenge for visitors was to see the unity and the differences running through the products of these peoples from Mexico. Then they could take those comparisons further into the world of the Maya in Central America, south into Colombia and Peru, Chile, and the rest of the continent; into the multiplicity of humanity evidenced by the things on display.

Unsurprisingly, the stunning collections from Alaska and Canada dominated the final American hall. The Nootka Eagle mask stared down at visitors from another geographical point in the displays. Here, too, the guide offered visitors the cultural context for the objects; it also credited the Hilfs-Comité and Jacobsen with acquiring these treasures, and with regard to the meanings and uses of a few items, it credited Boas as well.[25]

Over the next few years, the objects from China, India, Japan, and the rest of Asia and Southeast Asia were moved into the second floor; yet even in 1892, the guide underscored that the museums' arrangements were "provisional." They had to be. One of the not-so-well-kept secrets about the new building was the depressing fact that by the time it opened it was already too small for the collections, and Bastian's success at network building and organizing expeditions far outpaced the museum's ability to accommodate the waves of acquisitions into the displays.

As a result, guidebooks had to be reprinted regularly because things kept changing: cabinets were constantly being added to existing rooms and more objects to existing cabinets; or, conversely, hopeful pronouncements

in the early editions had to be quickly edited away. Since the museum opened just two years after Imperial Germany took its first colonies in 1884, the initial guide asked visitors to imagine a section devoted to colonial territories. Yet, after trying without success to fit all their collections into the building, Bastian's team could not imagine anything worse, and they redacted that thought from the next edition of the guide. Similarly, as they refined their discussion of the skeletal remains from European sites in some of the cabinets on the ground floor, they revealed their plans for including a physical anthropological section as well.[26] That idea came and went in the guides produced over the next decade, but the section never appeared.

By the mid-1890s, in fact, Bastian's team had stopped promising new things in their guidebooks and started adding explanations for the chaos eating away at the organization in the museum. In 1898, for example, they tried to help confused visitors in the Africa section by explaining that while everything was arranged according to geographical principles, the "powerful growth" sometimes made it impossible to follow that guideline, "so that cabinets set next to each other often contain collections from very different parts of Africa." They suggested looking at the "overview" they posted at the outset of the exhibits for orientation. These problems, however, soon became ubiquitous, and by 1900, the guidebooks had become essential for negotiating the emerging hodgepodge of items that were pressed into every corner of the museum and failed to follow any principle at all.

The guides also explained what had been removed: collections from Siberia, originally located at the end of the American rooms near Alaska, were put back in storage in 1895; the North African collections followed them into boxes just a few years later. For a short time, visitors were told that some of these items could be viewed during private appointments, but as the number of removed collections skyrocketed, that option was eliminated altogether, and increasingly, new acquisitions went directly to the depot in the suburb of Dahlem. There was no physical place for them in the museum.

Museum Chaos

In the mid-1880s, Bastian suggested building an ever-expandable structure made of glass and steel, something like London's Crystal Palace, as the site for his museum. By 1884 his collections were growing by close to ten thousand items per year. He did not want that growth to slow, and

years before the building was completed his discussions with the General Administration of the Royal Museums had already turned to covering the courtyard as a way of gaining more space. Later they would consider adding another floor to the museum. In the midst of these problems, he imagined a flexible structure that could grow with the collections and never run out of light and space.

Perhaps Bastian's efforts to create his Gedankenstatistik would have succeeded if he could have convinced the museum administration or city officials to adopt his plan for a flexible structure. That did not happen. They wanted a striking building, a municipal display that would fit their vision for Berlin's reputation and its future. So that is what they built, and it was depressingly clear to Bastian even before they began moving their collections into the new building on Königgrätzer Strasse (today's Stresemannstrasse) that the location offered them no chance for success.

By 1900 everyone knew their secret—the building that had taken more than a decade and a half to complete was a disaster. International visitors praised the collections and condemned the displays; fire marshals threatened to close the museum because there was not even enough space for visitors to maneuver through the hallways and stairwells; and government offices watched their files fill with testaments from Bastian and his assistants attesting to the chaos ruling their collections and undermining their scientific project.

Then the discussion became public. A reporter for the *Vossische Zeitung* wrote with astonishment about what he saw in the atrium after passing the giant Buddha surrounded by "sacrificial stones and architectural remains of ancient Mexican culture" in the vestibule. If that caused him some confusion, there was much more to come: "So it was that when passing into the atrium this astonishment gave way to a certain hilarity. It looked like this! German dugout canoes strewn here and there, gateways to Peruvian temples, Mexican gods, Indian *Geschlechterpfeiler*, an Indian *Götterwagen*, yes, even a small glass case with a type of ornate Damascene wax doll was there to admire." To make matters worse, "the light overshadows all this quite unfavorably and therefore such trifles can be found only with the help of great effort and serenity."27 So much for Bastian's dreams of sufficient lighting and space! That proved impossible even within the one room that had a glass ceiling.

In an effort to counter the public critique, city officials and administrators issued defensive retorts about the museum's virtues. But this only emboldened the journalist to expose the chaos and disorder plaguing the rest of the museum. The irony was rich: what, he asked his readers, would

any visitor think of "the wax puppet of the modern Syrian woman in canary-yellow silk next to the mighty gray stone sculptures of Guatemala, whose finely carved bas-relief requires side lighting, and the unattended grave slabs on the floor?" Why, they might wonder, is a "wooden Behemoth of an Indian God" set next to a stone gate from Lake Titicaca? Most visitors, he suspected, probably fled, "horrified" at the sight of all this. But what might the brave visitor find who dared to forge ahead, to venture into those rooms that once gained such praise?

> On the ground floor [the visitor] finds the *heimische* prehistory and the remains of the Schliemann *Iliad*. If he is able to pull himself away from the amphora from Troy or the innumerable pieces of pottery from the Prussian administrative region, he will immediately find himself in the middle of a hall, half of which is filled with Inca mummies and earthen vessels, the other half with fur overcoats from the inhabitants of the Amur region and metalwork from the land of the shah. Naturally only provisionally! He climbs to the second floor of the building; in the gallery he has the choice of turning from a store of Papuan idols right to the bronzes out of African Benin or left to the urns of now extinct Argentineans. He decides for Africa, gadgets in the South Seas, emerges out of New Guinea suddenly among the Tierra del Fuegians, and encounters in the last American hall Asian Tschuktschen with Eskimos, Mexicans, and Chileans united like neighbors. How could he still have the strength and courage to savor the exemplary ordered but overwhelmingly crushed-together treasures from *vorder-* and *Hinterindian*, Indonesia, China, Japan, which are on the third floor? With horror he hears that there is a fourth floor as well, which is shared by the anthropological collection and American plaster casts.

The journalist ended with the poignant question, "should these scientific collections from throughout the world be permitted to be mixed together like cabbage and turnips?"[28] Clearly, he did not think so.

Moreover, his public criticism exposed another question that had perplexed many for years: how was it possible that within barely a decade after its grand opening Bastian's museum had become the opposite of what he had hoped for?

The simple answer is that acquisitions far outpaced anyone's expectations. It was not just that all of Bastian's assistants participated in major expeditions, which brought the museum significant collections, or that other professionals such as Max Uhle, who helped shape the practice of archaeology in South America, and Paul Ehrenreich, who had

accompanied Karl von den Steinen on his second expedition to the Amazon, enriched the museum with their collections as well. Cadres of scientific collectors began working for his museum, offering their services and then using the funds they gleaned from selling the museum their collections to support their own scientific travel and work. Sometimes they were funded externally as well. Wealthy men of science were one source of those funds. Hermann Meyer, for instance, came from a major publishing family in Leipzig. He studied anthropology, earned a doctoral degree, and took part in an important expedition up the Xingu River, a tributary of the Amazon, in 1895. He donated the collections to the museum and then continued to support other German researchers and underwrite some of the museum's purchases of collections. He did the same in Leipzig. Arthur Baessler was perhaps the most important of these kinds of supporters. He led a set of his own expeditions through New Guinea from 1887 to 1889, and he traveled extensively in Australia, New Zealand, Polynesia, and Peru. He donated many of his collections to Bastian's museum before creating the Arthur Baessler Foundation in 1903 to support focused expeditions that would benefit the museum and the sciences of anthropology and ethnology.

At the same time, Bastian's collecting networks went into overdrive by the 1890s. His museum was engaged in ongoing exchanges of objects with other museums across Europe and the Americas, and as large collecting museums came into their own in Hamburg, Leipzig, Munich, and Stuttgart, he was working with them as well. Bastian also sent his assistants to scour the collections on display at world's fairs, colonial exhibitions, and regional exhibitions, and they returned again and again with rich materials. An international fishing exhibition in Finland in 1880 had already brought them a celebrated collection from China and Japan; the 1887 Philippines exposition in Madrid was a similar boon; so was the World's Fair there in 1892, where they gained more gold items from Colombia to match those Bastian had collected in 1876. His assistants picked up more collections at auction houses; the Benin bronzes are perhaps the most famous of the objects obtained in this way. Although many of those, like many other things in the museum, came from middlemen, from dealers in ethnological artifacts who proliferated as the collecting museums grew at the end of the nineteenth century. Since it was impossible to pay for everything on offer, Bastian enticed ever more Germans and non-Germans abroad to donate their collections to the museum by playing on their vanity. He worked with the government to create a system of honors and awards collectors could hang in their offices and pin to their chests.

The Royal Crown Medal Fourth Class was a favorite, and the tactic was so effective that regional governments, such as Saxony, quickly emulated it.

Objects from the newly acquired German colonies also inundated the museum. No one anticipated Otto von Bismarck's entrance into the colonial fray just two years before the museum opened. As Imperial Germany seized colonies, however, Bastian and his assistants sought to capitalize on the monopolies those geopolitical actions brought them over the material culture in the regions under German control. In part, that meant developing instructions for colonial authorities and troops about effective modes of collecting. It also meant lobbying with German authorities about gaining collections from the territory, until the *Bundesrat* (the upper house of the German parliament) passed a resolution in the late 1880s mandating that all objects collected in the colonies be sent first to Berlin, where doubles could later be distributed to regional museums. That led to a flood of objects that completely overwhelmed the African and Oceanic sections of the museum, skewing the holdings toward that small number of territories. The boon that followed their opportunism, in other words, quickly became a burden, repeatedly lamented in the internal reports to the museum administration. That did not, however, lead to an equitable redistribution of the colonial collections, a point the directors of other German museums criticized repeatedly right up to the outset of World War I.

The rapid growth of Berlin's collections through all those acquisition streams, however, a growth that so outdistanced other major collecting museums in the world, does not alone explain the chaos in its displays. In the end, Bastian the opportunist chose the chaos. He could have ended the collecting at any point. Yet he prioritized collecting over display because he knew that the more he obtained the better his museum ultimately would be, and the better his science would become. He also knew that while they were still collecting, the displays would always be provisional. Inductive science works that way. Consequently, he devoted himself first and foremost to hypercollecting and made ordering of the collections a distant second concern.

In some ways, it was a wise choice. After his experience building the museum on Königgrätzer Strasse, Bastian had no reason to believe that either the city of Berlin or the General Administration of the Royal Museums was going to work very hard to improve the lot of his museum or support his science. If that meant Bastian was unable to create the Gedankenstatistik he originally envisioned because of the perennial lack of light, space, and sufficient funding, he found some solace in his creation of a *Rettungssaal* (quite literally, a rescue hall) that at least exhibited some of the collection's potential and preserved the rest for future generations.

That really should not surprise us. Already in 1880, in his introduction to *The Sacred Legend of the Polynesians*, Bastian remarked on where he had begun his journey decades earlier, and on the "enticing magical vision that fueled ethnological research." At the outset, he remarked, "everything seemed simple and easy enough." However, as they approached their work, and as they began to specify "the intricacies of their detailed tasks," "the work that piled up appeared countless," and if some of them "threw themselves up looming mountains," and "if with great expenditure of strength they perhaps summited the first crests, they saw higher and higher before them new rows of mountains with summits reaching up into the heavens." Continuing to extend his metaphor, he doubted that anyone of his generation would ever manage "to look down on that land from one of those summits." That, he assured his readers, would be a task for a future generation.

Still, that realization made his work no less urgent. If, as he put it, members of his generation must "roll the burden of continuous construction onto the shoulders of future generations," then it was "imperative" that they accept the "duty" to "preserve and deliver the raw materials to posterity." His biggest concern, in fact, was that they might fail in that first fundamental task, and that, as a result, later generations would "lodge a severe and bitter accusation against us, because in the present epoch of contact with natural peoples we still could have collected and saved much that through carelessness and recklessness was ruined before our eyes." For the next twenty-five years, Bastian attempted to ensure that he would not be "reproached" by subsequent generations for permitting "losses that were later irreplaceable."[29]

Undermining the Vision

As the debates about the condition in the museum raged around the turn of the century and into the following decades, Bastian went away. Karl von den Steinen remarked that Bastian's assistants grew used to his absence. There was good reason. He missed the 1896 celebration in honor of his seventieth birthday, heading off to Java, Bali, and Lombok for another two-year study of Buddhism just before the celebration took place. He did not like such festivities. From 1901 to 1903 he vanished to India and Ceylon, two of his favorite regions in the world, and although he returned briefly to Berlin in 1903, he quickly left for the West Indies later that year. There he investigated prehistoric cave sites in Jamaica, traveled into Venezuela, and then turned to Trinidad, where he passed away on February 3, 1905.

During that period, Felix von Luschan stood in for him during many exchanges with the museum administration. After Bastian's death, he and Bastian's other three assistants were all promoted to departmental heads. But without Bastian, the museum was essentially headless. His position as the founder of German ethnology had been almost unassailable in Berlin, and there was little the General Administration of the Royal Museums could do to his institution while he was alive, except squeeze the budget. That all changed after Bastian's passing.

While briefly in Berlin in 1903, just two years before his death, Bastian had written a frank assessment of conditions within the museum to the kaiser's Geheime Zivilkabinett (secret civil cabinet) agreeing with the public assessments: "the current state of emergency in the 'Museum für Völkerkunde' mocks any description."[30] He explained in detail how the overcrowding undermined its purposes and how the storage of the items concerned him, since the staff could not care for the objects any more than they could put them to use, once objects were boxed back up and stacked in basement rooms and storage containers hastily erected in Dahlem, a neighborhood on the outskirts of Berlin. Moreover, he warned, popularization of unfounded ideas about human history was widespread, making the institution all the more essential. He also speculated that more recently founded museums, created with better facilities and more space, would soon surpass Berlin's own. The competition was keen. This final play on the city's and the state's competitive pride accompanied assessments from officials as they made their way up the administrative ladder to the kaiser himself. In the end, everyone agreed that the building was inadequate. The question remained: What was to be done?

An ongoing discussion ensued among Bastian's assistants and the museum administration that lasted from 1900 until World War I. It turned around a series of suggestions. One argument was to move the entire collection to a new location in Dahlem, on the southwest edge of the city, where land was cheap and a sufficiently large building could be erected. The fear, however, was that people being educated in Berlin to work abroad—in the foreign ministry, the military, the colonies, or simply in business—as well as the many students and faculty at the university, would lose access to the materials. Moving the collections so far from the city center might transform the museum into a mere Sunday destination.

Another option was to divide the collections in some way. Voss had been arguing for years that his prehistoric collections should be combined with those created for Virchow's Museum für Deutsche Volkskunde (German Folk Customs) into a kind of German National Museum. He even fashioned a proposal for a "newly built Museum of Prehistory and Folklore

for Germany," which he hoped would be located downtown near the Museum für Völkerkunde and the Arts and Crafts Museum. That alone, however, would not free up the space they needed.

A third option, which Bastian hated, was to divide the museum into a research collection, located in Dahlem, and a public display, or Schausammlung, left in the museum downtown. Some administrators also suggested the division between so-called cultural peoples and natural peoples.

In essence, none of Bastian's assistants supported these divisions. Some, like Luschan, agreed that Schausammlungen, when focused on particular themes, could enhance the scientific displays. He even argued that if he had had the space, he might have added one to his portion of the museum long ago. Yet he also stressed that "with such a Schausammlung alone, the needs of the public would never be fulfilled." There were just too many people who wanted to see the entire series of objects. He had daily requests. Moreover, he reminded the administration that there was more than one public to be served: "the mere curiosity and the desire for learning among the greater part of the public must be sharply separated from the need for knowledge expressed by a part of the public that is perhaps smaller, but still quite noteworthy. The latter is not served by a mere Schausammlung." Neither, he made clear, was the science.

Luschan's was the polite response. Grünwedel was more direct. He stated in clear text that "a division between a public display and a research collection is impossible and harmful." Dividing the collections in that way would destroy the entire point of the displays. As Bastian had consistently argued, the museum was about "the history of humanity in all its variations." Divisions made no sense. Steinen agreed, explaining that a division between cultural peoples and natural peoples "is completely out of the question," because "the study of transitions is a central problem in ethnology." F.W.K. Müller was even more to the point. He called the entire suggestion "highly questionable," and plainly stated what the others were suggesting: such a public display would be little more than a "worthless cabinet of curiosities."[31] He had a point—a very good point.

Conditions in the museum changed little after these discussions. The debates brought little as well. When Wilhelm von Bode became director of the Royal Museums, gained control of the budget, and began to rethink the distribution of funds and space in 1906 and 1907, he again reignited these debates. Politically conservative, an art historian by training, he had directed the Gemäldegalerie (Paintings Gallery) on Museum Island since 1890. Close to the royal family and tied into Europe's art networks, he had spent decades assembling huge collections for his gallery and for the new Kaiser Friedrich Museum (now the Bode Museum) on the northern tip

of the Museum Island. At the time, he was sometimes referred to as the Bismarck of the Berlin museums, and to this day he continues to be hailed as one of the founders of modern museology.

His vision for the ethnologists' museum was thus much different than that of the ethnologists. Essentially, Bode sought to place the Museum für Völkerkunde within his overarching concept of Berlin's museum complex. To do that, he needed it to function much like an art museum with representative objects and didactic displays. To his mind, the Schausammlungen made good sense, though the ethnologists continued to reject them. Art museums had them, allowing their directors to save space and bring order to their collections.

He also favored dividing the ethnological collections if that could help solve his problem, and he was eager to explore all the options in order to solve his problems—if not the problems of the ethnologists and their museum. He would have been happy, for example, moving the research collections to Dahlem while leaving a small Schausammlung in the Museum für Völkerkunde building in the city center. Moving all the collections to Dahlem and setting up a division there might even have been better—he could have used the building downtown for other things.

He also entertained other recombinations. For example, he thought mixing the Asian collections from the Museum für Völkerkunde together with the collections in the Museum for Asian Art would be grand. To his mind, bigger and better art collections were always good.[32] Berlin's ethnologists were dumbfounded by his suggestions.

In 1911, as Bode continued to press his points, he went so far as to suggest that the directors in the Museum für Völkerkunde would not only do well to focus only on natural peoples but also should actively attempt to reduce the size of their collections, through sales, exchanges, and gifts.[33] Reduce, reorganize, rethink: all of this made sense to Bode because he had no interest in the goals on which the museum was founded and thus little appreciation for the dedication to collecting that Bastian and his team had always shown.

In 1907, the Municipal Building Inspectors declared the museum a fire hazard, and in fall 1911 they demanded it be closed until enough material could be removed from the museum so that at least two people could walk abreast through the halls and stairwells. That led to a series of further meetings among government ministries and museum administrators and ultimately to some stunningly direct language in the halls of city government.

At the forty-sixth meeting of the House of Deputies on March 27, 1912, for example, Deputy Dr. Hauptmann, from the Center Party, threw down

a gauntlet. He declared that ever since Bode replaced Richard Schöne as general director of the Royal Museums in 1906, "the Völkerkundemuseum has been condemned to a lingering illness." In 1909, nothing was done for the museum because of funding shortages, but even after the funding improved Bode still did nothing. As the museum languished, his administration made a wide range of bizarre decisions, including allocating twenty thousand marks for the restoration and display of the collections obtained by Grünwedel's 1902 Turfan expedition to Xinjiang (Chinese Turkestan) on the northern Silk Road. Kaiser Wilhelm II had been particularly excited by the results of those ventures, and he helped finance subsequent trips (there were four between 1902 and 1914). While Dr. Hauptmann acknowledged that it might indeed require that much money to restore the important collection, the notion that it or anything else could be set up in the museum was "laughable" and "simply impossible." But since the money had been placed in the budget, he had a suggestion: "perhaps the 20,000 M can be beneficially employed for obtaining rat poison so that the rats do not eat up the entire collection from the Turfan expedition."

The "plague of rats" in the museum was well known, and his comment elicited a great deal of amusement in the house. His ultimate point, however, was not so funny. The Museum für Völkerkunde had become a "neglected stepchild" in the city, and the reason, he argued, was clearly the product of the organization of the General Administration of the Royal Museums. Bastian's museum suffered this fate "because the leadership of the art museums and the scientific museums is united in one hand"—to be precise, in Bode's hand. "One is either an artist or a scientist," Hauptmann argued, and as long as both kinds of museums are under one director, these problems will persist. Moreover, the character of the director mattered as well. This imbalance also had been evident under Bode's predecessor, Richard Schöne. He too was primarily an art historian, but "now," under Bode, "that is the case to a much greater extent." Consequently, Hauptmann wanted the immediate separation of the two fields and attention to the plight of the Museum für Völkerkunde.[34] That proposal gained him a loud round of applause. A year later, the House of Deputies approved a plan for an entirely new complex of four buildings, one for each of the four continents represented in the museum. In 1914, they finally broke ground in Dahlem.

Throughout all those discussions, and across the decade following Bastian's death, the hypercollecting continued, even increasing its pace.

Benin Bronzes

FELIX VON LUSCHAN wrote many frenzied letters on July 25, 1897, from the Berlin Museum für Völkerkunde. He began by contacting the London auction house Christie, Manson, and Woods. He was using their catalog to prepare his representative in London to bid on some African ivories from the Kingdom of Benin. He had already made offers on a few objects during a recent visit to London, and he was still keen to get a particular ivory cup with a cover. An unprecedented number of newer objects, however, had appeared in the catalog, expanding his wish list; he wanted to ensure they were still available. They were, but competition was keen, and his acquisition efforts were only partially successful. Over the next month, he would first contact the man in southwest London who had outbid him for an ivory amulet. He asked about photographs and for permission to make a casting, only to learn that the Englishman had already sold it to a competitor in Paris. Luschan tracked down that buyer as well. Eventually he got his photos and his cast—but not the amulet.

The most important of his letters that day, however, went to his colleague Albert Grünwedel, who was enjoying a peaceful vacation away from the hustle and bustle of the museum. Normally, Luschan would not have disturbed him. Everyone deserves some uninterrupted time away from the office. Yet Luschan could not wait. He needed Grünwedel's advice. He was unsure how to act. He needed to talk about the Benin ivories—and about the money. They were going to need a lot of money.

Franz Boas frequently argued that ethnologists must "strike while the iron is hot." For Boas, that meant heading to places like Canada's Northwest Coast region to acquire collections before indigenous cultures were

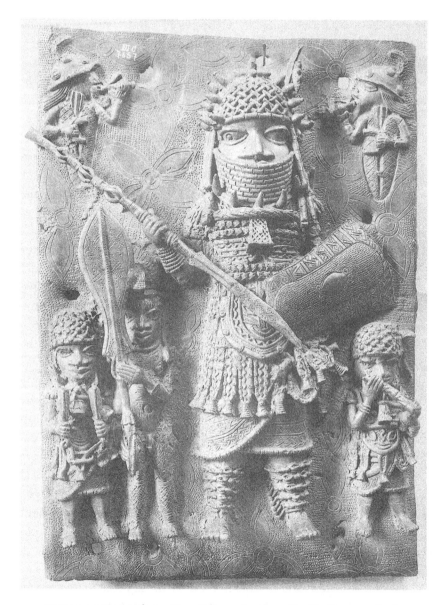

FIGURE 3.1. Bronze plaque. From Felix von Luschan, *Die Altertümer von Benin* (Vol. 2), 1919. © Staatliche Museen zu Berlin, Ethnologisches Museum.

devastated by money economies, political transformations, or war. In the case of the bronze and ivory artifacts that British troops seized during a punitive expedition to the kingdom of Benin in February 1897, there was no hotter time for them to strike than that summer.

Following Benin City's devastation, rumors circulated throughout Europe that British troops had found unique objects in the palace. Soon,

ivories like those Luschan had been chasing in London started trickling into Europe. The bronzes followed not long afterward. British soldiers, largely unaware of what they had, sold their war booty to almost anyone. Ship captains, perceptive merchants, even pawnshops in London bought and sold them during the initial weeks. Antiquities dealers and auction houses got many of them later.

It took months for Europeans to understand what, precisely, the British had seized. For Luschan, that epiphany began on July 25, when a "very curious thing" took place. A representative of the "Ivory Firm Theodor Francke, on Schmidstr. 25," a business unknown to him, stopped by the museum and informed him that "during the second week of August ostensibly 600 (six hundred!!!) *Centner* [600,000 kilograms] of ivory that the English had seized in Benin would come to auction in London." His visitor described them to Luschan as "huge tusks covered with ancient engravings and carvings of men, riders, animals, etc. etc." At first, he explained, "the entire treasure was already in the hands of one of the usual ivory buyers and was going to be sold in London simply as ivory." Then, as he put it, "they became aware of the scientific value, and now they want to bring the pieces to auction separately."

Luschan was perplexed. Carved ivory tusks from Africa were nothing new. The Berlin museum had plenty. So, he took the man into the tightly packed African halls and showed him their "collection of West African ivory carvings, which," he reminded Grünwedel, "is not to be sneezed at." Yes, the visitor noted, the tusks were something like that—but they were bigger, a lot bigger, and perhaps better as well: "according to his report," wrote Luschan, they were "incomparably large and valuable things." The man indicated that the "tusks are mostly bigger than our largest giant tusk (Umlauff 3000 marks) but carved in the manner of our most precious goblets."

One can only imagine Luschan's astonishment and perhaps disbelief as he absorbed the news. He was definitely excited. He wrote to Grünwedel that it must all be of "nearly immeasurable worth," yet the "man indicated that the largest tusks would only cost between 600 and 1,000 marks, if the value did not climb." None of this made sense unless the British still did not understand what they had. If that were true, they were astoundingly clueless.

After quickly listing for Grünwedel some choice items available at the auction, Luschan asked him rhetorically, "what should happen now? In my opinion," he wrote, "we must acquire by whatever means as many of these tusks as possible—if they really are as exceptional as they seem to be." That would be a major action, and he could not make such a decision

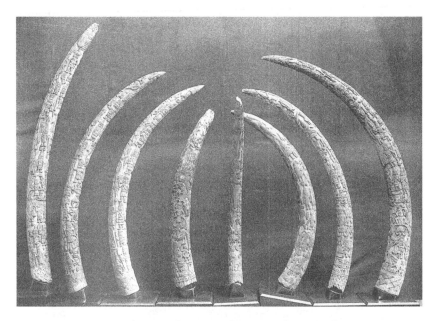

FIGURE 3.2. Carved ivory tusks. From Felix von Luschan, *Die Altertümer von Benin* (Vol. 3), 1919. © Staatliche Museen zu Berlin, Ethnologisches Museum.

alone. He needed Grünwedel's opinion, his support, and he needed help getting the funds. He was not sure if he should act through an agent or return to London immediately, and he began brainstorming about funding the venture. Should they seek credit? Could they turn to Bastian's Hilfs-Comité? Should he contact some of their wealthier patrons, such as Hans Meyer? Maybe Meyer, who had studied ethnology, created his own collections while on expeditions, and supported many museums financially, could buy some of the tusks and gift a few to the museum. Luschan was beside himself thinking of alternative scenarios. He needed to know if Grünwedel agreed with his assessments, and he wanted to know if he had better ideas about obtaining this "treasure."[1]

Grünwedel was understandably perplexed. More than twenty years later, Luschan would write in the first paragraph of his major study, *The Antiquities of Benin* (1919), that "the war booty from the conquest of Benin (18 February 1897) constituted the greatest surprise that had ever been visited upon ethnology."[2] In part, it was this surprise that caused Grünwedel and Luschan to agree that they needed to act quickly—while the iron was smoking hot. Grünwedel knew that Bastian's Hilfs-Comité could not be of much assistance at that moment, but he thought harnessing Meyer would be smart. He also urged Luschan to travel directly to London. Meyer was

game, responding to Luschan, "that would be of course a colossal story even if only half of it were true." Still not quite understanding the breadth and depth of this revelation, Meyer also recommended that Luschan visit some other dealers while in London, and he suggested that Luschan could stop by the Colonial Exhibition in Brussels on his way back. "If there is something good here or there to 'save,'" he wrote, "I would be happy to take part in it." Just a few days later, Luschan was able to confirm that there was more than "something good to save." He had just seen a photograph of some of the tusks, "which exceeded my highest expectations," and they really were going to be sold for little more than the weight of the ivory. Luschan left for London on August 7, 1897. They had not even seen the bronzes yet.

Saving the Bronzes

What followed was one of the more bewildering and controversial stories in the history of these museums. The Benin bronzes are completely unique in the art of Africa. Even today, people have difficulty explaining why by 1919 there were some 580 objects from Benin in Berlin's collections and a mere 280 in London, or why about half of what British soldiers seized from the city ended up in German museums. Germany, after all, had no colonial interests in Benin; Germans played no role in the devastation of the city; and essentially all of the Benin bronzes and ivories left the city in British hands. Yet British hands did not hold them long. The British Museum received only a few hundred items from the Foreign Office in 1897. Much of the rest went up for sale—the state sold some, but British officers and soldiers, who had seized these artifacts for themselves, sold many more.

As prices quickly rose over the next few years, British museums were driven out of the competition. They had neither the financial resources nor the networks Luschan was able to harness. They had few people with the kind of ethos that drove Meyer, the wealthy anthropologist Arthur Baessler, and other patrons of German ethnology to immediately respond to Luschan's call with a quip Bastian would have loved: if there was "something good to 'save,'" they were ready and willing to help.

With the exception of some collections in Hamburg, Leiden, and Vienna most of the larger collections that flowed out of Britain and into other parts of Europe and the United States went through Luschan, and so did a vast majority of the individual objects. Luschan, together with Grünwedel, Meyer, other patrons, and other museum directors managed to "save" a lot.

The Spoils of War

In the 1890s, Benin City was the capital of the Edo kingdom in what is today southern Nigeria. Benin had been engaged in trade with Europeans for centuries, and by the end of the nineteenth century, tensions arose as the British attempted to gain further control of that trade and impose on Benin's sovereignty. After eight of the ten members of a British delegation sent to pressure Ovonramwen, the king (*oba*) of Benin, were killed in an ostensible "massacre" outside the city in January 1897, the British government sent a "punitive expedition" of 1,200 marines to Benin City with the goal of devastating the city and placing Benin under direct colonial control. When the British military occupied the city, they discovered the bronzes and ivories, many under a thick layer of dust, in the royal palace. The officer in charge of the expedition had them collected. The initial idea was to use them to help pay for the conquest.

Despite the centuries of trade, Europeans were unaware of the existence of the bronze casts until British troops stumbled upon them. The soldiers were amazed. No one had ever seen anything like it. Images of a few bronzes and ivories found their way into the British illustrated newspapers in April. Yet journalists characterized them simply as war booty, or "spoils of Benin." They stood in for strangeness in essays meant to teach British readers that Benin was a barbarous place, a center of savagery marked by bloody occult rituals. Mostly, those readers learned about the righteous actions of their colonial troops, sacrificing for the good of the empire while taming an upstart king and a dangerous people.

Yet, as Luschan already knew from the first photos, the bronzes and ivories were more than war booty. They were high-quality "art," and the production of such art in the putatively barbarous Benin was a conundrum for Britain's Colonial Office, which was deeply invested in the facile and specious notion that their empire had brought civilization to savages. Consequently, many British officials and a surprising number of scholars sought a way out of that contradiction by attempting to locate the origins of the techniques that created these high-quality bronze casts in some other part of the world.

Even Luschan, after his first look at some photos supplied by a German consul in Lagos, who acquired a magnificent bronze rooster for the museum, scribbled off a note to Meyer praising its character and remarking, "I think Spanish-Moorish origins."[3] That opinion, however, vanished soon after he saw some of the actual casts, and he quickly

joined Justus Brinckmann, director of Hamburg's Museum für Kunst und Gewerbe, in identifying them as unique, high-quality African art: made in Benin.

Brinckmann acquired some of the first Benin bronzes to arrive in Germany, and he presented them in November 1897 to the annual meeting of the German Anthropological Society in Lübeck. He underscored the impressive technical skills that had produced the "fetish tree" and the bronze "bust" in his possession. He had no doubt that they were the result of an "an old indigenous African art [*Negerkunst*]" and that they could be included among "the most valuable discoveries that have been made in the area of art and technology of Africa."[4]

An employee of Heinrich Bey and Co., a trading house in Hamburg that had business in Lagos, Warri, and Saperle, sold Brinckmann the bronzes. Bey and Co.'s employees got them from British soldiers who began selling their spoils of war in Lagos before any of the objects arrived in London.

Luschan was jealous of that connection. When he first learned of Brinckmann's acquisitions, he wrote to him directly from London and tried to persuade him to send the bronzes to Berlin. He argued that while they were indeed notable works of art, they were nevertheless first and foremost scientific objects of the greatest importance for ethnology. As such, he contended, they belonged in an ethnological museum rather than an art museum or a museum of arts and crafts. The Hamburg Museum für Völkerkunde, he suggested, probably did not have the necessary funds to acquire them, but Berlin did, and he wanted them. Even without having seen the castings, Luschan wrote that he was "completely convinced that no sacrifice would be too great to acquire these pieces."[5]

Just a day earlier, Luschan had written to inform Meyer that Brinckmann—"regrettably!"—had already obtained two bronzes. He also revealed why he was so "completely convinced" of their value. What Luschan saw on display at the auction house in London was far better than the photographs had suggested, and he hoped to get as many of the objects as possible. For that, he was going to need more money (he had supplemented his initial collecting with a loan of five thousand marks from his brother-in-law), and he would have to act on multiple fronts. In an effort to undercut Brinckmann's Hamburg networks, Luschan sent a telegram to the German consul in Lagos, asking him to buy for the Berlin Museum "whatever was available, without consideration of the price."[6]

Collecting Frenzy

Thus began the frenzy of acquisitions and intrigue that drove the prices of Benin bronzes and ivories to levels no one could have anticipated. Between 1897 and 1901, when most of the more than 2,400 objects were secured, and for two decades thereafter, Luschan was at the heart of the fray: he tracked individual objects across Europe and the United States; he dealt directly with private collectors, auction houses, and antiquities dealers, such as W. D. Webster in London. Luschan competed against some museum directors, such as Brinckmann, targeting his early collections, undercutting his supply, wooing his supporters, and persuading collectors who had first thought of selling or donating their objects to Hamburg that it would be better to have them in Berlin. His biggest coup may have been his use of an audience with the kaiser and a promise of official honors to persuade the German consul Eduard Schmidt, whose collection of some eighty Benin objects were on display in spring 1898 in Brinckmann's museum, that he would be better served if his collection came to Berlin. The Schmidt collection, he later wrote, greatly expanded Berlin's holdings of "large [cast] heads and especially several groups in circular casts, which are much larger and more numerous than in any other museum." While the collection from Heinrich Bey and Co. in Hamburg brought the Berlin museum a whole series of unique plaques and "numerous other precious and in their way singular pieces," strikingly, Luschan also bought objects directly from the British Museum, which was under pressure from its government to sell them. He did that with the help of Meyer, who gifted thirty-two of those objects to the Berlin Museum für Völkerkunde and placed the rest in Leipzig's Museum für Völkerkunde. Meyer never understood why the British wanted to sell them. For him, their inattention to the ethnological value of the objects remained a complete "riddle."

Luschan happily would have bought everything that arrived in Europe in 1897 and 1898—but that was impossible. While he spent the second half of 1897 trying to locate individual objects and maneuvering around Brinckmann, by 1898 the character of the trading had changed. Everyone recognized that the objects were unique, their numbers finite; and the people who possessed them began to understand that the objects had significant financial value, even if their possessors did not understand (or even care about) their value for art and science.

As a consequence, Luschan increasingly was forced to compete, deal, and trade with everyone else in a public marketplace in which he too was soon priced out of much of the bidding. Repeatedly, W. D. Webster,

perhaps the most active private dealer in these artifacts, had to reject Lus-
chan's offers for the items in his catalogs because they were simply too low:
"You conveniently got a few things when they first came over," he wrote to
Luschan, "when the officers did not know their value." Yet, "now that there
have been 3 or 4 lots sold by auction in London," he explained, "they won't
part with them unless they get their price."

Initially, Luschan was taken aback by Webster's refusals; he also was
surprised that the dealer began repurchasing things he previously had sold
in order to sell them again at much higher prices. For Webster, that was
simply smart business. For Luschan, it was a revelation. As prices contin-
ued to rise, Luschan regretted having been so picky in the first months,
when everything had been relatively cheap. Yet he also quickly recognized
that he and Grünwedel, like Webster, could sell as well as buy. When
another auction was announced in November 1899, offering objects held
by British officers who had waited for prices to rise before selling, he was
astounded at the sums they commanded. Writing to Arthur Baessler, he
exclaimed: "at such prices our present Benin collection would bring well
over a million!"[7] Baessler too found the prices "enormous."

In addition to the intrigue and dealing, there was also a great deal of
cooperation. While Luschan was undercutting Brinckmann from the auc-
tion houses in London that first summer, he was also purchasing objects
for Franz Heger in Vienna's Völkerkunde Museum. As the collecting frenzy
continued, he traded and bargained with his counterparts in Dresden,
Frankfurt am Main, Hamburg, Cologne, Leipzig, and Stuttgart, and they
did the same with one another, with the dealers, the private collectors, and
with anyone else who had Benin bronzes and ivories to sell. The Museum
für Völkerkunde in Hamburg, despite Luschan's initial evaluation, ulti-
mately ended up with a stunning collection of 196 items. Brinckmann held
on to only three.

While Luschan's primary goal was to secure the largest and most
unique collection of Benin objects for Berlin, he also wanted to ensure
that the rest would end up in other, similar institutions, where they would
be "saved for science." To secure as many objects as possible in ethnological
museums, Luschan worked with not only the directors of other German
museums but also directors of foreign museums, such as Charles Dorsey
at Chicago's Field Museum. Luschan helped him secure "a nice series" of
thirty-three items.[8]

By the time he published his three-volume magnum opus on the
Benin artifacts in 1919, Luschan was aware of the location of most of
the more than 2,400 extant objects that had made their way into Europe

from Benin. Many had traveled far from England. Some were still in the hands of private collectors, while others were in institutions as far east as St. Petersburg and as far west as the United States. Ultimately, Luschan gained a keen knowledge of them all.

Luschan was satisfied with his efforts. He wrote to Count Karl von Linden in Stuttgart in November 1898, congratulating him after the Linden Museum had secured a large collection of Benin items. Stuttgart, he quipped, had become one of the main places, in addition to London and Berlin, "that one must visit, in order to study the Benin bronzes." That, he contended, was a good thing. As he assured Linden: "people in future centuries will be thankful to you for your energetic interventions."[9] It did not actually work out that way.

Saved for Science

By the time Luschan published his book on the Benin bronzes, the collections in Dresden, Hamburg, and Vienna had overtaken those in Stuttgart in size, and there were collections of similar size in Leipzig and Cologne. Nevertheless, Luschan's point to Linden still held. These German museums, in addition to the British Museum in London and the Pitt Rivers Museum in Oxford, were the main places where one would have to go (and where people still have to go) to study these artifacts.

When he published his study, Luschan knew a great deal about the entirety of the artifacts seized in Benin. He had spent those years since 1897 collecting not only objects but also information on everything he acquired, as well as on almost everything he did not. In the end, he created a catalog in which he described in great detail each object and documented its travels from Benin to the collection in which it was included. He called the end product of his efforts the *Corpus antiquitatum Beninensium*, and he hoped that as time went on his successors would continue to put it to use.

Luschan's compilation of information allowed him to identify characteristics among objects across all of the collections, from St. Petersburg to Chicago. Without leaving Berlin, for example, he could easily determine how many of the tusks had braids carved into them, or how many of the large bronze figures were round or square, or how many and what kinds of figures were on any single plaque. Ultimately, these types of comparisons, and his efforts in sorting through all of the collections, allowed him to come up with the sixty-four categories of Benin objects that he used to organize his book.

The main problem he faced, however, was the same problem they had had with the Jacobsen collection from Canada—although for different reasons. British soldiers had not gathered any ethnological information along with the objects. They had been engaged in seizing war booty and destroying property, not in creating ethnological collections. It was only after the materials were in Europe, after they had been through the hands of many people, that they were transformed from war booty, to coveted art, and finally to unique ethnological objects. They were, of course, always all three at the same time, and they had other meanings in Benin as well. What changed over time, however, was not only their locations but also the emphasis placed upon them by the people who possessed them—and the people who looked at them, talked about them, or thought about them. That is still true today.

Moreover, one of the challenges facing Luschan was the fact that the British soldiers had been anything but careful with the objects, and thus the Berlin museum had an entire box of pieces—figures broken off of larger objects and destined to be sold individually, or sometimes pieces of plaques that had been twisted or broken as the soldiers used their bayonets to pry them off walls. Not all of those pieces could be puzzled back together. In addition, Luschan was not convinced that the British had collected everything. He saw evidence of some pieces being reused in the past—melted down for later objects. Consequently, he was in favor of a scientific expedition to the palace at some time in the future, which he hoped would involve a complete excavation. He was certain it would unearth more information and many more surprises. In the years up to World War I, he hoped to be part of it.

Understanding the limits in the total collection of 2,400 objects was critical to reducing errors in analyses. Given what they knew, however, Luschan was certain of two things, First of all, "the style of the bronze works from Benin is purely African, absolutely and exclusively African." To talk about "Assyrian or Phoenician" forms, as some "dilettantes" had done in the first years, simply demonstrated that they "knew neither these forms nor modern African art." Second, and just as important, the Benin bronzes are of a quality equal to "the highest level of European casting technology. Benvenuto Cellini could not have cast them better, nor could anyone else before or after him up to the present day." The bronzes were at a level "of what is ultimately achievable."[10] Furthermore, there was no chance that some singularly talented individual had brought these techniques to Benin, because a careful analysis of the works themselves makes it clear that "there was a long period of development" in the casting techniques, and good evidence of "an entire school of casting that likely

continued over many generations." Thus Luschan dismissed the reports from the leading British scholars O. M. Dalton and C. H. Read of a mysterious "white" man bringing these techniques to Benin centuries earlier. There was no evidence to support that.

For Luschan, the origins of the casting techniques, so important for British colonial propaganda, were ultimately much less important to him than the "recognition that we have come to know a great and monumental native art in Benin from the sixteenth and seventeenth centuries, which at least in individual pieces, is the equal of contemporary European art, and at the same time is associated with a technique that is simply at the level of the achievable." Understanding that point, he underscored, entailed "a kind of general and moral meaning," particularly because of the "always in some circles prevailing contempt for the Negro."[11] People needed to accept that Africans were no less capable than Europeans.

Luschan used his vast knowledge of the collections to build his case about the African origins of the bronzes: he explained, for example, that the sixty-five or more extant plates on which sixteenth-century Europeans were portrayed all contained errors, in terms of European clothing, hairstyles, and phenotypes. Consistently across these plaques, "the Negro is always portrayed as he is, but the European is always the way he appears." That, he argued, would not be the case if a European had created these images. Yet again and again he heard Americans and Europeans repeat such assertions: "mostly from those who do not think the 'black savages' capable of such a skill at all." Over the years, Luschan had grown weary of those assertions. He was tired of explaining why they were so clearly wrong. What he most wanted, as he completed his book, was for people to accept the obvious points about African origins and the high quality of the artworks, and then to focus on the other, even more important, aspects of their value: "we see before us in great ethnographical splendor and with almost photographic fidelity, the Benin people of the sixteenth and seventeenth centuries, tangible and truly monumental. Therein lies for us the greatest value of these antiquities—not in the special technical question."[12] The objects, he repeatedly underscored, were first and foremost priceless historical texts—like so much else in the Berlin museum.

Debunking Race Science

There is no question that Luschan's analysis of the Benin bronzes undercut racialized arguments about differences between Africans and Europeans, between "blacks" and "whites." As a result, they also undermined colonial ideologies based on notions of biological racism. In fact, during his general

evaluations of relationships between Europeans and non-Europeans, Luschan often turned everyday notions of savagery, so common in the colonial press, on their head. For example: at the outset of his book, while explaining Benin's relative isolation during the nineteenth century, following a long history of active trading with Europeans, he characteristically wrote that the Kingdom of Benin, "like almost all African coastal towns, completely shut themselves off from Europeans as soon as they began to understand the tremendous danger they faced from the brutal slave trade of these white savages." Rather than a heartening tale of progress or a self-serving yarn about an enlightened spread of civilization, Luschan wrote that in both East and West Africa, "European influence acted like a poison that decomposes."[13]

That might make Luschan a figure sympathetic to readers today, and their sympathy might also increase if we add to those evaluations Luschan's lifelong effort to combat race science and racial theories. In that sense, Luschan followed directly in the footsteps of his mentor, Rudolf Virchow, publicly debunking race science as pseudoscience. His efforts in turn inspired many. W.E.B. Dubois, for example, one of the United States' leading African-American intellectuals during the first half of the twentieth century, wrote with affection and inspiration about the moment in 1911, during the First Universal Races Congress in London, when he "heard Felix von Luschan, the great anthropologist from the University of Berlin, annihilate the thesis of race inferiority."[14]

Those convictions led Luschan to devote his last major monograph to the same purpose: *People, Race, and Language* (*Völker, Rassen, und Sprache*), published first in 1922 and issued again shortly after his death, in 1926, was written for a general audience. He wrote it, he explained, because he was so often asked questions about cultural hierarchies, the "value of pure types," the "inferiority of mixed-raced peoples or 'Mischlinge,'" and the "'uncanny propagation' of the Jews." He quickly dispelled these putatively racial problems in his text. He did write that he and his wife, Emma (who often traveled with him, was an exceptional photographer, and compiled much of the data they collected), had once encountered a group of forty-one "racially pure Bushmen" who lived in relative isolation in the South African desert. But he underscored that they were an anomaly. There were "countless mixed forms" across Africa resulting from centuries of migration and movement. One could trace out the history of that mixing in part through linguistic and biological studies; but finding "pure types" was challenging at best. Even the use of typologies was highly problematic. As he explained to his readers, there were not

even any "blacks" in Africa—skin color varied dramatically from light yellow to dark brown.

What most perturbed him, however, was the tendency among "laypeople" to refer to Africans, or "Negroes," as "savages." He found that "embarrassing." For decades he had been arguing that "there are no savages in Africa other than some whites who have gone crazy [*tollgeworden*]." In 1902, for instance, he stood before the German Colonial Congress in Berlin and denounced the myths of racial difference and the putative benefits of European influence, arguing that too often in Africa and Oceania "Civilization = Syphilization." By the time he penned his final book, he added that "the atrocities committed by the Belgians in the Congo have proved me right a hundred times." If the old Africa he could glimpse in his studies of archaeology, ethnology, physical anthropology, and linguistics was fading, he attributed it here again to European influence and what he called the poison of Europe's four S's: "Slave trade, schnapps, syphilis, and shoddy goods."[15]

Just in case an inattentive reader overlooked the main points of his book, Luschan ended it with a list of ten declarative statements that argued, among other things: "All humanity consists of only one species: *Homo sapiens*; there are no 'wild' peoples, only peoples with different cultures than ours; the disjunctive properties of the so-called 'races' have arisen mainly through climatic, social, and other factors of the environment; there are no inherently inferior races." Moreover, he stressed, mixed-race children were never a priori "inferior," and the differences within groups or races were greater than those between groups or races.[16]

Luschan the Imperialist

From today's twenty-first-century perspective, and especially with our knowledge of the rise of racism in Germany during the 1920s, the strong turn toward race science among German anthropologists and other scientists during the decade before Luschan's death, and the subsequent crimes of National Socialism, Luschan's antiracism and his complete rejection of anti-Semitism are admirable. Luschan was, after all, bucking some of the worst trends in modern European history.

Does that, however, make Luschan one of the good guys in our stories about German history and our portraits of Germans' interactions with non-Europeans? Do his laudable positions legitimate all his collecting activities, all the actions he undertook, all the Fasutian bargains he made in the name of science? Do they make his evaluations of the Benin

artifacts and his efforts to "save" them more creditable than if he had been a dyed-in-the-wool racist? The overarching question is this: Do Luschan's motivations for collecting matter for our evaluations of his actions, for the tales we tell about his collections, and for our characterizations of the Berlin Museum für Völkerkunde or other German ethnological museums?

Before framing your answer, consider his collections of skulls. In addition to being a formidable archaeologist who went on three major expeditions to Armenia, Syria, and Turkey in the 1880s, and an ethnologist who devoted decades of his life to building up collections in Bastian's museum, Luschan was a physician and a physical anthropologist who did systematic studies of skin tones, hair color, bodies, and bones. He amassed a large collection of skulls. If he had been successful, he would have moved his collections of bones out of the dark basement room in which they were confined in Bastian's museum and created a set of public displays—but neither Bastian nor the directors of the other sections of the museum wanted that. Today his personal skull collection is in the New York Museum of Natural History. His wife sold it after his death. The remains of the collection he took with him to the Berlin University in 1909 and continued to expand while working there, some 6,300 skulls, are in the Berlin Museum für Vor- und Frühgeschichte (The Museum of Pre- and Early History).

Luschan collected skulls with the same enthusiasm he pursued the Benin bronzes. He regarded them as powerful archaeological evidence, and while much of his work with those skulls helped him to debunk racial theories, its creation and existence nevertheless supported general divisions among Germans or Europeans and the colonized peoples of Africa and the Pacific. That was in part because Luschan eagerly harnessed colonial troops to collect body parts, and especially skulls. That led to many contradictions. For example: during the Herero Wars and subsequent genocide in German South West Africa (1904–7), Luschan argued for the humane treatment of the insurgents, and he advocated for a protected area for the Bushmen (the San) in Botswana. Yet he also asked for colonial troops to collect the skulls of the vanquished following any altercation. While he reminded them that this should be done only in a legal or correct way, it nevertheless led to grisly acts in the internment camps during the Herero Wars, as women were forced to scrape the flesh off the skulls of the dead. There were no orders to do the same with European colonial troops who died in Africa.

Like his mentor Virchow, Luschan was a political liberal. Yet, unlike Virchow, a pacifist who had opposed Bismarck's imperialism and militarism while a member of the Reichstag, Luschan was also an imperialist

who took for granted Germany's acquisition of an overseas empire. Luschan saw nothing inherently wrong with war or conquest. Just the opposite: he saw virtue in those actions. So, while he ended *People, Race, and Language* with those strong declarative sentences against racial theory, he also began his study in a manner that would have left Bastian and especially Virchow uncomfortable: with a celebration of German colonial troops and their contributions to ethnology. In fact, in the introduction to his text, he lamented the loss of the German colonies during World War I. And as he reflected on the new Völkerkunde Museum building being completed in Dahlem in the early 1920s, he hoped that its African section would be "the most beautiful and greatest monument for our colonial troops—a true *monumentum aere perennius*."[17]

The problem is complex. If Luschan often castigated colonial abuses by the Belgians and others, he also frequently argued that anthropology and ethnology had their places in well-run colonial regimes.[18] Moreover, he actually looked to the British for an effective model of imperial management. He felt they had had the most success in modernizing colonies and improving the organization and lives of their subjects without undue abuse. He also embraced some elements of Darwinian nationalism and eugenics, believing that one of physical anthropologists' central goals should be to use their science to combat the growth of mental illness and declining birth rates. He made that clear at the end of *People, Race, and Language*: he extolled the great value of eugenics. Race scientists took advantage of that after his death in 1924. So, the questions remain: Do those facts dull the shine of his admirable words? Does his support for German imperialism change anything about our evaluations of his efforts to "save" the Benin bronzes?

Skulls and Bones

Luschan was not the only one who collected skulls. That was taking place before he arrived on the scene and it was not limited to German colonies. Johan Adrian Jacobsen, for example, collected them as well. So too did Eduard Arning and Franz Boas. Boas found it "repugnant work" but famously remarked that: "someone had to do it." There were many others. Arthur Baessler, for example, the great patron of German ethnology, collected 141 skulls on his expeditions in the South Seas. Luschan was impressed with them.[19] In the fall of 2017, Hawaiians, after twenty-six years of negotiations, were finally able to regain the remains of four of those people from Dresden's Museum für Völkerkunde.

In some cases, these and other collectors took skulls from archaeological sites. There were many European skulls in the prehistory section of Berlin's Völkerkunde Museum, and most Völkerkunde museums by the end of the nineteenth century had mummies from Peru and other places in the world.

Yet there was also a market for more recent skulls, like those Luschan had collected from battlefields. Physicians in Europe and the United States, who used skulls in their anatomical and pathological studies, had long found hospitals and prisons to be good sources for European skulls. The practice was also followed in colonial contexts, and they paid good money for collections from abroad. Physical anthropologists, many of whom were also physicians, followed suit, and as they sought to broaden their collections beyond Europe, they were utilitarian in their efforts: even those Germans like Luschan who held clearly antiracist positions and voiced humanitarian arguments against colonial violence were willing to use the powerful position of Europeans in the colonial and neocolonial contexts of the late nineteenth and early twentieth centuries to increase their collections.

Grave robbing, for example, was a common means of securing skulls in Europe and abroad. When Jacobsen set out on his trip to Alaska and Canada in the 1880s, for instance, he took along instructions from Rudolf Virchow to collect skulls. Virchow was particularly interested in anomalies and deformities, and he had read about the tendency of some Canadian tribes to elongate the skulls of their children. He was hoping for some examples for his skull collection, and he was especially interested in older skulls.

Sometimes Jacobsen was able to purchase skulls or to hire locals to help him collect them. On many occasions, however, he simply went into graveyards or burial sites and took what he wanted. That was true during his last days on Vancouver Island, where he picked up both skulls and weathered masks from a graveyard, and also the case in Alaska, when he irritated villagers with his pilfering of graves.

Jacobsen, in fact, wrote to Bastian in May 1883 about a scandal that broke out when he returned to a place in the Yukon where locals had learned that he had violated their graves. Their anger confused him. As he explained to Bastian in his broken German: "almost all travelers who have visited this area have taken heads," including "also Mr. Nielsen" from the Smithsonian Institution in Washington, DC. In this case, Jacobsen underscored, he had been collecting the skulls for Virchow, and he had only taken "3 heads and a mummy, a head above near Tannenna, a mummy

between Mision und Anock—2 heads on the lower Yukon." Locals, however, were holding him responsible for the actions of all collectors in the region, and were claiming redress: they wanted money for their relative's skulls, even the ones he had not taken.

Jacobsen apologized to Bastian for the scandal. He regretted the time he had lost sorting out the problem, and he underscored his mistake: "I am really very sorry that this has happened; the only guilt I am aware of, is that I took the heads while I had Indians in the boat, but they were from so far down the river that I surely believed that it would never get that far even if it were told." In short, if the scandal concerned him, his theft did not, and he did not expect it to concern Bastian or Virchow either. In fact, he did not stop robbing graves as a result of the scandal; he only became more discreet about it. As he reported from San Francisco that October, he continued to acquire more skulls and mummies for Virchow while traveling south.[20]

Luschan began collecting skulls even during his earliest excavations in Greece. He continued to do so during his later expeditions in Syria and during his many travels. Yet he also collected flora and fauna, objects and artifacts, took numerous photographs of people, places, vegetation, and insects. In that sense, his collecting methodology spanned many fields—physical anthropology was only one of them.

Yet, after Luschan became a professor of anthropology at the Berlin University and gained a research chair in 1909, his role in Berlin's Museum für Völkerkunde diminished. Bernhard Ankermann replaced Luschan, first as a directorial assistant of the Africa and Oceania collections in 1911, and then as director of those collections in 1916. Ankermann remained in that position until 1924, and neither he nor the other ethnologists in Berlin's Museum für Völkerkunde wanted anything to do with Luschan's collections of bones and skulls. There is a good reason his wife had to sell Luschan's private collection to the Americans.

Faustian Bargains

The bigger point, however, has less to do with the skulls than with the opportunism of the ethnologists in the Berlin museum and their willingness to take advantage of colonial and neocolonial situations (like those in British Columbia) to further their ends. Initially, colonialism had played no role in Bastian's vision. Neither Bastian nor Virchow favored Germany's gaining colonial territories. They both advocated against it. Moreover, the origins of Bastian's ethnographic project had nothing to do with German

colonialism. Bastian's vision took shape before the founding of Imperial Germany, and his arguments for a free-standing ethnological museum were well developed a decade before Chancellor Otto von Bismarck shifted his foreign policy in 1884 to include acquiring overseas colonies. By that time, Bastian's new museum building was all but completed and his collections were already extensive.

Yet once Imperial Germany began acquiring colonies, Bastian was happy to harness those state interests to further his ends, just as he was happy to harness anyone's interests to further his collecting mission. As a result, he began developing arguments that would appeal to colonialists, and he set out to enlist German colonial authorities—administrators, governors, the military, and anyone working under German colonial auspices—to collect for his museum. He also began making appeals to the General Administration of the Royal Museums, and through it, to higher levels of the German government, for direct state support of acquisitions in colonial territories. Eventually, those included in Africa: German Cameroon, German East Africa (including today's Tanzania and parts of Burundi, Kenya, Mozambique, and Rwanda), German South West Africa (present-day Namibia and part of Botswana), and Togoland (including contemporary Togo and part of Ghana). The Pacific colonies included German Samoa and the many islands and territories incorporated under the term "German New Guinea." There were also small possessions in China, most notably Kiautschou (Jiaozhou).

Already in March 1885, just after the close of the international conference in Berlin that initiated Imperial Germany's entry into the colonial competition, Richard Schöne, director of the General Administration of the Royal Museums, used reports written by Bastian about the great success of French anthropologists and ethnologists working with French colonial administrators in Africa to argue for similar state support in the new German colonies. If the French could do it, Bastian argued, surely the Germans could build such relationships as well. That was a stunningly quick and clearly opportunistic transition from opposing the acquisition of colonies to making the most of them. This was, perhaps, one of the most Faustian of their bargains.

Initially, Bastian had high hopes. He asked for the support of "expeditions" into Germany's newly acquired colonial territories in Africa and also northern New Guinea. He sought "exploration of this still unknown territory" and argued for the "acquisition of systematic collections to illustrate the culture of residents who are completely free of foreign influence." The timing was perfect. For Bastian, this too was a moment to strike while the

iron was hot—while the German colonial office created the structures and had the funds that would make such expeditions possible but before those structures and the subsequent colonial regimes fundamentally altered the cultures of the people living in the interiors of these territories. That, he knew, was inevitable.[21]

Bastian had little success convincing the German Foreign Office to bankroll such comprehensive scientific ventures. However, he was quite effective at gaining collections from the colonies through the same kinds of networks he had established elsewhere. Here, too, he contacted countless colonial officials and military men, reminding them of their duties, while stroking their egos. Imperial honors were available for colonial collectors too, and many came forward to help him secure collections. Because of the density of Germans in the colonial territories who were not only citizens of Imperial Germany but in many cases its employees, Bastian's networks in the German colonies quickly became even more productive than in other parts of Africa and Oceania.

Still, collecting in the German colonies posed particular challenges in many ways, because the objects acquired from these territories had more than scientific value. Many German officials could see their political and economic uses. Already during the late 1880s and 1890s, a debate began to emerge about whether ethnological collections should, as Bastian hoped, flow into his museum from the colonies, or if they should be delivered into a new colonial museum created for a general public. Such a museum could offer visitors a complete understanding of the flora, fauna, geographies, landscapes, and the cultures of the peoples in the colonial territories. It could also teach Germans about their economies and industries. Ideally, as Richard Schöne began to argue early on, this kind of institution could help Germans become familiar with the colonies, and that could stimulate investment and trade.

Bastian had made similar arguments for the importance of collecting in the colonies in his initial proposals; but he hated the idea of a colonial museum. He feared that a political project might absorb some or even all of the ethnological collections that he wanted directed into his scientific institution. Bastian wanted everything for his Gedankenstatitik, not for a public exhibition meant to stimulate trade. Fortunately for him, neither the Imperial government nor the city of Berlin proved to be in any rush to build yet another major museum.

In the end, as collections flowed into Berlin from the colonies, Bastian's museum acquired the ethnological ones. That gave it an exceptional position among German ethnological museums vis-à-vis the colonies. In fact,

by 1889, a decision by the Bundesrat mandated that *all* ethnological items acquired in the German colonies from travelers and researchers supported by the German government must be sent to the Berlin museum. Once there, those objects could be integrated into the museum's collections and any doubles could be distributed to other German museums. Yet little was ever redistributed, and as a result, even today there is a dearth of collections from Germany's former colonies in German ethnological museums outside Berlin.

Understandably, the Bundesrat's decision, and the ways in which Bastian and Luschan took advantage of it, irritated the directors of Germany's other ethnological museums. They too sought objects from the colonies to round out their geographically organized collections, and just like Bastian, they wanted to build collecting networks in the German colonies and harness the colonial administration to help them achieve their goals. Yet the Bundesrat's decision made that impossible. It actually produced giant gaps in their collections. Across the entire globe, the German colonies were the one place where German ethnological museums outside Berlin were forbidden to collect.

As a result, the directors of Germany's other ethnological museums spent a decade waging a bitter campaign to "break Berlin's monopoly" on colonial objects. That battle began in earnest as Georg Thilenius became director of Hamburg's Museum für Völkerkunde in 1906, and Karl Weule became the director of the Grassimuseum für Völkerkunde in Leipzig in 1907. Weule had already begun lobbying for greater redistribution of the colonial objects that arrived in Berlin after becoming directorial assistant in the Grassi Museum in 1899. In 1904, for example, he wrote with exasperation in a letter marked "confidential" to Karl von Linden, the director of Stuttgart's Museum für Völkerkunde, about Luschan's hold over the colonial collections and the fact that "except for a few broken arrows there was nothing to distribute."[22] Together they began to conspire against Luschan and the Berlin museum.

Thilenius soon joined their effort. Because the Hamburg senate had charged him with increasing his museum's collections and given him strong financial support, he quickly began asking Luschan in March 1906 about the actual process of redistributing the so-called doubles that arrived in Berlin from the colonies. "It would be for me, for my own orientation, welcome to hear," he wrote, "if a distribution of this kind has good prospects or if from the outset the entire acquisition is meant to remain with you." It turned out to be the latter. Luschan explained, in his thinly veiled response, that while he was in favor of rethinking the regulations

and following the rules, there were a number of problems. The first was the designation of doubles among the collections and the second was an equitable distribution of those putative doubles among Germany's ever-growing numbers of ethnological museums. Until those problems could be solved, he remarked, there was not much he could do.

More than a little vexed by Luschan's ruse, Thilenius began campaigning among colonial officials against the Berlin museum's privileged position, calling for a rewriting of the regulations. He also wrote his own "confidential" letter to Weule in Leipzig about what tactics would be most effective, saying, "I have long pondered how one might break Berlin's monopoly," and he ultimately agreed with Weule that underscoring Germany's federalism was the smartest move. As Weule had written to Linden in 1904, people in the colonies knew that Berlin always took the "lion's share of everything that came from the colonies," and not everyone liked that. Consequently, in those places where "discipline rules, they say, I have no interest to collect for Berlin, because I am Bavarian, Württemberger, Saxon, etc.," and "because I can only collect for other museums" after "involved efforts" to gain "higher permission, I no longer collect at all." He had heard the same from many sources, and the consequences for everyone, he maintained, were grim: "in Togo, for example, no one collects anymore." That, Thilenius believed, an argument that would give them traction in the German Foreign Office, and thus Thilenius and Weule harnessed those colonial reports during their "campaign against Berlin," arguing that colonial troops and officials should be permitted to send their collections to any German museum—not just to Berlin.

As Thilenius and Weule joined with other museum directors to pressure the colonial officials to call for changes in the law, Luschan continued to argue that identifying doubles was a tricky business. It was so tricky, in fact, that Arnold Jacobi, director of the Museum für Völkerkunde in Dresden, remarked that for Luschan "the term 'double' hardly exists in ethnology."

To get around Luschan's inability to see any doubles in his collections, they set out to create a commission that could do it for him. That, however, proved tricky as well. The inability of the museum directors outside Berlin to agree on a new system of redistribution proved a huge barrier to resolution. As Thilenius and Weule attempted to bind these directors to their cause, they split into factions. The directors of the smaller museums felt cut out by the larger ones, who expected larger shares of the collections. Meanwhile, museums in southern Germany insisted that if indeed Thilenius and Weule were able to create a museum commission to redistribute the doubles, northerners should not be allowed to dominate it.[23]

By 1910, Thilenius was becoming frustrated at the "petty jealousies between individual museums and the differences between the leading personalities." With these conditions, he confessed during a report to Hamburg senator Werner von Melle, "it will be not at all possible" to completely solve their problem.

Consequently, though Thilenius and Weule did manage to create their museum commission, they never were able to "break Berlin's monopoly." Their last meeting, scheduled for August 2, 1914, in Hildesheim, was canceled due to the outbreak of the war. After Germany lost all of its colonies, the point became moot.

The Burden of Monopoly

Still, in many ways, Berlin's monopoly on ethnological collections from the colonies was as much a burden as a boon. As Luschan explained, in 1880—more than a quarter century before he began working with the collections from Africa and Oceania—the museum had 5,845 objects from those areas. Five years later those holdings had more than doubled to 13,361. Ten years after that, in 1895, they had almost doubled again, rising to 25,672. By 1905, they had more than doubled once again, rising to 59,737. Since the new building opened in 1886, the amount of space allocated to the collections from Africa and Oceania had essentially remained the same, which is why the guidebooks increasingly told tales of collections repacked and stored in hidden rooms or never unpacked at all. By 1910, Luschan had 23,000 items on display in that same set of cramped display halls, another 11,600 packed away in rooms closed to the public, and 14,000 stacked up in a quickly erected storage shed in Dahlem.

In 1905, Luschan was starting to favor the creation of a major colonial museum—less because of his support for German colonialism and more because he hoped it would relieve the museum's distress. It was not a matter simply of a lack of space; his sections suffered from an overemphasis on objects from the colonial territories at the expense of the rest of Africa and Oceania. Nevertheless, because of the general overcrowding throughout the museum, and despite the surge of colonial items into it, he just could not fit that many items from the German colonies into the displays. As a result, he spent years trying to figure out a way a colonial museum might be included in the design of the new museum complex in Dahlem to absorb this bubble in his collections.[24] He never succeeded.

There were also other complications. Collecting ethnographic objects during colonial conflicts posed particular challenges as well as rewards.

That was also true outside the German colonies and outside Africa and Oceania. Adolf Bastian captured these dilemmas while making a strong argument to the German government for a scientific expedition to China during the Boxer Rebellion (1899–1901). His plea began with the example of the "campaigns of the Corsican conqueror," which filled the museums in Paris, the "city on the Seine." In particular, he argued, Napoleon's campaign in Egypt had set the key precedent. "Supported by a staff of 120 scholars, artists, technicians and engineers," it had "laid the groundwork for the magnificently acclaimed knowledge of Egyptology." Because of French scientists' "discovery of the Rosette stone" in 1798, which contained "the key to deciphering the hieroglyphics," Napoleon's expedition threw "a flood of light on the distant past." Despite that success, Bastian argued, too few military campaigns followed the Napoleonic model of including scientific men in their numbers, and thus more was destroyed in such conflicts and far less was preserved. With every colonial campaign, he stressed, valuable documents and objects were scattered and seldom retrieved.

The Benin collections, in that sense, were an exceptional story because they had been systematically relocated and "saved for science" after the fact. That, however, had been costly, difficult, and hardly ideal. Explaining that they were once again at a threshold with the conflict in Peking (Beijing), Bastian wrote to the General Administration of the Royal Museums in a letter that made its way to the minister of the interior, and eventually to the Reichskanzler, that a critical opportunity was near. "At the moment," he acknowledged, "the military operational aspects are holding total and complete attention." Still, he underscored, it would be wise to remind "those involved of this issue now, in order for them to avoid being criticized for missing an opportunity" if they began acting too late.[25]

Here again, Bastian argued, the iron was especially hot, and they needed to act to salvage materials before the majority were destroyed and, as so often in the past, nothing was left except "individual pieces of plunder" that slowly trickled into Europe, where they fell into "the hands of dealers" who demanded "exorbitant prices." "Perhaps," he wrote, "it would be appropriate to make timely arrangements in this case, so that the same thing does not happen again." One step, he argued, would be to make "officers and staff physicians aware of the present interest in artistic and scientific areas," and to instruct them that where "stores of art and knowledge can be saved from obliteration" and directed toward "museums in the homeland," such "meritorious support" is "certain to gain full recognition."

Perhaps Bastian's warning against future "allegations of neglect" was effective. Yet, by the time he had convinced government and military

officials, reports from China made it clear that it was far too late to instruct German troops to collect. Destruction and plundering were widespread in the combat and occupation zones, and dealers were hawking precious objects in the streets or packing them off to Europe and the United States. Thus Bastian convinced the minister of the interior to plead directly with the Foreign Office for a scientific intervention: "the current conditions in China," he wrote, "make it desirable to use the present opportunity to acquire Chinese ethnological objects, antiquities, and manuscripts in the interest of our scientific institutions, and, to that end, and in accordance with the example of other nations, to send a scholar familiar with Chinese science" into the fray. That successful plea led to the Imperial government's financing an expedition to the combat zone by F.W.K. Müller, a renowned scholar of Oriental languages and cultures and after 1906 the director of the Berlin museum's Asian section. As Bastian predicted, his efforts saved unprecedented collections of Chinese objects and texts for the museum.

That, however, was not how it usually worked in Germany's own colonies. Despite the many volumes of instructions Bastian, Luschan, and the others had penned for soldiers in those territories, and despite the networks Bastian and later Luschan had nurtured there, the military men in Germany's colonial forces showed little interest in playing ethnologist while on the battlefield, and no one assigned scientists—ethnologists or otherwise—to accompany German colonial troops as Müller had done in China.

The results could be frustrating. For example: following the 1905 Maji Maji uprising in German East Africa, Luschan received a delivery of some two thousand kilograms of objects, the vast majority of which were weapons quickly assembled or made in the heat of the conflict. He was terribly disappointed as he unpacked them. There were no older objects, nothing with historical meaning or cultural significance, nothing that had value for his museum. Understandably, none of the directors of other German museums clamored to get any of it. No one wanted these things, and his initial thought, that he might distribute them to German schools, was undercut because of the fear that some of the weapons could have poisoned tips. That was not an unfounded concern. Oswald Richter, a rising star in the world of German ethnology, who began working in the Berlin Museum in 1904, died in 1908 from blood poisoning caused by a cut from a poisoned arrow. Shipping this pile of war booty back to East Africa also made little sense; no one could justify the costs. Nor could they sacrifice any more space for its storage. So, with the permission of the General Administration of the Royal Museums, Luschan had most of it burned.

Managing Colonialism

If Luschan genuinely believed that ethnology had a critical role to play in educating Germans about non-Europeans, he also was convinced it had an important role to play in managing German colonies. His expectation was that if Germans and other Europeans involved in colonial enterprises learned to respect other people as humans, equal to themselves, then colonial regimes could do more good than harm. In 1903, just prior to the disastrous Herero Wars and the Maji Maji uprising, which caused so much death, Luschan wrote to the General Administration of the Royal Museums: "for an emerging colonial power . . . ethnology is not only of scientific and theoretical importance but also of the greatest practical importance." To support his point, he directed them to an enclosed copy of his "Lecture at the VII International Geographical Congress in Berlin in 1899." In that presentation, he stressed both moral and practical reasons for taking advantage of the science that studies the cultures of other peoples: "ethnology," he explained, "is not yet one of the officially recognized disciplines in the preparation for service in the tropics; therefore, there are still Europeans who underestimate the 'savages' and therefore—as sad experiences keep showing us again and again—mistreat them in the most brutal manner." He stressed that there were numerous examples of colonialists building better administrations through a clear understanding and appreciation of the people living within their newly acquired territories. Despite that, "we learn again and again with horror and disgust how some of our European compatriots act among the blacks, people who can justifiably be called 'white savages' and who in fact think and act like savages."

In addition to that moral failure there was also a practical one. He underscored that the economist Werner Sombart had long since established the importance of balancing capital, labor, and markets. "Only a few days ago," he wrote, "Sombart stated that the creation of markets was simultaneously an art and a science. But how little do we do this task justice in our colonies! I do not say we Germans in our German colonies, but more generally we Europeans in Africa and in the South Seas!" Colonialists, he lamented, were often lazy and immoral; they seldom took responsibility for developing colonial societies. They frequently sought only quick profits rather than long-term gains. As a result, Luschan complained, while in past centuries "valuable and useful wares" were exported by Europeans to these areas, "we now only import schnapps as the single mass-produced article!" That depressed him, because "instead of educating the natives to become earnest buyers of our best and dearest export

goods, we poison them with liquor or, as is customary in the Congo state, hack off their hands if they fail to haul in enough rubber or ivory."

Such "atrocities" were sometimes "due to the personal brutality of a single person"—but only sometimes. Luschan identified a systematic problem in colonial contexts, and he argued that ethnology could help solve it. Such acts of barbarity would "be much rarer if the broad strata of European peoples finally realized that the culture of the so-called 'savages' is not worse than ours, but only different. This insight," he continued, "which until now has only gone to the learned ethnographer, deserves to become the common property [*Gemeingut*] of the people." Above all, he argued, "it must be demanded that ethnology at least be given the leading position it deserves in the training of colonial officials." That was "not only a demand of science but also a demand of morality and national prosperity."[26] A colonial museum focused on investment and trade opportunities could never achieve those goals. The small, privately funded one set up in Berlin's Lehrter train station never did. It is unclear if a Völkerkunde museum might have. There is little evidence that the colonial office took him at his word, even after his revelations about the Benin bronzes, and even after the disastrous genocide that accompanied the Herero Wars.

Saved?

Luschan's magnum opus was not the last word on the Benin bronzes. Over the next century ethnologists and others have continued to work with these collections to learn more about Africa and the world. The collections have proven to be incredibly valuable historical texts, filled with information about Benin during the ages in which they were produced. Bastian and Luschan would not be surprised. That was the reasoning behind Bastian's call to "save what can still be saved"—be it the silver archaeological objects he purchased away from metallurgists in Peru, the bronze axe heads he guarded with his revolver in Ecuador, or the Benin bronzes seized by British colonial troops and auctioned off to the highest bidders.

Counterfactual questions are dubious things. Yet in this case it is worth asking: what would have been lost if Luschan had not pursued the Benin bronzes and ivories, tracked them, and helped to secure the vast majority in museums? Or perhaps it is better to turn the question around and ask what was gained through Luschan's actions, and what more might be gained if the half million objects in Berlin's ethnological museums, as well as the millions of objects in other German ethnological museums, were given the same attention today as the Benin bronzes?

It is tempting, of course, to avoid those questions by focusing on Luschan's character. It makes our evaluations so much easier. One can simply praise Luschan's staunch antiracist positions, laud his scientific integrity, and underscore his good intentions as a means to legitimize all his collecting. Or, for the opposite effect, one can condemn his violent imperialism, point out the consequences of his bone collecting in colonial contexts, and emphasize the arrogance of his Western perspective in order to tarnish his collecting activities as well as his volumes on Benin. While those are diametrically opposed ends, they are equally reductionist means, which not only belie the very human complexity of Luschan's character but also purposefully obfuscate any understanding of what his efforts might mean for the present. It is critical that we resist such facile polemics and understand the goals and purposes they are meant to obscure.

From the moment Luschan began pursuing the Benin artifacts, he believed that he was following Bastian's mandate: acting to save those material traces of African and human history for posterity. From the late 1890s until his death, Luschan remained convinced that, as he assured Count von Linden, "people in future centuries will be thankful to you for your energetic interventions." He wrote much the same in his 1919 introduction to *The Antiquities of Benin*: "Posterity" would be "thankful" for their efforts. Yet in the twenty-first century that assumption no longer rings true. The Benin bronzes and ivories have become the poster children for *Raubkunst* (looted art), and many activists, journalists, and quite a few scholars are eager to mischaracterize Luschan's actions while they question why a person today from Africa, Nigeria, or Benin City is required to travel to Germany to see a great deal of the Kingdom of Benin's cultural patrimony. Luschan's answer would unsettle many who do not understand the history: they *have to* do that because British soldiers seized it. More importantly: they *can* do that because German ethnologists saved as much as they could, preventing imperialism from obliterating these records of Benin's ancient past.

Guatemalan Textiles

PERSISTING GLOBAL NETWORKS

A SMALL METAL BOX sits proudly today in the MARKK: Museum am Rothenbaum: World Cultures and Arts (formerly the Hamburgisches Museum für Völkerkunde). The box is filled with cards labeled "The Elmenhorst Collection of Maya Textiles." Each card represents an object in that collection, and each holds details, written in English. That information is divided into clear categories: specimen number, acquisition date, object type, size, material, weaving technique, village name, group (tribe or ethnic division), design and color, and "remarks," which generally include how and when the item was acquired and how it was used. Many cards also include the name of the person who produced the item, a detail often difficult to obtain. The man who created this exactingly documented collection between the 1930s and the 1980s was neither English nor an ethnologist. Carlos W. Elmenhorst was a German who spent most of his adult life in Guatemala. He was a businessman, an entrepreneur who exported coffee, honey, and wax. In his spare time, he created an impressive collection of more than 1,300 Guatemalan textiles. In 1989, he donated that collection to the Hamburgisches Museum für Völkerkunde, not to the Museum für Völkerkunde in Berlin.

The reason is simple: not all roads lead to Berlin. They never did. As Bastian built his museum and pursued his vision, he engaged in keen competition with other German and non-German museums. At the same time, all of those institutions and the ethnologists in them believed they were engaged in a joint project. So, they also cooperated: they exchanged doubles from their collections, they trained and employed one another's assistants, and they launched jointly sponsored expeditions to Africa,

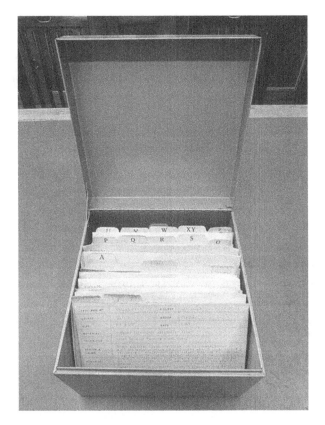

FIGURE 4.1. The box.

Asia, South America, the South Seas and other parts of the world that were underrepresented in their collections. By Bastian's death in 1905, there were many more museums in Germany than when his celebrated new museum building opened in 1886: large museums were set up in Hamburg, Leipzig, Munich, Stuttgart, and Vienna, and over the decades smaller museums appeared in Basel, Bremen, Cologne, Darmstadt, Dresden, Frankfurt, Freiburg im Breisgau, Herrnhut, Heidelberg, Kassel, Kiel, Karlsruhe, and Lübeck. There were thus many more competitors for objects by the 1920s, and many more museum directors building on Bastian's transnational networks. He trained them well.

All German museums have their networks. In many cases, those networks in non-European lands supported relationships that continued into the twentieth century, right through the two world wars and the accompanying economic and political disasters. Missionaries from Basel sent their collections from Cameroon back to Basel, rather than to Berlin or Zurich. The Linden museum in Stuttgart cultivated networks of Swabians

abroad; the Deutsche Auslands-Institut (Institute for Germans Abroad), also based in Stuttgart and focused on aiding outmigration during the interwar period, was able to help. It kept lists of both Germans and Swabians living abroad, particularly those who had become well established and important in their host societies. These were people to whom ethnologists in Stuttgart could turn for aid, and they did.

It was precisely their awareness of this kind of loyalty to cities and regions that had driven the directors of other German ethnological museums to try to break Berlin's monopoly on colonial collections during the decade before World War I. They knew from experience that Germans everywhere, not simply in the colonies, were connected to Germany through their hometowns or regions and were most loyal to their hometown institutions. In 1911, for example, while Georg Thilenius, director of the Hamburgisches Museum für Völkerkunde, was fighting for a share of objects from the German colonies, he approached the Hamburg senate with a proposal to systematically build connections with Hamburg's merchants abroad.[1] He included two maps showing the most important areas for acquisition, and he sought their help in soliciting aid from the sons of Hamburg who lived and worked in those areas. He was deeply jealous of the Hilfs-Comité that Bastian had created in the 1880s, and he was scheming, trying to figure out how best to enlist collectors, supporters, and people who would offer him similar kinds of assistance. He and Germany's other ethnologists had learned from Bastian's success: while they could and did effectively organize expeditions for targeted collecting in specific locations, it was the creation of global networks that would fill their museums. That had been Bastian's well-known secret; that is what had pushed the collections in the Berlin museum beyond all others in the world.

Germans abroad animated ethnologists' collecting networks with their own inquisitive energies. There were, for example, thousands of Germans working in schools, major museums, and national universities in industrializing countries and trade centers outside Europe. These people, much like many young German academics today, went abroad in search of such positions—and they stayed for years, decades, or lifetimes. Few were isolated; most remained tied together by German-language journals, periodicals, and correspondence. That is why German Guatemalans already knew who Bastian was before he arrived in Guatemala City in the 1870s, and that is why new arrivals and old residents there recognized Germany's leading Central Americanist Karl Sapper, his student Franz Termer, and other German scientists each time they appeared in Guatemala during the twentieth century.

German communities in Guatemala, in fact, offer us a fantastic example of the persistent networks that animated German archaeology and ethnology for more than a century. They also provide us with an ideal opportunity to go deep into those kinds of networks to see how they took shape and persisted over time. Understanding that process, in turn, helps to explain why so many objects and collections ended up in German museums, and why they continued to flow into German museums long after the heyday of German colonialism and empire.

The reason, of course, is that neither colonialism nor empire had driven the collecting. Rather, it was the appeal of Bastian's vision, the allure of his Humboldtian desire to know the world, to pursue a total history of humanity, which was shared by many Germans abroad. That explains their communities' appreciation for the painstaking work pursued by German scientists such as Sapper and Termer as they mapped Central American regions, recorded languages, exposed the traces of ancient civilizations, and gathered archaeological and ethnological collections for their promotion of the joint project—the total history of humanity. The persistent enthusiasm for that project among Germans abroad from the late nineteenth century right through the age of National Socialism and into the postwar era also reminds us that the appeal of German science outside Europe continued across the twentieth century despite the tragedies of fascism, the destruction of the world wars, and the division of the German nation-state after World War II.

When one ventures today into the archives of the MARKK in Hamburg, for example, one finds decades of correspondence: details of expeditions into Central America and other parts of the world by a succession of German archaeologists and ethnologists; letters between those ethnologists and the many members of the German community in Guatemala and elsewhere in Central America about archaeological finds and ethnographic collections; discussions of collecting practices; and complete collections created by Germans abroad and later given or sold to the museum. In many cases, passionate laymen like Elmenhorst produced those collections over decades—across all the successes and tragedies of twentieth-century German history.

The most fundamental questions one can ask about the Elmenhorst collection is why it was created in the first place, and why this, or any other collection, ended up in a Hamburg museum rather than in Berlin or some other city. The value of Guatemalan textiles is clear: the women's clothing and costumes are particularly beautiful, marked by vibrant colors and patterns produced in great variations across the country's many communities.

Yet much of their value stems from the symbols woven into the textiles. Those symbols articulate local, regional, general, and even pan-Maya identities. Many of those symbols, such as the waves representing serpents or the rhombus shapes representing offerings to gods, also harken back to pre-Columbian times, before the arrival of Europeans. They contain cosmological symbolism within the textile language, which identifies the wearer's place in society and the world. On the most basic level, as Bastian knew so well, collections of textiles are also collections of texts. And those collections are filled with information about the worldviews of the people who produced and used them. They also contain information about Guatemalans' collective memories. In short, the clothing is not only rich in colors but also in human history.

In that sense, ethnologists' efforts to gather, preserve, compare, and decode Guatemalan or Central American textiles is akin to the work of archaeologists in unearthing, recording, comparing, and decoding ancient buildings and monuments. Symbols one can find in carvings on stones for plates of offerings, serpents, the Tree of Life, and more, also can be found in textiles. One key difference, however, is that the production of Guatemalan textiles did not stop after Europeans arrived, after the Spanish created their colonies, or after the new nation-states took shape during the nineteenth century. They did not stop as the building of Maya cities did. Nor were the textiles covered over by the forests until archaeologists later unearthed them. The Maya continued producing their textiles across time.

It was only during the twentieth century, with the introduction of cheap, mass-produced goods, modern railways and roads, the greater mobility that followed, and money economies reaching into every valley, that the production and use of these textiles, and in many cases the memories of the symbolism woven into them, began to fade. That was also the moment when German ethnologists pursued their collections of these textiles with the greatest vigor; that was the time when Germans living abroad, people like Elmenhort, were drawn into this one small part of the collecting frenzy that filled Germany's ethnological museums.

Understanding how these textile collections ended up in a Hamburg museum rather than in Berlin, New York, or in some other European, North American, or Central American museum, requires peeling back the historical layers. There are good historical reasons why, for example, the MARKK boasts the largest and most important collection of Guatemalan textiles in Europe, and one of the most comprehensive outside Guatemala. It is not, however, because Hamburg's senate, its scientists, or even the directors of its ethnological museum had a particular interest in these collections. Rather, it is because of the many economic and human connections

that emerged between Hamburg and Guatemala during the late nineteenth and early twentieth centuries. It is because of the actions of the Germans who went to live in Guatemala but remained connected to Hamburg, its institutions, and its scientists while creating their lives abroad.

Carlos W. Elmenhorst (born in Kiel in 1910 as Kurt Wolfram Walter Carl Elmenhorst) was one of those thousands of Germans who spent most of their lives in Guatemala. He assembled his part of the Hamburg museum's collections while living in Guatemala from 1932 to 2000. His systematic mode of collection is one reason for its importance; the documentation is another. This was the kind of collection Eduard Arning had tried to create for Bastian piecemeal during his short time in Hawai'i in the 1880s. It was the type of collection that contained precisely the sorts of information demanded by Bastian, Boas, and their successors. Elmenhorst, however, was no more a professional collector than Arning. Nevertheless, he developed rigorous scientific standards derived from years of interactions with Franz Termer, who succeeded Georg Thilenius as director of the Hamburgisches Museum für Völkerkunde in 1935, and Termer's student Wolfgang Haberland, who also took three trips to Guatemala and eventually became director of the North American section of the Hamburg museum after World War II. As Elmenhorst wrote in 1986, without the documentation, his collection would have been nothing more than "a pile of old cloth."[2] Without his connections to Haberland and Termer, there would not have been this documentation. His donation was made "in memory of" those two men.

The history in Elmenhorst's card catalogs is thus part of a rich history of German interactions with Guatemala over more than a century. The histories of ethnological collections across German-speaking Europe contain such rich histories of German interactions from all over the world. By digging into this particular history, we can learn a great deal about how German ethnology shifted and changed in the age after Bastian, how his vision was challenged and undermined by the events of the twentieth century, and how, despite all that, much of his vision persisted and continued to be pursued by subsequent generations of Germans over time. That complex history produced a simple and brilliant result: a great confluence of well-documented Guatemalan textiles has been saved in Hamburg.

A Kind of Homecoming

Zipping down a highway below the Tecuamburro volcano in southern Guatemala, Franz Termer marveled at the changes. This was not how he had imagined the first expedition of his 1938 research trip. His muddy

boots and field clothing contrasted harshly with the light apparel of the two German teachers he had just met. He tried not to sully the man's car. The teachers had fled Guatemala City for a quick trip to the beach, a pleasant diversion from their long days at the German school. They were delighted to encounter Termer in the village of Guazacapán and eager to give him a lift to nearby Chiquimulilla. As he wondered about the behavior of the woman who sat in the backseat with her legs so carelessly stretched out between him and the driver, he worried little about when his guide, Federico Lima, and their mules would catch up with him in Chiquimulilla. The two men planned to stay there the next night during their trek around the volcano. For Termer, however, this bit of the journey suddenly required no trekking. He arrived rested and ready in less than half an hour.

This was nothing like Termer's experiences during his initial forays, a decade earlier, into the world of archaeological and ethnological research in Central America. That had been a time of arduous travel, mostly by foot and by mule, together with one or more indigenous guides and porters. They moved slowly, often alone in the forests and hills for long periods of time: collecting, digging, and traveling. Their conversations were in Spanish or a Mayan language (of which there are more than thirty) or some combination of both. His evenings were generally spent ordering his campsites, preparing for the next day's travel, recording his finds, and corresponding with his mentor Karl Sapper at the University of Würzburg. Termer was Sapper's favorite student, and he relied heavily on Sapper's connections to tie him into the networked world of German coffee plantations (*fincas*) in Guatemala.

The fincas ranged from isolated small farms to large plantations employing hundreds of people. By the early 1920s, German plantations, which sold most of their coffee on the Hamburg coffee exchange, generated a huge percentage of Guatemala's gross national product. That coffee capitalism and other forms of investment and trade were at the heart of German Guatemalan connections, but so too were family networks that, in some cases, went back multiple generations and extended far beyond Central America and Germany.

Termer came to expect hospitality among the German fincas' managers and owners: good housing, good food, plenty of research and technical support, lots of information about the surrounding areas, and tips about negotiating the landscapes, the populations, and the government. Sometimes they even told him where to find unexplored ruins within the dense vegetation. They received his mail while he was traveling; they set him up with guides, mules, porters, and supplies; and many of them took

great interest in his research and his findings. Sometimes their support was financial. He wrote up most of his initial reports and many of his first publications in their quarters. During the rainy seasons, he was frequently confined to them for weeks at a time. The mostly dirt roads and forest paths became impassable.

The fincas were still there in 1938, and their owners remained keen to host him. Just before his departure, in fact, Termer received a letter from Wilhelm Lengemann at the Chocolá plantation in the fertile Bocacosta of southwestern Guatemala. It was one of the largest fincas in the region. At its height, its expanse covered more than 360 square miles, including about nine square miles of Maya ruins, which by 1938 already had seen the attentions of Karl Sapper, Termer, and many others. Lengemann assured him that his old field bed was where he had left it, and he was welcome to stay at the Chocolá plantation as long as he wished. Termer was delighted. He regarded his return as a kind of homecoming.

Still, though the fincas remained, much else had changed. Lengemann was only the first to warn him. In part, it was the politics of the day. The Nazis were in power in Germany and angling to gain parts of Czechoslovakia. Europe was divided over the aggression, and so too was Guatemala's German community. In that sense, Termer's timing was terrible. In fact, neither his wife nor most of his colleagues had believed his ship would even leave Hamburg in September 1938. As it turned out, it left twice.

Termer departed the first time as Nazi and Western European officials were gathered in Munich arguing over Czechoslovakia's fate. When Termer made a quick trip to Bruges and Ghent during his ship's scheduled stop in Antwerp, he watched Belgian troops quickly assembling, preparing to leave for the French border. His ship left Antwerp for France on the evening of September 27, just as the political tensions in Munich came to a head. When he woke the next morning, he realized their course had reversed. "It hit like a bomb," he wrote a colleague, when the captain announced they had been ordered to return. His ship was filled with Jewish refugees. Some had just escaped from Hamburg, others had boarded in the Netherlands. The stress was palpable; the captain and crew taciturn. The next day they anchored near Cuxhaven, suspended in limbo at the mouth of the Elbe. For hours, they waited without communications. Then carloads of passengers who had missed the original departure began arriving on the evening of September 29, and at three o'clock the next morning they miraculously left Germany again.

Termer contemplated those political tensions while writing to his wife, Nora, about the cliffs of Dover that hovered above their ship on October 1

and contrasted starkly with the mood on board and the distress in Great Britain. The English were preparing for war. Gas masks, he heard, were being distributed in London, trenches dug in parks, children sent out into the country. Machine guns loomed from church steeples. Another one hundred passengers joined them. Many were afraid.

Still, once they were at sea, conviviality reigned. Termer was expected to dress for dinner even as they entered the tropics. A steward laid out his tuxedo each evening; the ship's captain ensured they were well entertained. Termer, however, was not prepared for the costume party planned at the end of their first week. He wore only a silly, stiff hat with his tuxedo; the man across the table from him came dressed as a bumblebee. Termer wrote Nora about it with humor; but mostly he wrote about his anticipation, the excitement and trepidation of returning to Guatemala after a decade, and about how much he loved her, how tightly he felt connected to her and their children.

Persisting Connections

By the time Termer set off to Guatemala in 1938, he was one of the leading Americanists in Germany, an indirect successor of the world-renowned Americanist Eduard Seler. Yet Germany's museum landscape had expanded greatly since Seler's day. Termer was working in Hamburg rather than Berlin as he continued the tradition of venturing into territories uncharted by experts and adding to the vast ethnographic project Bastian had begun before Termer was born. His position in the profession was sound. He was director of Hamburg's Museum für Völkerkunde, professor of Völkerkunde at Hamburg University, and chairman of the German Society for Völkerkunde. Before he succeeded Georg Thilenius in those positions in Hamburg, he spent 1925–29 pursuing archaeological, ethnological, and geological research in Central America. When he returned he took up a position as associate professor of geography at the University of Würzburg. He quickly succeeded his mentor Karl Sapper as professor there in 1932, but the dual position of museum director and university professor in Hamburg was better. It was one of Germany's most coveted jobs. He retained it until he retired in 1963.

By 1938, however, the heyday of German ethnological museums was long over. Despite his institutional affiliations, his international connections, and his good reputation, Termer was barely able to scrape together the money for his 1938 trip. Hamburg's finances were strained, his museum had little cash, and he was not able to rely on the German Guatemalan community for much direct financial assistance. Not this time;

money was tight there as well, and their numbers dwindling after the successes of the 1920s. National Socialism had split their once inclusive community; Nazi politics caused tensions with the Guatemalan government; and Nazi trade policy had forced many German businesses there to look to the United States for markets. That gave the Americans even greater influence over Guatemala's economy, and it allowed the United States to exert more political pressure on the state.

There was also a different mood in Guatemala in the late 1930s, which had little to do with geopolitics. It was less remote, more accessible to travelers. As a friend in Puerto Barrios warned Termer in English, "you'll find this country now, nearly everywhere, infested with motorcars and tourists."[3] Termer read that repeatedly in letters from acquaintances and friends he contacted about his upcoming trip, and he continued to hear it after he arrived. The fincas in particular had changed; the owners and managers of the larger ones seldom used their mules anymore. Many relied on cars to move from one part of their operations to the next. To facilitate that, roads rather than muddy paths tied fincas to villages and even to towns. From there, many were connected to highways, and thus to city centers.

The roads made travel faster, more predictable, and less dangerous. One sometimes saw women, especially American women, traveling in cars alone. That spoke volumes. Termer first felt those changes during a quick trip from Guatemala City to the old colonial capital, Antigua, soon after he arrived. A decade earlier, he had written an essay praising the "enchanting city" of Antigua, which was set among three volcanoes and speckled with the ruins of cathedrals and churches devastated by earthquakes. It is only forty kilometers away from the capital. In 1938, a car filled with prominent German Guatemalans took only an hour and a half to get him there. He could tell the moment he arrived that it was becoming the tourist center it remains to this day.

Nevertheless, Guatemala continued to appeal. "Antigua," he wrote to his wife Nora after that short day trip, "has not lost its charm. It is the most peculiar city in America. The drive between the coffee groves and the old churches and palaces always with a view of the volcanoes Agua, Acatenango, and Fuego was wonderful." The same was true for the landscapes that greeted him when he arrived in the country. As he crossed the "Gulf of Amatique" in a motorboat and came ashore: "everything was familiar to me again, the Cerro San Gil with its virgin forests, the shallow mangrove coasts with their pelican swarms, here and there fisherman huts, everything as it was." Even the port of Livingston was "essentially unchanged." The roads did not go everywhere.

Everything also felt familiar as he went upriver: "the jungle accompanies the banks completely dense and untouched, one sees peculiar birds, hears indefinable sounds, everything is strange, eerie, especially since the two waters have no current and appear endlessly deep." In tiny Cayuga, memories flooded back into his mind, releasing a wave of self-reflection. From that village, "I looked at the mountains from which we had descended in 1928, incredible to the people, when we crossed the San Gil." He was stunned: "It was like a dream to me, and I often felt as if I was returning directly after my last trip. It can be seen," he realized, "how strong the impressions from that time must have been on me."[4] Termer loved Guatemala.

Some things, in other words, remained the same. Some things persisted. The landscapes and towns continued to work on Termer as before, and the communities continued to welcome him. Immediately upon his arrival in Guatemala City, old friends and new acquaintances came out to see him, much as the German Guatemalans had hurried to greet Adolf Bastian half a century earlier. Like Bastian, Termer soon found himself whisked off into the German Club, where he played the role of a local celebrity: "in general you should see," he wrote Nora, "how they all come to me from every storehouse. It is really too nice." German officials, the ambassador and the consuls, helped him sort his paperwork; David Sapper, his mentor's cousin, helped him get his luggage and instruments through customs; and Germans all over town invited him to dinner. They were happy he was there.

It was those persistent, intimate connections within the community that led him to the Finca Santa Isabel near the Tecuamburro volcano. Sitting in his Hamburg office, Termer already knew that the area around the volcano had received little scientific attention, and he was pleased that the Keller family wanted to host him there.[5] Federico Keller had been a kind of pioneer in the area in the 1890s. By the late 1930s he and his wife belonged "to the characteristic Guatemala-Germans, both over 70 years old." Sadly, he explained to Nora, "the old man" recently had become ill. He was forced to travel to the Tropical Institute in Tübingen, Germany, for care. Meanwhile, "the old lady" was the "head of the Women's Union of Guatemala and thus in a senior position within" the German Guatemalan community. Those were good connections to have.

Their son Fritz had taken over running the finca while his parents lived in the capital. Termer liked Fritz, and he enjoyed traveling with his family "at a brisk pace" in their new Buick down the "wide beautiful country road" that ties Guatemala City to San Salvador. In particular, he wrote to Nora, "the young Mrs. Kell, named Lux, is a lively young lady, born in Bremen, she grew up in Berlin, she is very free, modern, chic,

and currently expecting their third child." After they turned off the main highway under the Cerro Redondo Volcano, into the winding curves of the mountain roads, he "admired" Lux, who, "while nursing," with "one hand on the hood, the other on the seat, as if hovering in a gimbal, and smiling," explained to him "that in her condition she mastered such things with ease."

Along the way, he counted off the German fincas, the rivers, and the volcanoes. They stopped to remove a dead mazacuate, a poisonous snake, more than one and a quarter meters (four feet) long from the middle of the road. To tease her, he sent Nora a picture of him holding it at arm's length. In a cave below the bridge that spanned the Ahuacapa River he took another picture of a deadly Casampulga spider, "ca. 5 cm long creature, with a round black body and long limbs." There was still no antidote for its poison, he wrote. Both encounters, he assured Nora, reminded him to walk with caution in Guatemala's high grasses—especially on the way back to the car in his gray travel suit and dress shoes.

The Valle de San Nicolas, where he would set up his base camp with the Kellers, reminded him of "an alpine valley in upper Bavaria." They arrived just as the rains began. The young Kellers' house was new, the views fantastic. "One can feel comfortable here," he wrote, mixing glee with impatience. The heavy rains had made even the new roads impassable, just as they had closed the dirt roads in the past. A drenched German traveler, escaping a bus caught in the storm, arrived at the Kellers' that night with only one shoe. The other was lost somewhere in their mud. They took him in until the rains passed, giving Termer more company in the cozy home.

Still, the waiting made Termer antsy. He was tired of preparing. He wanted to start his explorations. He craved heading out into the uncharted territory he had been contemplating for years from his Hamburg desk; but in Guatemala, everyone had to wait for the weather to clear, and he had to wait for his things to be delivered from the city. He could not go exploring in his leisure suit and dress shoes. So, to bide the time, he borrowed Fritz's "large SA-boots." At least he could "wander around a bit" dressed in part like a stormtrooper.

After a week of waiting, Termer set off on his first excursion with his guide, Federico Lima, toward the village of Guazacapán under the Tecuamburro volcano. It was his first time on a mule since 1929, and it felt good. Termer was pleased with his guide and with his sure-footed mule. He was comfortable in the saddle and with using his compass. It was like old times, and he was looking forward to roughing it over the next four days.

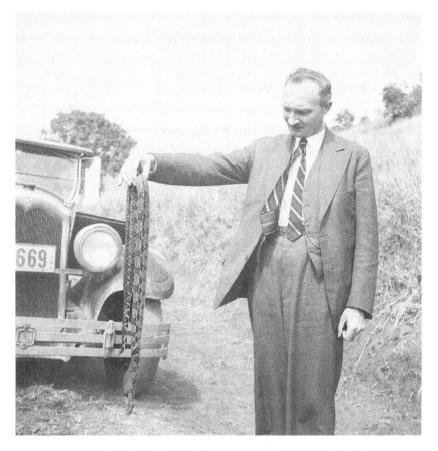

FIGURE 4.2. Termer and the snake. © MARKK, Museum am Rothenbaum
Kulturen und Künste der Welte, Hamburg.

During those days he made a series of important discoveries based on
years of interconnections and reflection. He had chosen his location well.
On arriving at the village of Guazacapán, for example, he was surprised
to encounter people speaking a Xinca language that neither he nor other
ethnologists associated with the area. That was his first important find.
His accommodations in the village, with the bad food, large cockroaches,
sparse furnishings, and noisy nighttime rats, were less surprising—he took
them all in stride. Tortillas and cheese were enough for dinner, he could
pass on the dubious rest, and his field bed kept him above the vermin.

The next day, a village local led them to a set of monuments and
Termer's next surprise: a large stone head, "whose face was half fash-
ioned like that of a normal human being and the other half like a skull,
a strange and unprecedented thing." He was convinced it and the other

stone monuments in the area demonstrated the extension of Mexican Pipil culture much farther south than he or other ethnologists had imagined. There were more artifacts in the bushes and under the vegetation.

He imagined a site rich for exploration; yet he knew it was hardly pristine. The clock was ticking here, as elsewhere. Much that could be saved was being lost. "It's a pity," he wrote to Nora, that locals treated many of these artifacts as mere curiosities, sometimes giving them to their children as playthings. No "specialist" had ever been to the region, he explained. As a result, archaeologists knew little of the extensive ruins; no one living there realized their scientific value; and Termer, like Bastian and Seler before him, saw so many records of Central American history, of human history, that could be saved.

His final surprise on his short excursion came in Guazacapán, as he prepared to travel on to the village of Chiquimulilla. In the hotel, he and Federico Lima encountered the German teachers looking for a meal after their beach adventures. He had not met them before, but they immediately recognized his name. Termer was well known among the teachers who rotated in and out of the German school every three to five years. But they were surprised to see him dirty, in his "field dress with a slowly developing beard." They were also grateful to hear his warning about the hotel's meager menu, and they happily offered him a ride to Chiquimulilla, where they all hoped they could get a good meal. By car, they assured him, it was only twenty minutes away. That night in his field bed, Termer wrote to Nora what happened next: after Federico Lima departed with the mules: "We men sat in the two-seater, Fräulein . . . [he only used ellipses, never her name] swung herself onto the folded-up top in the back and let her legs dangle between them, which caused great astonishment among the onlookers." Along the way, "Fräulein . . ." revealed that she "had studied in Hamburg and was a student of Flittner. So, there was immediately a connection."[6]

Connections

"Connections" were what made Termer's career. Termer did not simply extend Bastian's vision or follow in Eduard Seler's footsteps. His success stemmed from building on generations of connections that tied Germany and Guatemala together, and building on generations of knowledge about Guatemala produced by his predecessors. Those connections and that knowledge informed his every move, his every evaluation right from the outset. He also extended these German Guatemalan connections over the course of the twentieth century. As a result, "connections" continued to fill the Hamburgisches

Museum für Völkerkunde from Termer's first moments in Guatemala in the 1920s until long after his retirement in 1963 and his death in 1968.

When Termer first arrived in Guatemala in October 1925, the connections he gleaned from being Karl Sapper's student not only gave him places to stay, mules for his travels, and a network of younger and older friends to accompany him on research trips. He got much more than that. Even when Termer was alone, he could harness the knowledge German Guatemalans had been producing for decades. The Academia de Geografía e Historia de Guatemala, which was by no means limited to German Guatemalans, was supported by many of them. It offered German researchers like Termer a congenial intellectual base in the capital, an ever-growing library, and a place to present and debate the results of their efforts while they were still in Guatemala. Termer became a corresponding member in 1926, and he presented his research there during all of his visits. This Guatemalan institution, supported by many Germans living in Guatemala, was a cornerstone for the pursuit of his science.

As Karl Sapper's protégé, Termer integrated easily into community, family, and international scientific networks during his first months of travel in Guatemala. He undertook his first short excursions with Sapper's family members, and during his first months in the country, he often traveled under the auspices of Schulbach, Sapper & Co. His first trip to see the Pacific coast and the Guatemala-Mexico border, for example, was also meant to put him in touch with Berlin ethnologist Walter Lehmann, who was researching there. Lehmann too was supported by German Guatemalans. Together, they recorded language samples from "Mam-Indios," an exciting first bit of fieldwork for the eager Termer. Afterward, they traveled with Lehmann's secretary to Finca Chocolá, where Termer would spend so much of his time over the next three years.

Through Schulbach, Sapper & Co., Termer also became a regular at the nearby Finca San András Osuna, where he immediately received an invitation from Prince Sigismund of Prussia and his wife, Princess Charlotte Agnes, who had arrived only a few years earlier to become part of the German Guatemalan community. Times had changed drastically for Prussian royalty after World War I. The prince was managing the nearby Finca Santa Sofia, and he and his wife wanted to take the young Termer to the ruins recently uncovered at El Baúl, just four kilometers north of Santa Lucía Cotzumalguapa, which Bastian had helped to make famous in German circles. From the photos Termer first saw, the ruins at El Baúl seemed to resemble Chichen Itzá on Mexico's Yucatán Peninsula. Termer wrote excitedly to his mentor about this opportunity. He hoped he could

Mitt. d. Geogr. Ges. in Hamburg, Bd. XLI *Tafel 1*

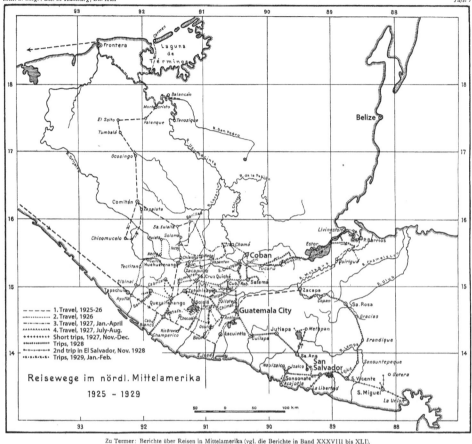

Zu Termer: Berichte über Reisen in Mittelamerika (vgl. die Berichte in Band XXXVIII bis XLI).

FIGURE 4.3. Map of Termer's many travels through northern Central America, including Guatemala, El Salvador, and Mexico, between 1925 and 1929. Franz Termer, *Mitteilungen der Geographischen Gesellschaft in Hamburg,* Vol. XLI, 1930 © Geographische Gesellschaft in Hamburg e. V.

excavate there.[7] Yet he had an overwhelming number of options. Schulbach, for example, had just purchased more land on the coast near Caballo Blanco, and his workers discovered pyramids while clearing it. Termer was ecstatic: "also there," he wrote to Sapper, "I've obtained a monopoly on digging."[8]

After Termer traveled with the former royal couple to El Baúl, he wrote to Karl Sapper like a giddy schoolboy about the pyramids, the ball court, the large stone heads, and the comparisons he began making between what he encountered there and the images he had seen from other ruins, even the contours of Melanesian and Polynesian masks. Everywhere, Termer saw in these stones the very connections Bastian had always written about.

In a field freshly cleared for sugar cultivation, for example, they found artifacts strewn across the ground. There was so much to save. They pounced on the site like beachcombers looking for precious shells. Termer thrilled at the designs he found on the shards and the colors still gleaming on much of the pottery. The prince, Termer noted with only a twinge of jealousy, found "a shard with the hieroglyph Ahau in beautiful colors, very much in the style of the jars of Chama," referring to a site in the Alta Verapaz region that had seen considerable attention in the 1890s. This moment made him want more, and with the unbridled enthusiasm of a newcomer he wrote his mentor: "I'm convinced that in Baul a generous excavation would certainly be worthwhile and that here we would come across a layering or jumbled mixture of different cultures."[9] He included a sketch of the area with his letter.

That is how it worked. This is how Termer's career started and continued over time: with German Guatemalans showing Termer around, offering him places to stay, directing him to newly uncovered ruins, connecting him to other German scientists. After that introduction, it was only a matter of extending his range, venturing out of the center through the German Guatemalan networks. Many of his central research questions were geological, and the Geographical Society of Hamburg, as well as the Association of German Science and the Schulbach trading house in Hamburg, supported his trip financially. The Geographical Society expected reports for their journal, but he also had been charged with archaeological and ethnological collecting for the Hamburg museum. In addition, he took photos, made sound recordings, and films—this was modern fieldwork, all building upon and extending what Bastian, Eduard Seler, Karl Sapper, and others had done.

Pursuing Bastian's Vision across Generations

Like Bastian and so many others, Termer began the first of his extended ventures in Guatemala with the volcanoes around Antigua. Climbing them had long been a rite of passage for visiting scientists and many German Guatemalans alike. Termer joined that club, setting off by mule one early morning in December from the Finca San András Osuna, accompanied by the young Richard Sapper (his mentor's nephew) and two helpers or "mozos" from the finca, Narciso and Luis. It was, he wrote later, a "caravan of seven animals, four mounts and three pack animals." Luis was only fifteen years old; it was his first time off the plantation. He whistled lightly as they rode. Their initial goal was to ride through the fields of sugar cane

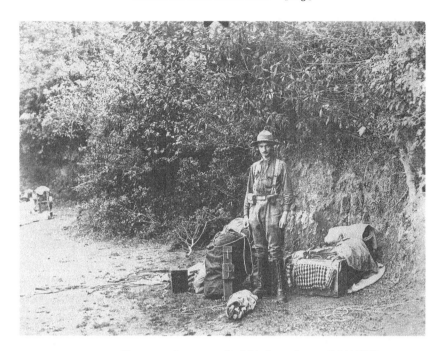

FIGURE 4.4. Termer on the way to climb his first volcano. © MARKK,
Museum am Rothenbaum Kulturen und Künste der Welte, Hamburg.

and the corn that fed residents and workers alike toward another finca,
San Sebastián, near the base of the 3,960-meter-high volcano Acatenago.
There the owner put them up for the night, and the next day he supplied
them with four porters who guided Termer and Sapper up the volcano.
They also took the excited Luis.

After two hours of riding, they pushed on by foot. The Germans car-
ried backpacks, the porters carried their instruments and supplies. They
worked their way through the oaks draping the mountainsides until they
approached the treeline near 3,100 meters. They made camp just above
the trees, where Termer took measurements from the air. They were shiv-
ering and probably dehydrated. Sapper's head pounded from the change
in altitude, and Termer soon realized he had forgotten his blankets. That
can happen. As a result he spent the night wrapped in a hammock and
shaking, near the dying coals of their fire.

Termer woke early from the cold to drink coffee in a thick fog. At day-
break they pressed up to the beginnings of the cinder cone at 3,500 meters.
When the clouds parted for a moment, they glimpsed Antigua in the
sunlit valley below. Yet, as they reached the saddle between the volcano's
two peaks, the winds made it difficult to stand, almost impossible to take

measurements. The temperature was a harsh three degrees. In the distance they caught a brief view of the Atitlán volcano, their next goal. Its peak glowed fiery pink from the sunrise. On Acatenago, however, the clouds, fog, and mists made it impossible to take the photographs or make the measurements he had planned. They had chosen the wrong volcano that day.

After waiting two hours for a shift in the weather, they retreated. They broke their camp below and made their way to their animals at the foot of the volcano. It took another four hours to ride to the village of Acatenago, where Termer's governmental letters won them a place on a shop floor. Luis scavenged bottles of beer for them; the others were amazed and grateful. During the night, the village erupted in a fiesta, unanticipated by Termer. The drunken festivities persisted until the morning. He was the only one of his group who managed to sleep, so heavy was his exhaustion.

In each location between Acatenago and Atitlán, Termer recorded how people dressed, what clothing they wore, their language, and the things each village produced, much as Bastian had done in the 1870s. When they crested the shoulder of Atitlán after several days of riding, Termer caught his first glimpse of the lake some one thousand meters below. It was, he wrote later, "a view that I count among the most beautiful I have ever seen." In Panajachel, on the edge of the lake, they recovered in a hotel run by a German who also managed the motorboat business on the beach. Termer loved it. He called it "one of the most beautiful places in the world."[10]

From there they took a side excursion to Chichicastenango, an important market town for the entire region, where thousands of people were gathered for the Santo Tomás Festival from December 18 to 21. They stayed with a German pastor and encountered a teacher from the German school in Guatemala City, Franz Joseph Lentz. In his spare time, Lentz too climbed volcanoes, made geological observations, engaged in ethnological and linguistic studies, participated in archaeological digs, and shared his finding with German scientists. Termer termed him "a great person," and they spent many months together in Guatemala City before Lentz's term at the school expired and he returned to Remscheid in the summer of 1926.[11] Unsurprisingly, Lentz's 487-page book, *From the Highlands of the Maya* (1930), is dedicated to Karl Sapper, who had recommended Lentz for his job.

In Chichicastenango, Termer first saw witchcraft performed with candles, incense, and alcohol in its cathedral, much as Bastian had some fifty years earlier. Termer too was fascinated by the performances, by the meshing of religions and worldviews captured in this moment. He continued to pursue those ceremonies, combinations of witchcraft and Christianity, over the years.

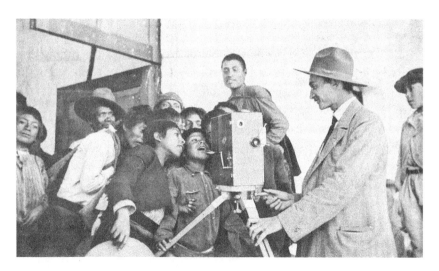

FIGURE 4.5. Termer with children and his camera in Chichicastenango. © MARKK, Museum am Rothenbaum Kulturen und Künste der Welte, Hamburg.

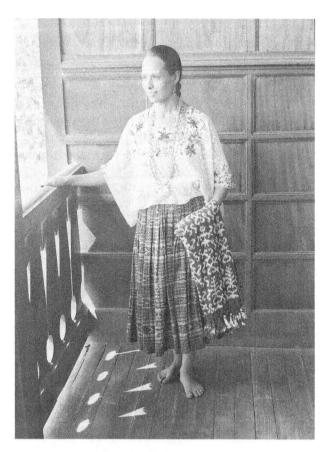

FIGURE 4.6. Searching for folk costumes in Guatemala.
© MARKK, Museum am Rothenbaum Kulturen und
Künste der Welte, Hamburg.

He was also stunned by the varieties of dress worn by the people who arrived from outside the city. He learned quickly that in Guatemala, the patterns, colors, and construction of folk dress vary from one village to the next. He observed the symbols woven into the fabrics that carry meanings. Some, he knew from his readings, were spiritual. All of them show the wearer's connections to particular communities and places. He confirmed as well that many of the garments are stunningly beautiful, and it was no wonder that collectors and tourists had long pursued them purely for their aesthetics. Termer, however, immediately understood their scientific value: like all material culture, they carried traces of the producers' and wearers' histories. Yet, because of the markings connected to Mayan spirituality, those were much deeper histories than he had anticipated. Consequently, he chose them as his primary illustrations in his initial publications, and he continued to collect them during every subsequent trip to Guatemala. This was the moment of origin for Hamburg's extensive collections of Guatemalan textiles.

Yet it was only the beginning. Systematic collection does not come easily. Termer was immediately frustrated, for example, that he could not engage in a systematic study of either the dress or performances he witnessed during the festival. No one wanted to be interrogated about their religiosity or textile production during the celebrations—they were too busy with the parties. "That," he wrote Karl Sapper glumly, "makes ethnological work rather difficult." But he had other successes. He managed, for instance, to acquire a fine Tecomate gourd marimba in the market, which he had shipped back to Guatemala City and later to Hamburg. Termer also made films of events during the festivals, a modern ethnological feat, achieved with a camera that cost him a great deal of effort to transport and even more to repair months later after it plunged from a rope bridge into a river.

After leaving Chichicastenango, Termer continued north with Richard Sapper, where they again met Lentz in Quetzaltenago. Termer's second major excursion followed from there. It too was made possible by Sapper family connections. This trip took him far above the Mexican border, and it involved a combination of people tied to the Sapper family's interests in Quetzaltenago as well as the Finca San Antonio in Chiapas, Mexico. And, like everything else, it built on the work done by his predecessors, in this case the extensive explorations of Eduard Seler.

He had a fantastic plan: "we will go," Termer wrote excitedly to his mentor in Würzburg, "from Comitan along Seler's path north to Bajecue or Vugel, and then turn eastward into the mountains. Our goal," he explained," is the Rio Usumacinta, which I want to reach by Agua Azul,

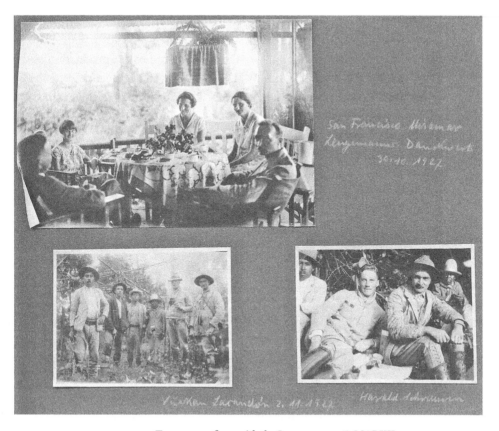

San Francisco. Hiemann
Lengemanns. Danckwerts
30.10.1927.

Linken Lacandon 2, 11.1927. Harald Schramm

FIGURE 4.7. Termer on a finca with the Lengemanns. © MARKK,
Museum am Rothenbaum Kulturen und Künste der Welte, Hamburg.

where you were during your time here." After that, they expected to visit
the ruins of Yaxchilan, and see "if the Laguna de Chicosapote, which on
your map is near the Usumacinta, actually exists."

Again, that is how Termer did it, how he built on older German con-
nections and records and extended them into the future. He moved from
one German location to another. He teamed up with other Germans.
Then, together, they followed "Seler's path" on a quest to challenge Karl
Sapper's map. This is also how Termer became a leader in his field. With
the help of many others who were tied into the German connections that
had been taking shape in Guatemala since before he was born, Termer
mastered landscapes and languages, found archaeological sites, negotiated
blank spaces on maps. During these first trips, he began to generate col-
lections for Hamburg's museum that would continue over a series of seven
major excursions across three and a half years.

German Guatemalans remained essential for all of Termer's endeavors. His trip across the border, for example, hinged on the twenty-two-year-old nephew of a German in the midst of Quetzaltenago's coffee production. In Gustavo Kanter, Termer wrote, "I have found the man I need." Kanter "knows the area from Comitan to Palenque, is personally acquainted with the *finqueros* [plantation owners] in Yaxha, Bajecue, Vergel, and further on to Ocosingo and Tecojá," and he had even "hunted in the desert." Moreover, "it's especially valuable to me that he speaks Maya, Mam, and some Tojolabal." That, he remarked, would make him "particularly useful." Perhaps most important, "he is a nice and modest person, mixed-race, with a strong German character [*germanischem Einschlag*] as well as a strong young man." Kanter, Termer reported, was also "very excited" to take part in the trip. For his part, Termer was extremely pleased: "I like Kanter better than anyone," he wrote to Sapper, "because I can rely on him."[12]

The knowledge pool, however, ran even deeper. Unlike Bastian, Termer was coached from abroad as well as assisting on site during his first years in Guatemala—one of the benefits of being part of the later generations. During his entire stay in Guatemala, he remained in constant correspondence with Karl Sapper, allowing him to draw directly on his predecessor's knowledge. It traveled easily across the generations. The postal system was amazingly effective—there was no email, after all, yet the correspondence is surprisingly thick. Karl Sapper's advice was constant, generous, and often wise: from his letters Termer learned how to walk in the high tropics, how to maintain a good pace without overexertion, how to pick the best guides and porters, and how to choose the best pistols (never too big for a pocket). Termer frequently used a red pencil to underline the place names where Sapper told him to go in search of archaeological and geological sites Sapper had seen but had been unable to properly explore. In addition to practical information and research suggestions, Sapper also supplied him with updates on what other German ethnologists were doing in Central America—where they were traveling, what they were researching, and what they were publishing at home.[13]

After Termer began writing up his research findings, Karl Sapper also encouraged Termer to take advantage of his proximity to the United States to expand his German American connections, and he especially encouraged him to contact Franz Boas in New York City. Boas had become a leader in the field of American anthropology by the mid-1920s, training huge cohorts of students and recasting the profession. Sapper recommended that Termer send Boas his essays, and he encouraged him to apply

to attend the next International Congress of Americanists, which Boas was organizing in New York for 1928. More connections were better.

Sometimes Sapper even gave Termer step-by-step instructions on where to go. When Termer inquired about geological formations, the kinds of stone available in Guatemala, and particularly the places with fossilization, Sapper directed him to an area near Santa Isabel. It was, to be exact, "3,170 steps north of Santa Isabel, 410 steps (single steps!) from the crossing of a small creek, behind which fossils follow." From there he provided Termer with a step-by-step plan of the kinds of fossils he would find within a radius of several thousand steps. He was able to do that because Sapper still had his notebooks from the 1880s and 1890s, in which he pretty much mapped out all of Guatemala according to his steps, and that is how he created the first modern map of Guatemala.[14] Later in life Karl Sapper gave those notebooks to Termer, and today they, as well as all of Termer's notebooks and much more, are in Hamburg's Museum on Rotherbaum.

Generations of Knowledge

At the end of his career, Termer often looked back on those generations of knowledge producers and credited them for his own achievements. In 1963, for example, the same year Termer received the Civil Commander's Cross of the Order of the Quetzal for his service to Guatemala, Termer also received a letter from Ernesto Chinchilla Aguilar, a history professor at the San Carlos University in Guatemala City, president of the Academia de Geografía e Historia de Guatemala, and secretary general of the Seminario de Integración Social Guatemala. He wanted to publish an extended biography of the leading German researchers of Guatemala, and he asked for Termer's biographical details. He explained they already were planning to include Karl Sapper, Eduard Seler, and Otto Stoll, and he hoped Termer would recommend others. Termer immediately scribbled "Bastian" in the margins. When he replied, he also included more of Bastian's generation. They had all contributed to the foundation on which Termer began his research.[15]

Termer had made the same point about his deep scholarly debts in a lecture he gave at the Academia de Geografía e Historia de Guatemala decades earlier, in 1939. As he spoke in Spanish to the Guatemalan audience about the long history of "nuestra Republica" and "nuestra Pais"—quite literally, "our republic" and "our country"—he stressed the long

PETERMANNS GEOGR. MITTEILUNGEN

86. JAHRGANG 1940, TAFEL 34

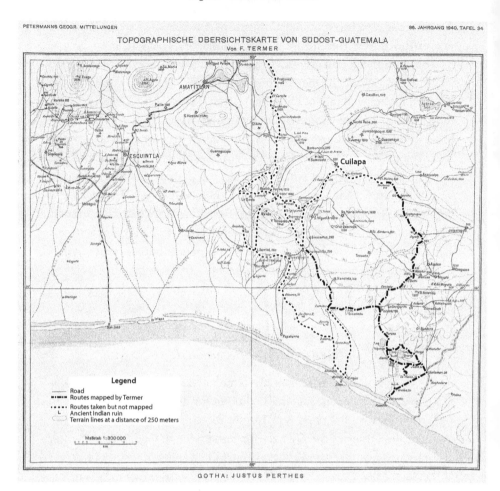

TOPOGRAPHISCHE ÜBERSICHTSKARTE VON SÜDOST-GUATEMALA
Von F. TERMER

GOTHA: JUSTUS PERTHES

FIGURE 4.8. Map of Termer's 1938 travels in southeastern Guatemala,
including routes he mapped out while traversing them. *Petermanns Geographische
Mitteilungen* 86, no. 9 (1940).

heritage of scientific studies from which he had benefited as he sought
to extend the early history of Guatemala beyond the Maya to include the
Pipiles, and then argue that the Xinca speakers he had encountered the
past November near the border of El Salvador might very well be the last
representatives of an indigenous group in the north of Central America.
Those were bold statements based on lifetimes of work that had come
together during his four-day excursion around the Tecuamburro volcano.

That is the point that is so crucial to understand: as Termer settled
onto his mule on that sunny November day in 1938, appreciated the beauty
of the volcanic landscape, and later amused himself while hitching a ride
in the teachers' car, he simultaneously assessed the geological formations

around him and calculated what those had and had not provided earlier inhabitants. He did not simply see old ruins and artifacts pointed out by a guide. He combined his archaeological, ethnological, and geological knowledge acquired over the last decade or more to ascertain how the people who had created them built their settlements and temples into those locations. He noted how they had accommodated the ubiquitous rains and inevitable flooding into their lives. He also quickly saw that the area around the volcano had undergone significant changes since then—it had not always been so wet. The settlement patterns told him that.

Accessible written records began after Spanish colonization, led by Pedro de Alavardo in 1524, but archaeological studies of other ruins in Central America by Eduard Seler and others gave Termer a much deeper historical record for the comparative analyses that took place at the very moment he saw the monuments and ruins. The structures' character, their arrangements, their art—all of it allowed him to discern interconnections with objects he had seen either in scholarly texts or, for example, in Maya collections in Berlin's Museum für Völkerkunde. That comparative knowledge revealed to him the presence of Pipiles, not Maya, at this location, and he later determined their settlements extended even further south. At the same time, his ability to understand the implications of encountering Xinca speakers around Guazacapán was made possible by his familiarity with Lehmann's work in the north. Thanks to Lehmann and other linguists, the essays they had written, and the recordings they had made, Termer not only recognized the language spoken near Guazacapán but also understood that hearing it in that particular place and time meant that Guatemala's history was different than he had thought. It was different than the authors of any of the histories had thought: there was more cultural and linguistic diversity, and greater mobility in pre-Columbian Guatemala than they had imagined. Termer knew his insights were made possible by the work of others; all of his studies, he understood, had been part of a joint project from the outset.[16]

Shattered Networks

Maintaining that joint project was harder in the 1930s than it had been in Bastian's time or even in the 1920s. For example, despite Termer's eagerness to acknowledge the work of his predecessors, he seldom included Erwin Paul Dieseldorff in those public or private discussions. That was a notable absence. Dieseldorff had arrived in Guatemala on the same ship as Karl Sapper in 1888. He too came from a well-established merchant

family with ties to Guatemala, and he also became one of Guatemala's leading coffee capitalists, building a vertically integrated business that rivaled that of Richard Sapper Senior, Karl Sapper's elder brother. During his early years in Alta Verapaz, where the city of Cobán became known as a "little Germany," Dieseldorff not only built up his holdings of fincas but also participated in archaeological explorations with Karl Sapper, who had taken up surveying work in the area to help pay his bills. Like many German plantation owners, Dieseldorff also quickly immersed himself in local Maya cultures. He became fluent in the Kekchí language, and he later integrated himself into the kinship networks of the people working on his plantations.

Unlike the other plantation owners, however, Dieseldorff also became an acknowledged expert in Guatemalan archaeology, botany, ethnology, and languages. He was deeply intertwined in scholarly discussions about Guatemala from the 1890s through the interwar period. He too presented papers at international conferences. He published books on Mayan studies; he wrote essays for scholarly journals; and many American and European scholars sought him out when pursuing their inquiries into Central America. Dieseldorff never attended a university, and he never held a position in a scientific or educational institution; but his collected papers are filled with international scientific correspondence, and one can find his collections in Berlin, Hamburg, and Guatemala City museums. Today, many scholars writing about the history of archaeological and ethnological research in Central America list him together with Sapper, Seler, Termer, and others.

So, why did Termer leave him out? In part it was a result of the family feuds that animated the German Guatemalan family networks. Not everything was peachy. Not everyone got along. Dieseldorff, as many people in Guatemala knew, was an overbearing personality. He could be ruthless in his business dealings, chiding those who failed to follow his wisdom on how to best manage fincas, funds, labor, and the fickle commodities markets. He profited greatly from others' mistakes, and he showed little remorse while absorbing their properties. He and the Sapper family had been at odds for years before Termer arrived.[17]

As Dieseldorff developed his scientific interests, those personality traits followed. He respected established professionals, and he maintained exchanges with Karl Sapper and other scientists, but he grated on the young Termer. Already in 1925, after only a month in the country, Termer wrote his mentor that he had accompanied David Sapper to a lecture by Dieseldorff, "but only endured 30 min. and then quietly disappeared

from the lecture hall."[18] Later, toward the end of that trip in 1928, Termer expressed his dismay that Dieseldorff too would attend his first meeting of the International Congress of Americanists in New York City.[19] He hoped to avoid him. A decade later, little had changed. During the first months of his 1938 trip, Termer also reported to Karl Sapper that Dieseldorff, who had heard about Termer's return to Guatemala, wrote to David Sapper that "I should come stay with him for a month in Coban, where he would like to explain the Mayan calendar to me." He was surprised and uninterested: "Since I no longer have any connection to E. P. D, after his earlier behavior, I will not use this [opportunity]. I also won't be able to visit Coban. It is too far out of my way."[20]

What precisely happened between Dieseldorff and Termer is unclear. Perhaps there was an incident, or a series of offences, or maybe Dieseldorff, who always believed he knew better, simply wore Termer down. Whatever the case, there is no question that Termer found him unbearable. He was also dubious of Dieseldorff's later scholarship. Soon after retuning to Hamburg in 1939, for instance, Termer wrote to Karl Sapper asking, "Did D. also send you his last lecture from Mexico on the Tablet of Palenque? Again, everything is presented without any argument. But I do not react to these works because the sensitive author cannot stand criticism."[21] Even as a museum director, some relationships were not worth cultivating.

Many of Termer's acquaintances in Guatemala knew about the tensions between Dieseldorff and Termer, and those who disliked Dieseldorff for their own reasons were especially eager to keep Termer informed. Just that August, for instance, one had reported to Termer:

> Once again, our friend the Jew E. P. D. was unable to rest on his laurels and has again graced his dear fellow human beings with the results of his wisdom. On Monday, July 31, he gave a lecture to the Geographical Society here, which promptly appeared in [the newspaper] *Imparcial*. I allow myself to forward this article to you, not doubting that you will "learn a lot" from it for yourself. Who is this Ludendorff?[22]

Another wrinkle: according to the Nazis, Dieseldorff was Jewish. That had not been the source of Dieseldorff's tensions with the Sappers, and it never made its way into Karl Sapper's discussions of him. The only time it appears in Termer's extant writings is in another letter to Sapper, just after Dieseldorff's death.

> An unpleasant thing happened recently: the Hamburg-based daughter of E. P. Dieseldorff and her husband had asked me to publish an

obituary on EPD, which I also wanted to do. After all, some of the beautiful Chajca vases and two from Chama are in Hamburg, which I have thought about for the museum. I had recently sent the obituary to *Forschungen u. Fortschritte* [*Research and Progress*], when I received a message from the Berlin Anthropological Society. From it the following came out: our friend EPD was 2nd grade Jewish mixed race. The family [has been] in Hamburg since 1803. The first member of the family was then called Moses Lazarus Dieseldorff. He and his descendants were converted Jews. Before his move from Dusseldorf to Hamburg, this Moses Lazarus Dieseldorff was called Moses Lazarus Levy, and he had himself rechristened as Dieseldorff. Since 1853, the Ds focused on the emigration business, where they earned a lot. If the Ds have been baptized since 1820, they are still tainted with the Jewish stigma today. All I can do now is ask if I still can publish an obituary. Otherwise it could get very uncomfortable for me. All things one never needed to think about before."[23]

Termer's obituary for Dieseldorff in *Forschungen und Fortschritte* was glowing. He praised Dieseldorff's collections and called him the "best authority" on the "Indians of northern Guatemala." There was not even a hint of negativity.[24] Yet, after 1933, there were "things" he had to bear in mind.

In fact, keeping up good relations as a museum director after the Nazis came to power became more difficult in Guatemala as well as in Germany. Long before Termer returned to Guatemala in 1938, the German Guatemalan community had split between detractors and supporters of National Socialism. Already by 1933, a chapter (*Ortsgruppe*) tied to the Foreign Organization of the NSDAP in Berlin emerged in Guatemala City. By the end of the year, the German school there became a flash point, as newly arrived teachers joined the chapter's efforts to politicize the community. Among other things, the new teachers organized a Hitler youth group at the school that excluded the ten percent of the students who were Jewish as well as the many mixed-race children.

That sent shock waves through the community, particularly among those like the Sappers, who had been living in relative harmony with other Guatemalans for decades, and who had taken pains to maintain good relationships with the government. After the German ambassador, Wilhelm von Kuhlmann, who had been tied into this community for a decade, wrote in dismay to the Foreign Office in Berlin that November, arguing that such actions would not only undermine the school but also

the position of the German Guatemalan community in the country, he was transferred to Ireland. As Nazi Party members pursued a campaign of harassment against their opponents, which ultimately led to the resignation of the school board's members in late 1935, and its replacement by one made up of by party members, the Guatemalan government reacted by closing the school—just as Kuhlmann had predicted.

Termer remained informed about these transformations. He felt so invested in the German Guatemalan community that when he heard of the school's closing he visited the Foreign Office in Berlin in an effort to help resolve the crisis. It changed nothing, and only confirmed in his mind that the leadership of the Foreign Organization of the NSDAP had no idea what they were doing, nor did the new ambassador.

While Termer was relieved when he learned the school was reopened again in the spring of 1936, he remained distraught by the ways in which "our party people, together with the envoy, behaved unbelievably awkwardly. . . . What a different sort of people," he wrote to Karl Sapper, as he forwarded the reports from Guatemala "were the v. Kuhlmanns." Elly and Wilhelm von Kuhlmann, with whom Termer stayed in contact for the rest of their lives, had understood Guatemala. Elly later took up a strong anti-Nazi position after her husband's death. The new German officials, however, much like many of the more recent arrivals in Guatemala, did not understand the challenges of maintaining a German community under the auspices of another nation state, particularly not one under the ever-increasing influence of the USA.[25]

When Termer returned to Guatemala in 1938, he therefore moved within two overlapping worlds. On the one hand, he was welcomed again into the networks of Germans he had come to know a decade earlier and remained tightly connected to ever since. But he also moved among Nazi Party members. In fact, it was largely party members and teachers who greeted him at the German Club in Guatemala City when he arrived—the others had stopped going to the club. The party even set him up in one of the city's best hotels during his first weeks in the country. Some of his oldest friends, like Wilhelm Lengemann, who was managing Chocolá by then, were also convinced National Socialists.[26] As for those teachers who gave him a ride around the volcano, like all teachers working abroad by 1938, they were party members too.

Termer acknowledged his appreciation for the party's support when writing to his colleague Hans Plischke at the University of Göttingen about his finds in southern Guatemala, signing his letters, as he signed most of his official correspondence, with a resounding "Heil Hitler!" When he sent

a similar report about his discoveries to Carl Ludwig Nottebohm, however, the head of one of the leading German Guatemalan families, which had also supported his 1938 trip, he left out the bit about the party and signed the letter "your very devoted." The Nottebohms were not supporters of the party in either Germany or Guatemala.[27]

Signatures mattered. Termer learned that the hard way just as he left on his trip. In December he received a letter from the Prussian Academy of Science, inquiring about an angry open letter from Franz Boas in the United States. Boas had received a copy of a circular Termer had written for the members of the Society for Ethnology, "in which the changing of its name to the German Ethnological Society [Deutsche Gesellschaft für Völkerkunde] was announced." Termer explained, "this printed circular contained as a signature 'Heil Hitler' and my name. It was meant only for members within Germany." Boas was accidentally included on the mailing list. Termer explained that Boas was so angered by this circular that he had sent the text back to Termer with a pointed annotation: "He wrote under the text with a typewriter: 'I don't accept any writings signed with 'Heil Hitler.'" Two weeks later, Termer also received Boas's open letter. He assured the German officials that it had not had a wider impact; he felt the matter was settled, and then he added, "Boas is today one of the worst enemies of the Third Reich in North America and attempts at every opportunity to strike against us with the horn of Jewish agitation. But as I have just learned here abroad, there are a lot of North American scientists who disapprove of this practice." He signed it, "In greatest respect, Heil Hitler!"[28] This is not the only place anti-Semitic language appears in Termer's official correspondence.

Termer had great respect for Boas. He had gotten to know him in 1928 while attending his first International Congress of Americanists in New York City; in 1931 he also had penned a celebratory essay in honor of the fifty-year anniversary of Boas's doctoral degree. In that essay he called Boas's major works on culture and race "landmarks in modern ethnological literature." He also argued, "if such extensive research is done today in the United States in the fields of anthropology, ethnology, and linguistics, then this may largely be attributed to Boas and his circle of students."[29] Boas, who had been named a member of the Bavarian, Prussian, and Viennese Academies of Science, deserved, he wrote, "the lasting thanks of the old homeland." In 1943, Termer also argued that same point when Fritz Krause, a Leipzig ethnologist and ardent supporter of National Socialism, tried to ignore Boas's contributions to the science in a publication they

were planning together. Termer defended Boas with the same language he had used in 1931.

Yet, as an enthusiastic German nationalist who was watching the influence of German science and Germans more generally slipping away in Guatemala, Termer was impatient with Boas's politics. Scores of American scientists backed by large research foundations seemed to be descending on Guatemala in the 1930s, whereas he arrived with barely two dimes to rub together, was forced to live on handouts from locals, and was unable to collect much of anything—because he had no funds for collecting on that trip. He was also correct about Boas. If he was not "the worst enemy of the Third Reich in North America," then Boas was certainly one of its strongest detractors. Moreover, Boas embraced that role with all of the conviction he had earlier thrown into his research. He was horrified with Nazi politics and dismayed by the respectability race science had gained under its auspices. While writing to Nazi officials or colleagues who were strong party supporters, Termer, in turn, had no problem using their language to denounce Boas's politics; however, there is no sign of these sentiments in his letters to his wife. Back on the ship mired in Cuxhaven, at the mouth of the Elbe, when no one could predict their fate, Termer had written to Nora with sympathy, not ire, about the plight of the Jewish refugees around him.

War

When Termer returned to Hamburg in 1939, his concerns shifted quickly to maintaining his museum in a time of crisis and then to surviving the war. In January 1940 he spent much of his time trying to stay warm. Coal was in short supply everywhere and the museum was freezing. Mostly, he worried that because of Hamburg's location the warm weather would bring bombing. Across the war he also wondered what would become of his science and the connections that had maintained it. So much was being lost.

Termer was against the war. In a letter to his mentor he called it "a ghastly affair and completely nonsensical. It will end," he lamented, "again as in 1918, with neither winners nor losers, rather Europe will be broken [*kaputt*]." He had also lost his tolerance for the colonialists and imperialists who speculated about great victories and new acquisitions abroad, and he found the eastward movement of Germans ridiculous: "what will the 60,000 Badener und 50,000 Württemberger do in the East?"

At the Hamburg University, the decline he had long been lamenting in his profession simply picked up pace. He had trouble filling his classes; students were looking to medicine and the natural sciences; Völkerkunde was no longer even an examination subject; "politically correct" fields had replaced it—prehistory and race biology. Fewer than five people visited the museum on any given day.

A few months later, none of that mattered anymore. The museum had to close because of the lack of coal, and Termer and his staff began looking for places to hide their collections. 1941 was even colder, and as the bombs began falling on Hamburg he and his staff focused first on moving more than 200,000 objects into central rooms and then turned to packing them for transport.

Termer was not surprised when he heard about the fate of German Guatemalans. The Guatemalan government, acting under pressure from the United States, which presented it with blacklists of Germans and German businesses in Guatemala, began seizing Germans, confiscating their property, and delivering hundreds of those people to the US. Many would spend the war interned in camps in Louisiana or Texas. As Termer wrote to Karl Sapper after an evening of packing collections:

> Unfortunately, I have to say that it is our attitude in Guatemala, that is, the attitude of a section of the German colony that extended far into governmental circles, which prepared the ground for the mindset recognizable today in its effects. Now we are reaping the fruits, ripened by the foreign organization of the party. If today decades of work by the Germans in Guatemala have been destroyed, then we have to thank our completely misguided assessment of our policies toward the US-Americans and Ibero-Americans. No one listened to any of the judicious and experienced people, because they were so old and calcified. Now we have the results.[30]

Some German Guatemalans managed to avoid the roundups. The blacklists were inconsistent, but many had also been preparing for such actions by giving up their German citizenship or placing their properties in the hands of their children, many of whom were of mixed races, and all of whom had Guatemalan citizenship by virtue of being born there. Termer, the ultra German nationalist, could not blame them. As he wrote his mentor in late 1942: "Many in party circles are angered about the behavior of the families Töpke, Keller, and Dieseldorff, who have opted for Guatemala, but which I myself can understand. The children [of] Töpke

and Keller were already Guatemalans in their own right, and for both the vital question was the preservation of old family property. I cannot agree that they now have become bad Germans."[31]

As the war neared its end, and as life in Hamburg became desperate, Termer continued to fear the approaching devastation while keeping up with events in both Central America and Europe. Termer wrote in January 1945, in one of his last letters to Karl Sapper, who died soon afterward, "I heard from the Nottebohms that almost all the fincas had been taken from them as well. Carl Ludwig Nottebohm died of grief and anguish last week. He could not overcome the loss of his house with the beautiful collections. . . . My museum is still standing. How long???"[32] Despite the extensive firebombing, the building somehow survived more or less intact. Large parts of the collection, however, hidden in the small mining town of Lautenthal in the Harz Mountains, burned that April.

Persisting Connections

Termer was unable to return to his research in Guatemala for decades. In part, that was due to the war and its aftermath in Europe. Yet it was also due to the Guatemalan revolution (1944–54), which brought a communist regime to power until a CIA orchestrated coup ended it a decade later. Guatemala was also one of the last states to establish relationships with West Germany after the war. The question of the seized German properties, valued at many millions of dollars, made those negotiations difficult, and they dragged out until 1960. In the meantime, Termer survived the immediate postwar years and rebuilt his museum, all made possible by his persisting connections, which had extended beyond Guatemala and long before the war. Astoundingly, despite the radical transformations that had taken place in the world during the war years, those connections quickly reemerged.

Termer's first chance to return to Central America came in 1949, through an invitation to the International Congress of Americanists in New York City from A. V. Kidder, head of the Archaeology Division at the Carnegie Institution in Washington, DC. Termer had met many Carnegie researchers in Guatemala City in the 1930s, and Kidder's invitation arrived like a breath of fresh air, a signal that he might still have a place in the international world of science.

But if money for international travel had been scarce in 1938, things were much worse in 1949. That April, Termer began a letter to Kidder by

thanking him for the food and the clothing his wife had sent to Termer's family. Nora added her own heartfelt, handwritten thanks on the last page. Termer reported that while the Marshall Plan had helped them a great deal, and their conditions were improving, fats remained in short supply and they still only received one hundred grams of meat per person each week. He also wrote that while he was eager to attend the meeting, he was unsure if he could make a trip to New York. He also was unsure if the American government would let him enter the country, or if Central American states would either. Hamburg also had no money to pay for his travel. It looked grim.

In the end, old connections that survived the war made it possible. He received a grant from the Carnegie Institution's Viking fund. The US allowed him a visa for two weeks; and German Mexicans in Mexico City paid for him to pursue several months of research in their country. This allowed him to return to sites he had not seen in decades, and it took him to the Yucatán for the first time. The German Mexicans also made him part of a celebration in honor of Eduard Seler's one hundredth birthday and asked him to contribute an essay to their Seler commemorative volume. No one had been more important to Mexican archaeology and anthropology than Seler, and many Mexicans regarded Termer as his successor. They still saw value in the generations of German science.

Excitedly, Termer contacted old friends in Guatemala. Initially, the news was good—his connections had survived. He learned that the Germans there would happily help him as before. Fritz Keller, in fact, wrote to Termer, "of course it would be a pleasure for me as well as for my wife" to have him back in their house. "The room on the upper floor of our house, which you stayed in before, as well as the others are at your disposal." Federico Lima was also still there, happy to travel with him again, but rather than mules, Keller could offer him "the almighty Jeep . . . which is much more practical."[33] Here again, as in the 1930s, Termer would have been able to count on a trip free of most expenses. When geopolitics made that impossible, he wrote sadly to David Sapper: "It is bitter, but I have to face the facts. The worst is that I will not be able to see you and other old friends again."[34]

Termer's first impression of New York was the "pulsation of life." It was astounding, and he felt it the moment he got off the plane. The most lasting impression, however, was one of waste: he was stunned by the contrast between wealth and poverty, surprised by the city's well-armed police, disturbed by the filth. "But one thing remains predominant: that

of abundance. In general, food is wasted in ways unimaginable to us. In the restaurants, even the simple ones, there are huge portions, only half of which are eaten. The other half is thrown away. Cigarettes too are smoked only halfway, the rest is tossed aside." Everyone left the lights on; commodities were incredibly cheap. He spent much of his time eyeing clothing and reporting to his colleagues the prices in marks.

To save money and to see more of the United States, Termer chose to take a bus to Mexico. What a different world. He went to museums in Philadelphia; he was treated to hot dogs at backyard barbecues; and he experienced unimaginable conveniences:

> In modern America I was introduced to a so-called "supermarket," a huge market hall, beaming with cleanliness, where you take everything for yourself, whatever your wish, and you drive around with a small wire cart in which you put your stuff, and at the entrance everything is packed and paid for within a few minutes. Fabulous. Yes, and then I saw there in the house of my friends, a "dishwasher," an electric *Geschirrwaescher*, which also quickly dries the plates, etc., so that after 10 minutes everything is ready to go back in the kitchen cabinets.[35]

Mexico was more familiar. Termer crossed the border with the first visa granted to a German after the war. Once there, groups of German Mexicans greeted him excitedly at stops along the way to the capital. He was welcomed into their communities, given tours of their homes and businesses, and once in the capital, members of the Alexander von Humboldt Association celebrated him, and he was quickly drawn into Mexican research projects. Although he had not been in Mexico for twenty-six years, he stayed his first nights in the same hotel he had used during his last trip, and he almost immediately encountered a friend, now seventy-two years old, who had climbed volcanoes with him in Guatemala.

One of his chief goals was to visit the ruins scattered around the tourist city of Oaxaca, which he managed toward the end of his trip. With his camera and notebooks, he recorded the mix of old and new churches, the villages and markets, as well as the collections of ruins. Near the village of Mitla, he found only the "small remnants" of the "frescoes Seler once copied in the 4th complex." Left "unprotected" in the weather, those images had been all but washed from the stones. "What a service Seler had done," he wrote to his colleagues in Hamburg, when he "saved so much back in the nineties!" Termer saw much more to save wherever he went.

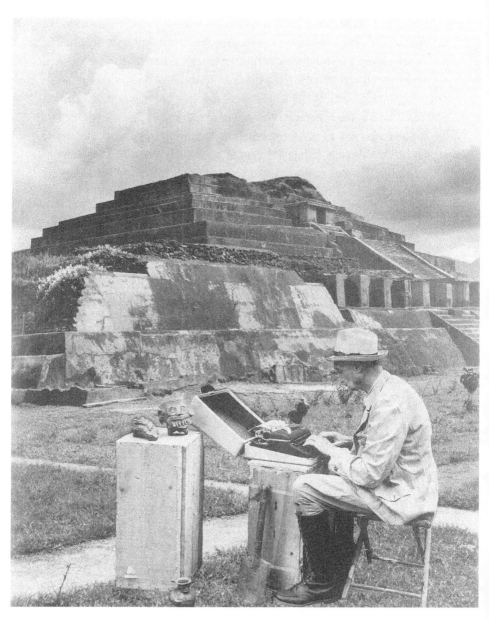

FIGURE 4.9. Termer at his typewriter among ruins. © MARKK, Museum am
Rothenbaum Kulturen und Künste der Welte, Hamburg.

Saved by Others

The Guatemalan textile collections that came together in the Hamburgisches Museum für Völkerkunde took shape because of the complex histories of German Guatemalan connections and despite the damage visited upon those connections by National Socialism and World War II. The vision promulgated by Bastian a century earlier, and spread among experts and laymen alike, survived. That broad interest is central to this story: although Termer recognized the value of Guatemalan textiles early on, and while he sought to acquire as many as possible, he did not create these collections. No one, in fact, orchestrated the process. Rather, these collections were the product of the joint project that had shaped Termer's career and which he had helped to transfer across generations. Like so many objects in German ethnological museums, other people saved these collections, not the ethnologists themselves.

Termer began creating a small collection of Guatemalan textiles during his first trip in the 1920s. With his limited collecting budget, they were one of the few things he could afford. Recognizing even then how quickly folk costumes were disappearing from everyday life, he made an effort to acquire more during his visits in the 1930s and the 1960s. Most of Hamburg's holdings, however, arrived in its Museum für Völkerkunde as part of collections created by German Guatemalans Termer came to know over those decades. Their influx into the museum began just as he was poised to retire in 1962.

In 1961, he acquired a collection of more than 360 pieces from Jorge (Georg) Mann in Guatemala City. Inspired by a slideshow on Mayan ruins as a boy, Mann had moved to Guatemala in 1921. Like Elmenhorst, he was drawn into the world of coffee capitalism and life on German Guatemalan plantations. He and his wife, Milly, began their collection with a gift of a yellow wedding blouse from their cook at Finca Trece Aguas, and continued to build up their collection over decades. The quality, Mann explained to Termer, stemmed from the fact that they, like so many of the German coffee capitalists, spoke "one of the Indian languages, and with the help of this knowledge they were able to gain the trust of the Indians and collect the best pieces."[36]

That knowledge of local customs and languages served them well for decades, and it allowed them to quietly continue their collecting across the turbulence of the war years. When the Manns moved from working on fincas to running a hotel in Antigua, they also engaged in avid textile trading and sales to tourists. That gave them access to textiles from all over the

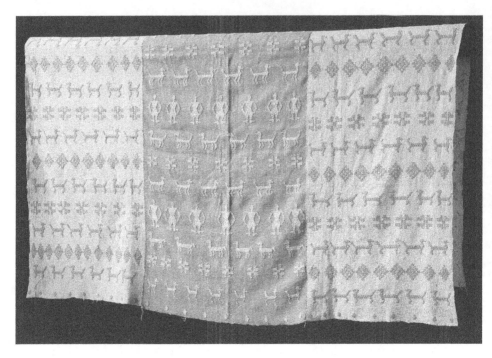

FIGURE 4.10. The first piece in the Mann collection, a wedding huipil from 1850 that they
received from their cook. It is perhaps the oldest such object of its kind.
© MARKK, Museum am Rothenbaum Kulturen und Künste der Welte, Hamburg.

country. As those flowed through their hands, they kept the best pieces for
themselves, building their collection. They continued collecting until Georg
Mann was seized during World War II, along with hundreds of others, and
sent to an internment camp in Texas. From there he was sent to Hamburg
as part of a prisoner exchange, and after the war he and the family, which
had also traveled to Germany just in time to flee the Russian armies as they
approached Bautzen, and ended up first in Colombia then returned to Gua-
temala and life on the fincas.[37] Almost seamlessly, they also resumed their
collecting. While a number of American museums had heard about this col-
lection and tried to acquire it, they had always been oriented toward other
Germans, in particular Termer and the Hamburg museum. They were part
of his connections. In fact, as the Manns knew very well, it was largely the
other Germans, influenced by Termer and his students, who had set the
standards in textile collection. Americans lagged far behind. As a result,
when his wife passed away, and he felt it was time to ensure the longevity of
their collection, Georg Mann sought out Termer in Hamburg.

Termer was delighted by the opportunity. In order to better assess
the Mann collection, Termer wrote to his old friend Elly von Kuhlmann.

She too had been an avid collector, a part of Termer's circles, while her husband was the ambassador to Central America during the 1920s and 1930s. By 1962, she was an energetic seventy-year-old and proud of her collection, which she had arranged according to governmental districts and tribes. Termer corresponded with her for decades about Guatemala and her collections, and already in 1951 she had donated a part of them to Termer's museum. Her collections were indeed exceptional, and her skills allowed her to pick apart the list of items in the Mann collections with an exacting eye. She also mused about traveling to Hamburg in May 1962 to see the temporary exhibit Termer created after they acquired the Mann collection. She promised to help him make better sense of how to build on it. "It would be," she told Termer, "a game with old memories."[38]

From Termer's point of view, however, this was no "game." When he first arrived in Guatemala, he saw people in folk costumes wherever he went. By the time he took his last trip there, those days had long since passed. Men's clothing, in particular, had changed radically, to store-bought pants, shirts, and shoes. As his career came to an end, he was trying to fashion as complete a collection as possible; trying to save what could still be saved. His museum had lost some of its textiles during the war, but they had also managed to "save" some more recently from the area around Sololá.

The Mann collection was thus a fantastic addition to the museum's broader efforts. Many of the items in the Mann collection, in fact, were "unique"—they have no counterparts in other collections. As a result, they alone document a period of Central American textile art from the middle of the twentieth century that otherwise is simply gone. That means that they alone also document a period of human cultural history that was otherwise lost, left unrecorded. Termer understood that, and therefore he was delighted to get these articles. He also hoped to build further on the Mann collection. A year later, in 1963, just before her death, Kuhlmann helped him with another donation.

The Hamburg textile collection grew most dramatically and gained much of its current importance, however, decades after Termer's death, with the Elmenhorst acquisition in 1990 and another collection of 314 textiles from Matilda Dieseldorff de Quirn, which arrived the same year. The second is a unique collection of mostly women's blouses from the Department of Alta Verapaz. Matilda Dieseldorff de Quirn was the daughter of E. P. Dieseldorff, with whom Termer had had such tense relations. She too was an autodidact. She was never trained in ethnology, but she had followed her father's interests and collected locally for much of her life in the area around her hometown of Cobán.

Initially, she hoped to preserve her collection in a local museum, but one was never created. So she turned to Germany, and as she decided on the proper home for her collections, she followed the networks of connections that Termer and others had developed over the course of the century. Because Dieseldorff de Quirn was a well-known figure in the German Guatemalan community, she naturally knew Elmenhorst and the Manns. She also had known the Sappers and Termer most of her life. When she heard of Elmenhorst's donation of his large collection to Hamburg, she followed suit. Like Elmenhorst and Mann before her, she contacted the Hamburg museum about selling them her collection. To her mind, it was the logical place for her collection to go. It was the best possible place, the one where her collection would gain importance as part of a larger one; the place where her precious textiles would gain the greatest appreciation and care. Many years after Termer's death, and despite the traumas of the twentieth century, there were still "connections."

The Yup'ik Flying Swan Mask

THE PAST IN THE FUTURE

THE YUP'IK FLYING swan mask returned to Berlin in the early 1990s after a half-century-long postwar odyssey. Fringed with caribou fur and set upon a piece of baleen that made it tremble when touched, the shaman's dance mask was fashioned to help bring birds and their nutritious eggs back to Alaska's Yukon coast in the spring. Ever since the Norwegian collector Jacobsen acquired it for Adolf Bastian along Alaska's Kuskokwim River in the 1880s, the mask held a distinguished place in Berlin's Museum für Völkerkunde. For almost two decades, it hung top and center within a prominent glass cabinet in the Eskimo exhibit among the museum's celebrated new Schausammlung, which opened in 1926. As bombs threatened to fall on Berlin in the early 1940s, however, the museum's ethnologists packed it and almost everything else into boxes. Then they squirreled them away in hiding places from which some never returned.

Already in 1934, five years before the war, Berlin's central museum administrators were anticipating a conflict. They instructed the directors of the Berlin museums to divide their holdings into three categories: the "irreplaceable objects"; those "of high value"; and everything else. If war came, they planned to spirit away items in the first category and hide the items in the second. Yet nothing was so simple once the war actually consumed the city. Despite all efforts and precautions, the collections were devastated, many scattered across vast distances. Afterward, the museum fell into a postwar limbo for decades.

Although ethnologists had begun packing up some of the Museum für Völkerkunde's collections years earlier, the exhibits remained open to the public until 1941. Once they closed, the ethnologists recognized that many

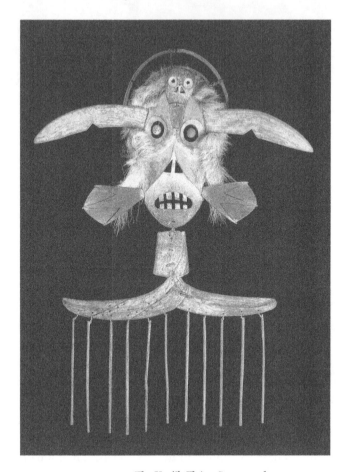

FIGURE 5.1. The Yup'ik Flying Swan mask.
Technische Hochschule Nürnberg Georg Simon Ohm.

larger items, such as Bastian's world-renowned Santa Lucía sculptures, were far too heavy for transport into bunkers, so they were moved into the museum's basement and walled in. Despite the extensive war damage inflicted on the building, they survived unscathed. On the ground floor above them, a colossal wooden Amitābha Buddha statue from Japan, Chinese wooden figures of the Eighteen Lohan, as well as some of the many Turpan frescoes could not be moved in time, and perished during the explosions and fires.

Even worse, some 33,000 objects from the African collections, mostly items from West Africa, were also lost in "safer" locations. Those losses ultimately reduced the museum's African collections by half. The reports on the East Asian collections were grimmer: only 40 percent survived.[1] The putatively safe locations included bunkers at the Berlin Zoo and in the

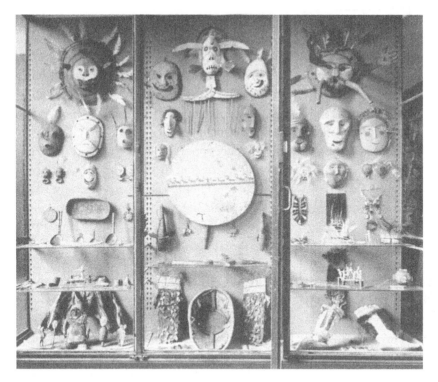

FIGURE5.2. The Yup'ik Flying Swan mask in the 1926 cabinet.
Staatliche Museen zu Berlin, Ethnologisches Museum.

Volkspark Friedrichshain neighborhood, the deep safe in the Royal Mint, mines in the Harz Mountains, and Schräbsdorf Castle in Silesia. The fates of the objects in those and other sites varied greatly.

When the Museum für Völkerkunde's ethnologists resurfaced after the Nazi capitulation, they found the bunkers burned and emptied. Over time, it became clear that Soviet trophy brigades had seized some 75,000 or more archaeological and ethnographic objects from the bunkers, the Royal Mint, and the mines and the castle in Silesia. In Berlin, the trophy brigades had moved quickly between May and June, rounding up museum collections of all kinds before other Allied forces arrived in the city that July. The Soviets sent millions of cultural objects from Germany through Poland to Leningrad—the transports continued well into 1946. The Yup'ik Flying Swan mask was among them. So too were the famous crest poles that had been prominent in the museum's vestibule since 1886, and much of the Jacobsen collections.

Many artifacts, however, never made it out of the city. Fires broke out twice in the Friedrichshain bunker in May 1945 long after the cessation of

hostilities. The second fire destroyed thousands of objects that had survived the bombings and the first fire. For years afterward, Berlin's ethnologists and museum officials were unsure what had been destroyed, lost, or seized. They knew the Soviets had captured a great deal, but no one had a detailed list of what precisely had been destroyed or taken. None of them knew if the Yup'ik Flying Swan mask had been burned, lost, or seized. They could only determine what remained.

There was some good news: collections hidden in the Harz Mountains had survived. British forces had discovered them and transported them to nearby Celle Castle, the largest castle in the southern Lüneburg Heath region of Lower Saxony, which the British transformed into a fine-arts depository. Ethnological objects filled more than 2,500 of the crates in the castle, stacked floor-to-ceiling in room after room after room. Similarly, American forces had stockpiled art and cultural artifacts in Wiesbaden. Ninety-two of the more than 1,600 crates in their possession also came from Berlin's Museum für Völkerkunde.

Here too, Berlin's ethnologists did not initially know what, precisely, was in all those crates in the Western zones. There was no way to know what had been destroyed, lost, or seized. Nor did they know if they could expect their return. After all, the collections could simply be claimed as spoils of war. Moreover, because Prussia was dissolved at the end of the war, many among the Allies, as well as many officials in the other *Bundesländer* (German states), argued that even if the Allied powers chose not to return home with this war booty, treasures once belonging to Prussian cultural patrimony should be distributed to cultural institutions across the new Germany—once it took shape.

Amazingly, amid this postwar devastation, Germany's surviving ethnologists quickly returned to their science and began trying to reconstitute their museums. In Berlin's craters, ethnologists again set out to "save what could still be saved." Despite the skeletal landscape of bombed-out buildings that greeted the Occupation forces, they soon learned that many ground floors and basements remained intact, and more infrastructure survived than anyone thought possible. That was small solace for the survivors, who spent their nights in eerie blackouts, accustomed to the scent of death in the ruins of the urban landscape.

The mind reels at the notion of Berlin's ethnologists in those early months digging out collections from the basements of their museum and their storage facilities like archaeologists on site. Hungry and harried, they worked diligently in gray shadows and grim conditions, lamenting the losses, marveling at the things that survived, and pondering the durability

of structures that once housed their collections. Could Bastian's museum be salvaged? They debated it. How many of the weight-bearing walls were still sound? To know for sure, they would have to wait for the engineers. How much could they do with the few intact rooms on the ground floor? Some, at least, could sleep in them while figuring it out.

As they surveyed the devastation in the city center, the old idea of moving all the collections to Dahlem began to make sense. When water started flooding the basement of Bastian's old museum building in 1948, they knew it was time to move. Parts of the museum complex Wilhelm von Bode had envisioned before World War I, the part that actually had been completed in Dahlem before funding ran out, had weathered the conflict well. The windows were blown out, but the roof was only slightly damaged—and weathertight roofs were at a premium in postwar Berlin. Moreover, the Museum für Völkerkunde had a claim to this one, because its ethnologists had used it as a storage and research facility during the interwar period.

Consequently, they abandoned the ground floor of Bastian's building to the Museum für Vor- und Frühgeschichte and transported their salvaged collections across war-torn Berlin. Once reestablished in Dahlem, the ethnologists began unpacking and sorting, lamenting and repairing, all while wrangling with other museum directors and the newly created Free University over the use of the space. Many coveted their building. The Museum für Völkerkunde could not retain the entire thing, not in that devastated city. The directors and staffs of Berlin's art museums also needed dry spaces under a functional roof; they soon arrived and claimed the building's east side.

To solidify their hold on the west side of the building, Berlin's ethnologists began using salvaged objects to create temporary exhibits, and by December 1949 Bastian's Guatemalan sculptures from Santa Lucia, transferred from the old museum building's inner-city basement, were again on display in the entryway of the new Dahlem location. A fraction of the salvaged collections, set up in twelve of the building's rooms, became the basis of the new exhibits as well as the new heart of the museum.[2]

Meanwhile, the British military government brought an assortment of German museum people to the Celle Castle in Lower Saxony. They began unpacking some of the art collections and creating exhibits titled "Exhibition of Old Masters in German Possession," which became popular with local visitors. Some of Berlin's ethnologists participated in creating exhibits as well. Having traveled to Celle to take stock of the ethnological collections and combat the plague of destructive moths in their boxes, the

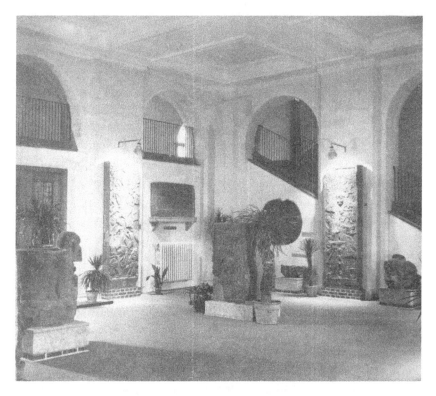

FIGURE 5.3. The Dahlem entryway. © bpk-Bildagentur / Ethnologisches Museum der Staatlichen Museen zu Berlin / Art Resource, NY.

Berliners strengthened their claim on their old collections by caring for them and by using them for a series of temporary ethnological displays in the castle that also happened to delight visitors.

In fact, Berlin's ethnologists continued creating special exhibits in Celle for the local public from 1951 to 1957, and thus, for more than a decade, neither they nor their colleagues in Berlin knew if these were temporary or permanent conditions. The fate of the collections, much like Germany's fate, was still up in the air. It took five years of negotiations before the Allied powers decided they would return the ethnological collections in Celle and Wiesbaden to Berlin. By that time the escalating Cold War had complicated the use of the roads and rails to the city.

As a result, once the decision was reached to return the collections to Berlin, some two thousand crates filled with ethnographic artifacts had to be flown across the air bridge into Berlin. It took another two years (1956–58) to get them all there. Those transports kept a lot of people busy. Imagine: every few days, a couple more crates arrived at the Tempelhof

airport; every few days trucks delivered more to Dahlem. Every day there was more for Berlin's ethnologists to unpack, to inventory, and to store in Dahlem: every day, for years.

Once unloaded, moreover, it was unclear what Berlin's ethnologists should do with them, because they never had enough space for the returning collections. They could not fit them all into the west side of the Dahlem building, and very little of what did fit in that building could be put on display. So, the museum's ethnologists, and particularly the series of directors who came and went between 1945 and 1965, spent a great deal of their time scrounging for storage space in and around Dahlem and writing proposals for relocating all or some of their collections.

Desperate, they even posited new ways in which they might put the old Bastian building on what was now renamed Stresemann Street to use again. Maybe, they thought, the only solution was again to divide the collections. Maybe, they argued, the city could be convinced to allocate funding to reconstruct the ruin. Yet all that arguing, consulting, proposing, and thinking was fruitless. The city government always had greater priorities and it consistently rejected their proposals; none of their plans came to fruition. Then, in 1960, city officials demolished the old building to make way for one of its greater priorities: a highway that was never built. Today, the only remnant of Bastian's museum building that once stood next to the Gropius building in downtown Berlin is a small, lonely sign at the edge of the parking lot that replaced it.

It was not until the creation of the Prussian Cultural Heritage Foundation in 1957, founded by the federal government to obtain and preserve Prussian cultural heritage, that conditions improved. With funding by the West German government, the foundation provided the necessary monies for the expansion of the museum complex in Dahlem and, with it came the chance that the Museum für Völkerkunde's ethnologists would finally be able to organize its collections in a single location and set up a full-standing exhibit.

Yet gaining that external support from the national government had been a long and dismal process involving years of haggling between the national government in Bonn, the city of Berlin, and the federal states about the implications of transforming Prussian cultural heritage into West German property. Part of the problem was that according to West German law, the national government was not meant to play a large role in cultural affairs. Those were supposed to be left in the hands of the different states. West Berlin, however, could hardly afford to rebuild its cultural institutions alone—especially not with Museum Island and all its buildings in Communist-controlled East Berlin. Moreover, the leadership

in some of the other states, particularly in Bavaria, had little interest in helping it. And that was the bigger problem.

So, once again, city politics, national politics, and political infighting channeled and shaped the fate of the Museum für Völkerkunde's collections and delimited what its ethnologists could do. Only the dramatic escalation of the Cold War brought the fraught negotiations to a conclusion: Berlin's ethnologists in Dahlem joined the celebration for the Prussian Cultural Heritage Foundation support of cultural institutions in West Berlin, just six months after the Berlin wall began rising up in 1961 in the city—boxing them in.

Even then, the completion of the museum complex in Dahlem took time. It did not drag out as long as the completion of Bastian's museum in the 1880s, but for many it seemed like a snail's pace. It took eight years after the national government allocated the funding for the foundation to complete the complex, and the museum's ethnologists needed another three years to move the collections into the new space. Only in 1970 could they begin systematically ordering the collections in the new buildings—a task that no one had done with the African collections, for example, since 1905. That had been generations ago. By that time, in fact, no one was left in Berlin who could even remember those displays; no one could remember what Bastian's museum had been like in its heyday.

What is more, as the Dahlem complex was built, the Museum für Völkerkunde's ethnologists again were forced to fight tooth and nail with the directors of the art museums to gain and retain space within the complex. In her 1973 history of the museum, published in a commemorative centennial volume, ethnologist Sigrid Westphal-Heilbusch, who was part of these decades of postwar interactions, looked back on them with melancholy. Summing up her experiences, she characterized the period as "a very long period of stagnation in the development of the Museum für Völkerkunde."[3] That was quite an understatement, and it was not even half the story.

The Leningrad Collections

Across the stagnant decades of the 1950s and 1960s, and well into the 1980s, shifting generations of ethnologists in Berlin's Museum für Völkerkunde continued to work with the collections salvaged from the rubble and retrieved from the Western Allies. Over time, some set off on small collecting ventures and research trips, expanding the collections with new acquisitions. As more time went by, and as the museum complex

in Dahlem took shape, fewer and fewer of Berlin's ethnologists thought about the tens of thousands of things that might be in the Soviet Union. Occasionally, rumors circulated about objects from the prewar Berlin ethnographic collections showing up in Soviet exhibits. Already in the 1950s, some objects from the Berlin collections also appeared on the international art markets. Others continued to appear over the years. Yet no one in West Berlin ever knew what exactly the Soviets had.

Soviet scholars were also unsure. While thirty-eight packing boxes filled with books and documents arrived in Leningrad with the ethnographic collections immediately after the war, they had had nothing to do with those objects. The documents they needed, which contained all the extant details about the collections that arrived in Leningrad in the late 1940s, had been hidden in different locations than the objects and, as a result, were still in West Berlin. This made the tasks of the Soviet ethnologists decidedly difficult. The best they could do was describe what they saw as they unpacked the Yup'ik Flying Swan mask and the other objects in the boxes, created new inventory lists in Russian, and stenciled new markings on the objects. Then they repacked the newly numbered collections and held them in storage for decades until shifting relationships between the Soviet Union and East Germany led to their transfer to Leipzig in the 1970s.

As part of an effort to strengthen their ties with East Germany and aid its competition with the West, Soviet authorities began sending German cultural treasures seized at the end of the war to East Berlin. Two major shipments took place in the 1950s, which included even the monumental Pergamon Altar. The Central Committee of the Socialist Unity Party had it, and thousands of other objects, quickly reinstalled on Museum Island, making a public claim on German cultural history. There were, however, no ethnographic collections in those early Soviet shipments, in part because there was no ethnological museum to house them in what had been the Soviet Zone of Berlin. Thus, the seized Berlin ethnographic collections continued to languish in cold storage in Leningrad until the 1970s.

Then, between 1977 and 1978, the Soviets used a series of twelve transports to quietly ship almost 50,000 of these ethnographic objects to the Grassi Museum in Leipzig.[4] Returning the artifacts to the Berlin Museum für Völkerkunde, located in West Berlin, was politically untenable; and the East Berliners had no space for the ethnographic collections on Museum Island in East Berlin. The East German leadership, however, recognized the collections' potential value in future negotiations with West Germans

over material they hoped to gain for the art museums in the East. A future trade might be possible. So, they decided to have Soviet authorities deliver the seized Berlin collections secretly to the largest of East Germany's three ethnological museums.[5] Leipzig's ethnologists, however, much like their counterparts in Leningrad, were overwhelmed by the 500 cubic meters of objects, which arrived in 727 crates: 505 large packages, along with 293 single objects. Like the Soviet ethnologists, those in Leipzig lacked access to the documents in West Berlin, and while they debated among themselves about if and how they might integrate all those objects into their collections, they also were able to do little more than store them until they could be used as bargaining chips in some future political negotiations.

At first they piled the collections in the Grassi Museum's attic, where the objects remained until a water leak from frozen radiators damaged them. After that, they secreted most of the collections not so secretly in the room devoted to temporary exhibits. The two nine-meter-long crest poles, however, would not fit in the room. They were left "temporarily" wrapped in plastic in the entryway for over a decade. Eventually the open secret made its way to the Berlin museum. That, however, took much longer than the Leipzig ethnologists would have liked. Imagine working around a closed room filled with objects you are not allowed to talk about when much of the work you want to do has been made impossible by the lack of space.[6] Let's just say they were frustrated.

Once West Berlin's ethnologists finally figured out that the museum's old collections were in Leipzig, they and Berlin city officials were eager to regain them. Thus, astoundingly, amidst all the other events of 1990, while the world watched the fraught process of German unification unfold, negotiations between these two museums began almost immediately. On May 25, 1990, driven by excitement and curiosity, Wolf-Dieter Dube, general director of the Berlin State Museums, and Gerd Höpfner, a curator at Berlin's Museum für Völkerkunde, traveled to Leipzig to meet with the Grassi Museum's director, Lothar Stein, to determine how they could proceed with a transfer of what they had all come to call the Leningrad collections.

Yet the reality of what that transfer would entail sank in only after they arrived. Both men were shocked by the sheer mass of stuff. How else could they have reacted? These were not the same people who had packed up the collections five decades earlier or sifted through the rubble at the end of the war. There were, in fact, few people alive in Berlin who had ever seen any of these objects. If museum employees had read about them in documents and books from the first half of the century, most were aware of only the items that had once been part of their own sections of the museum,

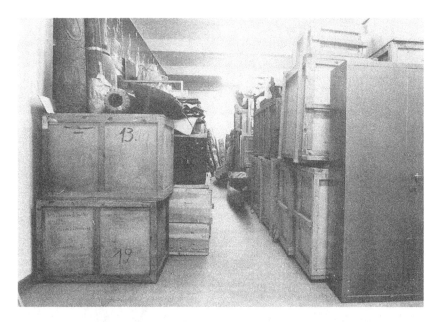

FIGURE 5.4. Boxes in Leipzig. © bpk-Bildagentur / Ethnologisches
Museum der Staatlichen Museen zu Berlin / Art Resource, NY.

the ones crossed out on old inventory lists, often designated as "burned"
or "lost" during the war. For decades those losses had been lamented; one
wondered what had survived.

It is hard to imagine what it meant for these men to encounter looming
piles of materialized rumors and histories, veiled by wooden crates and pack-
aging. Mostly, Höpfner later wrote, they were overwhelmed: "We stood there,
impressed by everything that could be seen, namely mountains of stacked
boxes of all sizes, packages with bundles of spears and shields, drums, boats,
sculptures, and wooden architectural pieces, the ivory tusks and the Benin
statuary kept separate from the rest, and a ten-meter-long partition, under
which lay the two huge totem poles from the American Northwest Coast."[7]

How were they supposed to make sense of it all? Crest poles one hun-
dred years old, prominent as centerpieces in old black-and-white photo-
graphs of Bastian's museum, now lay on the floor of Leipzig's Grassi
Museum in full color. Boxes with labels in German and Russian promised
to solve decades-old mysteries and reconstitute once-world-famous col-
lections. But what was in the boxes? The contours of sculptures under
their coverings offered some hints; and some even quickly solved a few
mysteries—the crest poles, after all, were just lying on the floor, plain
as day. How was that possible? What else was in those boxes? Yet the

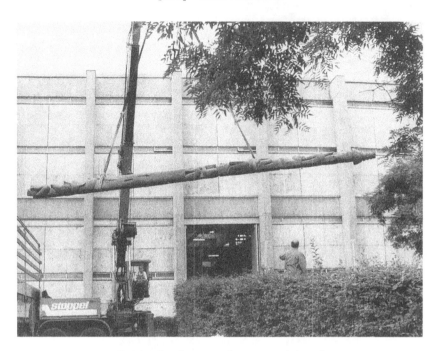

FIGURE 5.5. Raising the nine-meter-long crest pole into the museum.
© bpk-Bildagentur / Ethnologisches Museum der Staatlichen
Museen zu Berlin / Art Resource, NY.

dominant question in both of their minds was an exasperated: "But where and how?" In other words, what on earth would they do with it all?

As Berlin's ethnologists unpacked the containers in Dahlem, they compared old inventory lists and guidebook descriptions to the objects emerging from the crates. It is hard to imagine the thrill that must have gone through those rooms. The museum employees had all heard about these collections; many had confronted the old lists. Some of the objects were famous—singular examples of material culture unseen for a half century or more. Now, standing around the assortment of crates and packages, the ethnologists engaged the objects rather than rumors and myths.

Among other things, the Jacobsen collections—so much of which, everyone assumed, had been forever lost in the depths of the Royal Mint—were reconstituted to a spectacular degree. The Yup'ik Flying Swan mask, for example, was only one of more than a thousand objects from the Alaskan collections that had celebrated their arrival in Europe over a century earlier and returned now to the Berlin Museum. In fact, most of the Jacobsen collections that had been prominent in the museum's standing displays from the 1880s through the 1930s were in Berlin again. It was all so sudden.

Yet this was no reunion. The Yup'ik Flying Swan mask and the other objects had never been seen by the people taking charge of them. They emerged from the old crates like Rip van Winkle in Washington Irving's classic tale of a Dutch American man who falls mysteriously into a decades-long sleep in New York's Catskill Mountains and awakes after the American Revolutionary War: the objects were again in Berlin, but they reemerged into a wholly different world. This was a Berlin with different politics, different international relationships, different dramas, and different people fussing over them. In total, there were some 25,251 objects from the old African collections, 1,900 American archaeological artifacts, 7,610 ethnographic objects from the Americas, 1,558 from Europe, 3,956 from East Asia, 3,129 from South Asia, 3,485 from the South Seas, and 380 from the Islamic Orient.

It must have been like an ethnologist's Christmas, opening those first boxes with such anticipation. Or maybe it was euphoric only for some, or for only a short time. Either way, alongside the thrill was consternation. Not everything on the old inventory lists emerged from the boxes during the next three years of unpacking. Some 20,000 to 25,000 objects remained missing. Much of what returned also had to be sent directly into a quarantine hut, quickly built for that purpose on the premises. So much of it had to be cleaned and disinfected before it could go to restoration. So much had suffered.

The eagle at the top of the Haida crest pole, for example, had forever lost its beak and wings somewhere during its journey. Was it at the outset? Was it on the transports to Leningrad? Were the pieces still lying in a Russian or a Saxon attic? Maybe they had been swept up from the Grassi Museum's entryway after the trucks finally carried it off? We do not know when the damage happened.

Nor will we ever know what or who shattered the Yup'ik Flying Swan mask. It is hard to imagine that any of Berlin's ethnologists were delighted when it emerged from its box no more than a pile of pieces, missing an eye, the caribou fringe long since devoured by insects. Still, with exacting skills, they saved it, and not long afterward, it again delighted Yup'ik elders.

The Yup'ik Flying Swan mask, along with all the other collections, experienced a kind of catharsis after what can only be called a hard and long twentieth century. In fact, the "very long period of stagnation in the development of the Museum für Völkerkunde" that Sigrid Westphal-Heilbusch evoked in 1973 actually had begun much earlier than she admitted. It also continued much longer than she anticipated. Those postwar

FIGURE 5.6. The Yup'ik Flying Swan mask before
restoration. Peter Bolz and Hans-Ulrich Sanner,
eds., *Indianer Nordamerikas: Die Sammlungen des
Ethnologischen Museums Berlin*, p. 48, fig. 32.
© Staatliche Museen zu Berlin, Ethnologisches Museum.

years contained only the last two acts in a tragic, twentieth-century play
that began even before Adolf Bastian's death.

Schausammlung

A decade after Bastian's passing in 1905, Wilhelm von Bode had sensed
victory. In 1912, the city government had approved a museum complex in
Dahlem, which would include buildings for each of the four non-European
continents. In 1914, workers broke ground and began constructing the
first of these buildings. It was meant to house Bode's long-desired "Asiatic
Museum." That was a particular coup. Bode planned to fill it with the city's
Asian art collections and cultural objects located in Berlin's Kunstgewerbe
and Völkerkunde Museums.

For about a year, Bode delighted in his success, gleefully anticipating
his building. Then World War I stopped the construction—funds and man-
power were reallocated to the war effort. When the German government

and the economy collapsed at the end of that war, completing even that first building became impossible. In 1921, the new city government decided to cut its financial losses by simply putting a roof on the part of the building they had completed and turning it into a storage facility for the overburdened Museum für Völkerkunde. That was the building the ethnologists fled to in Dahlem, and had to share with others, after World War II.

That hard blow to Bode's vision in 1921 was not only brought on by financial problems but also by Orientalist scholar and new minister of culture, Carl Heinrich Becker. Like most of Berlin's ethnologists, Becker did not share Bode's enthusiasm for an Asiatic museum. Nor did Becker like Bode and his authoritarian attitude. Becker found them far less suited to the needs of the new Weimar Republic than they had been to the Prussian crown. So Becker ended the project. Frustrated, Bode stepped down as the director of Berlin's museums in 1921, but he remained influential as the director of the Gemäldegalerie until 1925. He passed away four years later.

Still, there was a notable success for Bode wrapped up in that failure: after decades of effort, Bode had managed to transform the Museum für Völkerkunde—by forcing it to conform to his museum ideal. By 1923, Berlin's ethnologists were recasting Bastian's museum building downtown, on today's Stresemann Street, into a space that made little sense to most of them but had always made good sense to Bode: they transferred the vast part of their collections into the newly won space in Dahlem, leaving only enough objects in the museum downtown for a Schausammlung. There, in direct opposition to Bastian's vision, they tastefully arranged arresting and unique objects in a manner that pleased Bode's aesthetics and ostensibly communicated to visitors ethnology's latest insights into the cultures represented by these airy displays.

The Yup'ik Flying Swan mask, for example, hung in one of the new glass cases in the North American section, nicely centered at the top of four neat vertical rows of masks and objects from Alaska (Figure 5.2). The case was set against a wall, making everything in it easy to see and quick to absorb. Visitors could take in the entire case at a glance or ponder one or more of the individual objects at length. There was no fear of their being overwhelmed. Most everything else was stored away in Dahlem—out of sight and out of mind.

Larger items—carved pillars from the South Seas, statues from North Africa, house posts from British Columbia, a beautifully decorated boat from southern Cameroon, even some costumed figures dressed as North American Indians, were placed thoughtfully among the cases that were still geographically arranged or set out in the center of the larger rooms, where they quickly caught visitors' eyes. The lighting was pleasing, and there was plenty

FIGURE 5.7. The 1926 Schausammlung. Staatliche Museen zu Berlin, Ethnologisches Museum.

of space in these rooms for standing and walking. There was, in fact, a lot of empty space, or, as Bastian would have thought of it, a lot of wasted space. Visitors were not challenged to make connections between groups of people across time and space; there was no effort to draw visitors in to the production of knowledge about a total human history, as Bastian would have liked. Instead, the visitors' role was to passively consume the narratives articulated and illustrated through the well-chosen, representative objects.

This transformation of Bastian's museum from workshop to showcase was part of another Faustian bargain: after decades of resistance, the museum's ethnologists moved the majority of their collections out of the public eye and set up the new Schausammlung in exchange for the promise that they would finally get the space they needed to unpack their overcrowded and boxed-up collections and put them to work.

For many of the ethnologists, however, this Faustian bargain turned into a bitter exchange. Not only did they gain only a fraction of the space in Dahlem promised them before the war but they also had to pay for the move themselves. A year earlier, Bernhard Ankermann, Felix von Luschan's successor as director of the African and Oceanic collections, made that possible by selling four of the bronze heads from their Benin collection for 320,000 marks. In 1923, after inflation, he sold thirteen

more pieces from Benin.[8] That was a distasteful action. At least, however, Ankermann and the other ethnologists agreed, they would finally be able to create what everyone started calling the *Studiensammlungen*, or study collections—the vast majority of the collections, which were open only to researchers—in Dahlem. That, ostensibly, is where the knowledge production would now take place, far removed from the public exhibits. The problem was that after the ethnologists fulfilled their side of the bargain by moving their collections and creating a Schausammlung for the curious, they never got the space they needed—not in the 1920s, the 1930s, or during the rest of the century.

Bastian must have been rolling in his grave. Not only did this division of the collections and the creation of a Schausammlung run contrary to his original vision and the very purpose of creating a museum building, but the celebratory reopening of the new Schausammlung in June 1926 coincided with the one hundredth anniversary of his birth. What a bitter gift.

There were complaints. Konrad Theodor Preuss, for example, still embraced Bastian's vision, and like many of the museum's ethnologists, he must have been grimacing during the opening ceremonies. Preuss had been trained by that generation of men who came to work in Bastian's museum. He worked most closely with Central Americanist Eduard Seler, the internationally acclaimed authority on Mexican archaeology. Preuss had been one of Seler's best students, and he had been working in the museum since 1900, when Bastian and Bode were already debating the notion of Schausammlungen. Preuss watched those debates unfold over the next decade while becoming a formidable Mexicanist in his own right. After Seler's retirement in 1920, Preuss also replaced Seler as director of the American section of the museum, and after that point, he was forced to help negotiate its transition.

Preuss had a prickly personality, and it is easy to imagine what he was thinking that opening day, as the minister of culture lauded the illustrious Schausammlung. How wonderful, Becker remarked, that it displayed "characteristic" and "typical" cultural objects from people around the world in a way that he claimed was both good for specialists and well suited to general audiences—and thus to the democratic needs of the Weimar Republic.

Preuss was almost certainly cursing under his breath. Ironically, a love of Schausammlungen was one of the few things the minister of culture shared with Bode. Both thought they were good for entertaining and teaching audiences. Such exhibits used representative objects to tell stories about particular cultures—about their arts, their industries, their family and social structures.

Such displays were and still are wonderfully malleable. A Schausammlung can, in essence, tell any story a curator might like. In that sense, they have always been ideologically driven, always easily recast to the politics of the day. There is, in fact, no such thing as an ideologically free Schausammlung. Not even displays geared toward evoking wonder rather than facilitating education are free of ideology. Preuss understood that.

Much like his mentors before him, Preuss regarded such exhibits as nothing more than a current fashion stemming from the overwhelming dominance of art and art historians in the museum world. Ethnology, however, is a science, and ethnological museums were created in Germany as research centers, not showcases. Begrudgingly, Preuss bit his tongue while listening to city officials and politicians at the opening ceremonies use Bastian and his scientific museum as tools to promote their own political ends. Their gestures to modern politics and the public were equally irritating and predictable.

Later, however, Preuss spoke out in a poignant essay that remains timely today.[9] At a time when museum employees who disagreed with administrators' and officials' decisions could still voice their opinions, Preuss made it clear that they had made a mistake. Despite the minister of culture's claims to the contrary, Preuss was aware that the new displays offered specialists little, and he doubted they would do the general public a great service. Preuss had spent decades around those publics, and "even the simple visitor," he wrote, "according to my experience, is not bound by the technical or the artistic aspects of a single outstanding object, but by the life of the people as a whole and by the knowledge of the spiritual life of the creators. Ethnology and its museums," he reminded his readers, "thus coincide in their goals."

No ethnologist, however, could pursue those goals with exhibits made up of "characteristic" or "typical" objects. That is why, he explained, the first thing Bastian had done in 1868, when he came into the museum as a directorial assistant, was to break "with the usual practice of considering only externally attractive pieces worthy of collecting." That is also why, "in contrast to the previous trophies of rarity cabinets, he instructed travelers again and again to collect all the inconspicuous objects of daily life, in order to obtain a true picture of the common culture of each people."

Simply setting up the aesthetically pleasing pieces as curators had done in the past, and as he and his colleagues had been forced to do once again, would, he warned, do little more than reconstitute the old "curiosity

cabinets," those collections of rare and wondrous things that were created for the amusement and edification of nobles. That much was clear. Such exhibits could still inspire wonder, which is why they had sometimes been called *Wunderkammern* (cabinets of wonders) and teachers might use them didactically. Yet that, Preuss contended, was a poor use of the objects acquired to be part of Bastian's Gedankenstatistik.

The problem, Preuss knew, was that such vapid displays left no chance for knowledge production, no place for Bildung. They offered the modern public only a watered-down and likely misleading education about a few cultures and peoples outside Europe. "But if they do not set up entire cultures," he warned, "then the connections between all of humanity would be interrupted, and the aim of ethnology, as Bastian established it, and as it still exists today, would no more come to fruition than by the mere selection of pieces that appear before one's eyes."

He did not name the antagonists or condemn those responsible for this current misstep, but Preuss made the problem as he and many of his colleagues saw it crystal clear: "through the struggle between these particularly contradictory points of view, it has come about that the idea underlying the old Bastian Völkerkunde Museum has been considerably changed in the Schausammlung." This was hardly a fitting present for Bastian's one hundredth birthday. Yet, once the exhibit was up, it stood there largely unchanged for the next fifteen years—an awkward symbol of the "long period of stagnation" and the demise of Bastian's vision.

Progeny

Other political forces had undermined Bastian's vision as well during the interwar and Nazi periods, leaving ethnologists with even greater concerns than the fate of their collections. In 1946, their field was a sundry mess. In an effort to contain the damage, Franz Termer, who had survived the war in Hamburg but would wait for years to return to Central America, opened the first postwar meeting of the German Ethnological Society in Frankfurt that year by focusing on loss and regeneration.

Termer began their 1946 meeting by reading out the names of ethnologists who had died during the war. Those included famous researchers such as Carl Meinhoff, Karl Sapper, and Max Uhle; museum men such as Bernhard Ankermann, Augustin Kraemer, and Lucian Sherman; and there were so many promising young men and women who had died in the conflict that he could not list them all.

Termer also surveyed the museum landscape and assessed its potential. The loss of collections and research material extended far beyond Berlin, across the German-speaking lands:

> Berlin, Hamburg, Leipzig, and Lübeck have suffered the worst losses, while Freiburg, Göttingen, Karlsruhe, Kiel, Mannheim, Munich, Nürnberg, Stuttgart, and Tübingen have almost completely salvaged their collections. Frankfurt and Dresden have recorded only small losses. Cologne has suffered serious losses due to their relocations in the Eastern zone, also Bremen has been hard hit. The Breslau collection and library were saved and are now in Polish hands. Happily, the archives and libraries—apart from some minor losses—were almost completely saved, excepting Lübeck and Berlin, which aside from some general ethnological works and journals were completely lost. Even the valuable library of the Berlin Anthropological Society was completely lost after it survived the war.[10]

Much worse was the damage to the museum buildings. The news was indeed grim. Only in Dresden, Göttingen, and Hamburg were the buildings more or less intact. "Berlin (with the exception of the storage facilities in Dahlem), Bremen, Frankfurt, Mannheim, Munich and Stuttgart," he reported, "must be rebuilt for the most part." The only really good news came from Vienna:

> About Vienna we have learned that the buildings, the collections, and the library have been completely preserved and the entire installation has been started up again. This large museum, then, with its exquisite treasures, is the only one in Central Europe that has remained completely intact. With the loss of Berlin, which possessed the largest ethnographic collections on the continent, Vienna must now be accorded this distinction.

Even before the Cold War was in full swing, it was clear that Berlin would no longer be the center of German Völkerkunde. It did not turn out to be Vienna either.

Wherever the center might be, in 1946 Termer's chief goal, and that of the other members in the Ethnological Society, was to argue that the science of Völkerkunde was not dead. It had not only survived the bombings but also the interwar and Nazi years. That, he believed, was a good thing: their science, Termer argued, based on Bastian's original vision, had a critical role to play in this new world. "Our confidence," he explained, "is that the call to participate in the high aims of an all-inclusive science of

people and cultures, spanning the millennia of their becoming and passing away, will reach us in the not too distant future." Then, "after years of hatred between peoples and the separation of nations," they would have the chance "to contribute to ethnology's renewal" and its "treatment as one of the fundamental pillars of humanity."

Termer argued about the future of ethnology and ethnological museums based in part on his assertion that the vast majority of German ethnologists had not lost their way during the age of National Socialism. He was adamant: they had not been drawn into the trends toward race science and "*Völkerhass*" (hatred of a nation or people). During the Nazi years, in fact, Termer had lamented the decline of his unfashionable science in private letters and professional correspondence. Displays that might have been useful for teaching the public in the early years of the Weimar Republic became almost obsolete under National Socialism. Inductive science fell to the wayside, as it was unable to support the fascist and racist politics of the day. So too were Humboldtian total histories of humanity. The project that had first sent Bastian into action lacked useful hierarchies and biological schemes that could justify the Nazis' new world order. Thus it languished.

That, at least, is what Termer thought with some bitterness as his profession fell from favor during the Nazi era, when even new displays, such as Berlin's celebrated Schausammlung, fell into disuse. That is also what he argued publicly to his colleagues in 1946: "If I think of the limited circle which ethnology has always encompassed in Germany," he began, "I would like to emphasize here that we have always worked loyally, and in many cases amicably, with our foreign colleagues and, with a few exceptions, held our science outside the political sphere of National Socialism." As a result, "we had to face bitter experiences during the twelve years of National Socialist patronization of science," but "we consciously resisted with clear recognition the outrageous doctrines of radical racial and cultural teaching." That had its price, and as a result of their ostensible resistance, "ethnology as a science was suppressed by National Socialism in favor of race science and folklore, also prehistory, because our doctrine did not fit into the ideologies of National Socialism." It was only when National Socialists could use "our museums for propaganda purposes, our research for colonial aspirations" that they remembered the ethnologists and "sought to boast of our achievements. . . . Think of the danger," he went on, "that the ethnologist should become a handmaiden of colonial propaganda. The insightful among us," he exclaimed, "recognized this danger and resisted it."

Termer believed what he was saying. Much as Preuss had lamented the political trends that caused the transformations of the Berlin exhibits during the Weimar Republic, Termer had witnessed how the shifting political winds under National Socialism directed funding away from his and other ethnological museums and from their ethnologists' research projects. Those politics had also drawn students away from his university classes, which also had added to the stagnation of the science.

Termer never directly opposed the Nazi regime, but he did not like what it had done to ethnology. While some of his colleagues had embraced those winds of political change—quite a few more, in fact, than he indicated in his speech—their willingness to follow those political trends had no more saved the science than those ethnologists around Preuss just a decade earlier, who had made their peace with what he considered insipid, fashionable displays. Under National Socialism, Termer argued, ethnology had become obsolete.

The fall had already begun, as Preuss knew so well, during the Weimar period, and that had included research as well as public displays. With the loss of the German colonies, the German navy, and so much of German shipping after World War I, not to mention the repeated financial crises that racked the Weimar Republic, major scientific expeditions had ground to a halt. What money still existed for original research during those crisis years the funding bodies redirected toward politically correct institutes, especially those that promised to help solve the contemporary problems of the German nation-state: particularly its place in the international hierarchy of states and the loss of so much territory to the east.

A sea change followed. Institutes of prehistory, for example, became refashioned as sciences of the fatherland, which could help legitimate claims that Germany's natural borders lay far beyond those of the Weimar Republic. Termer was right about that. Much more than ethnology, with its focus on a pluralistic history of humanity, and ethnologists, who mostly remained committed to an inductive science during the 1920s, the new prehistory, freed of those pluralistic leanings after the passing of Germany's leading anthropologist, Rudolf Virchow, and his generation of liberal-minded anthropologists and archaeologists, could help legitimate political claims to territories across Eastern Europe. This made the new prehistory a particularly useful science.

In the hands of archaeologists and prehistorians such as Gustaf Kossinna, who usurped the position of classical archaeology at German universities in favor of greater attention to Germans' early history, archaeology and prehistory gained political clout. Politicians and scientists alike

could easily harness them to support ethnic nationalist and even Nazi racial claims on a European *Grossraum* (great space) for the German people. Prehistory of this sort could create historical legitimacy for future conquest of Eastern Europe by tracing those claims back over centuries to a period in which putatively still-pure German tribes had controlled those lands.

The fact that Rudolf Virchow's studies of European settlements and the bones found among them had demonstrated Europeans' long history of extensive mixing was beside the point. Virchow's inductive science, and the people who continued to read and follow it, would have made such ethnic and racial claims on Eastern Europe impossible. But Virchow, the staunch political liberal who had opposed Otto von Bismarck from his seat in the Reichstag; Virchow, the rigorous champion of inductive science who had been a leading pathologist, physician, prehistorian, and a founding figure in German anthropology in Imperial Germany; Virchow, who championed social medicine and declined ennoblement, died in 1903, and the people he had convinced were not the people who gained leading positions in the new interwar and Nazi institutions.

In the new political contexts of the interwar period, in which many Germans who felt slighted by the Treaty of Versailles and longed to reclaim lands to the east, the Prehistory section of Berlin's Museum für Völkerkunde, which had been part of the museum since before Bastian took over the collections, was transformed in 1931 into its own entity: the Staatliche Museum für Vor- und Frühgeschichte. That gave Kossinna's many students, and the ethnic nationalist arguments he had inspired in them, a formidable institutional base in Berlin. Its staff worked happily with people in other museums, with colleagues in universities, with supporters of historical preservation, and with various associations committed to the new trend of *Ostforschung*—the history of German culture in the East. Together, these groups eagerly pursued an emphasis on ethnic distinctions tied to specific archaeological sites.

When Nazi officials came to power, they immediately lent those research projects their support. In particular Reichsführer Heinrich Himmler, who was enamored with German prehistory, ensured that more funds would be directed into prehistory institutes and research projects during the Nazi era. Under his auspices, the ethnic distinctions prehistorians claimed to locate in the earth were easily recast as racial imperatives.

Similarly, physical anthropology flourished during the interwar and Nazi era. Once again, Rudolf Virchow's inductive, pluralistic science was refashioned around a race science he had deplored, making it politically

useful in all sorts of unprecedented ways. Just how quickly state-backed funding streams could transform this science to accommodate the new racial politics was signaled almost immediately after Felix von Luschan retired from the Berlin University. Eugen Fischer, who had held a position at the Freiburg University's Anatomical Institute since 1918, not only took over his chair in 1927 but also became director of the Kaiser Wilhelm Institute of Anthropology, Human Heredity, and Eugenics in Dahlem. This demonstrated a total reversal in the character of physical anthropology in Germany: under Fischer, Germany's new "social anthropology" moved from denouncing race science to actively promoting it.

Fischer was also a strong supporter of National Socialism, quickly signing the oath of loyalty of German professors to Adolf Hitler and the Nazi State in 1933. His work also had a direct political impact in Germany and abroad. Among other things, his books influenced Hitler's ideas on race, and his arguments informed the character of the Nuremberg Laws. Hitler, in turn, made Fischer rector of the Berlin University in 1933, and Fischer, unlike Termer and the ethnologists in Germany's museums, had no shortage of funds to pursue his experiments and research projects.

Fischer's physical anthropology, like Kossinna's prehistory, was driven by precisely the kinds of dangerous scientific practices that Rudolf Virchow and Felix von Luschan had warned against for half a century. To this day, Fischer remains infamous for his initial research work in German South West Africa (today's Namibia), which led him to call for bans on racial mixing, and for his unethical medical practices in Namibia and later in Germany. His studies on mixed-race children in Germany, for example, were followed by those children's forced sterilization.

Fischer and Kossinna's brand of science rose to prominence in the interwar period and flourished under National Socialism because it fit politicians' worldviews and suited their needs. These too were fashionable trends. Meanwhile, people who shared Virchow and Luschan's convictions about what constituted good science, and refused to embrace race science, fell from favor. They, along with unfashionable fields such as ethnology, faced growing disinterest and diminishing resources, as Termer and many others attested.

That does not mean, however, that all German physical anthropologists followed suit, adopting Fischer's goals and methods. Nor does it mean that all the ethnologists opposed National Socialism. Most did not, and it is hard not to recall, when reading Termer's 1946 statements about the sufferings of ethnologists under National Socialism, how well they fit

into the ubiquitous and dubious statements from those postwar years that Germans were the first victims of National Socialism.

Termer's statements, in fact, were incredibly self-serving. He named no names when he evoked the "few exceptions," those ethnologists who did not, as he put it, "remain loyal" to their scientific integrity. His lists failed to include those ethnologists who were forced to flee, those who did not get away and died in camps, or those who were happy to see them go. Those included scholars such as Hans Plischke, who was not only a professor and director of the Ethnological Institute in Göttingen but also a Nazi Party member who signed the same loyalty oath as Eugen Fischer and played a leading role in the National Socialist Teachers' League. Plischke denounced Jewish colleagues, even though he rejected race science. Termer knew that. Moreover, Termer failed to mention in his rousing speech that while ethnology had not proven as politically useful to the Nazi regime as many other branches of the human sciences had, it was also true that a great many ethnologists had always worked in multiple fields, including those that were, indeed, quite useful to the Nazis.

Termer's statements are not untrue. Yet, because of the absences and silences, they are incredibly misleading. They fail to acknowledge, for example, that while only a few ethnologists shifted their research or attempted to recast German museums in ways that would support the racial science of the regime, almost none used their convictions derived from their science to oppose it—as Virchow and Luschan would have done, and as Franz Boas continued to do from America until he died in December 1942, distraught by what had happened in Germany.

For the most part, German ethnologists, including Termer, had either accepted or followed the scientific fashions driven by the Fascists and hypernationalist politics and failed to lead an opposition.[11] Who then would take up the leadership of the science during the postwar decades? In that intellectual vacuum, is it any wonder that Berlin's Museum für Völkerkunde continued after World War II to be characterized by its stagnation?

Coming to Terms with the Past

When I arrived in Berlin in the mid-1990s, I had a clear dissertation project in mind. I knew that Germany's Völkerkunde museums had been the world's largest collecting museums during the late nineteenth century, far outdistancing those in Great Britain, France, and the United States.

I also knew that Germans began founding those museums in the 1860s and 1870s, before the creation of the German nation-state in 1871, and long before it became a colonial power in 1884. I knew as well that many had been established, essentially one after another, across the German-speaking lands. No one, however, could tell me why.

Email being still rudimentary, I sent letters to the directors of Germany's leading ethnological museums. I explained my research questions and asked to visit their institutions. My intention was to focus on the four largest ethnological museums: in Berlin, Hamburg, Leipzig, and Munich. My hope was that the answers to my questions would be in those cities' municipal, state, and museum archives.

The answers were there, but they were not easy to access. The director of Berlin's Museum für Völkerkunde in Dahlem, for example, told me that he had an employee working on the history of their museum, and he did not want that person to face any competition. So, he would not let me see the documents. That was an interesting dodge. He denied access to two other American doctoral students as well. The Völkerkunde Museum directors in Hamburg and Munich employed a different tactic. Both told me that there were no archival documents in their museums. What did exist, they explained, was in the city archives. I later learned that was untrue.

In Leipzig, however, Lothar Stein, director of the Grassi Museum during East Germany's final years, and who remained its director until 2001, welcomed me into his office, gave me complete access to the museum's archive, and instructed his staff to give me whatever I needed. Moreover, he invited me to coffee. He listened patiently while I detailed my research questions. Above all, I explained, I wanted to understand why so many Germans had created and supported these museums during the second half of the nineteenth century. His response was astonishingly frank: it was colonialism.

I was stunned by his answer. During the 1980s, the painful effort to come to terms with an "unmasterable" German past (*Vergangenheitsbe-wältigung*) dominated public debates in West Germany. Historians and other scholars fought publicly with each other over how to narrate German history. Among other things, they debated their mentors' actions during the Nazi era, and many questioned the silence of Termer and his generation about who, precisely, had taken part in supporting the Nazi system. Meanwhile, their students responded to those debates by digging into the histories of all kinds of institutions—museums, research institutions, universities, the Foreign Office—you name it. Essentially every institution had hidden histories to expose.

It is therefore unsurprising that the first scholarly conferences devoted to ethnology's relationship to National Socialism took place at that time, that the first book on the connections between National Socialism and ethnology appeared soon afterward, in 1990, or that a series of younger scholars continued working through the biographies of individual ethnologists across the next decade.[12]

Their research soon demonstrated that a good number of ethnologists had found ways to take advantage of National Socialism or supported it directly. They also made it clear that this had hardly been a secret in 1946. Despite Termer's quips about loyalty, de-Nazification commissions had identified quite a few Nazi supporters among the ranks of German ethnologists. They included Hans Plischke in Göttingen and many others, such as Otto Reche, a professor of anthropology and ethnology in Leipzig who had also been a staunch party member and later an apologist for genocide. Termer knew both of them well. The Allied powers got to know them too. They interned many of these men, stripped them of their abilities to research and teach after they were released, and in several cases, the administrations of German universities refused to pay their pensions.

Within only a few years, however, many of those same scholars, such as Reche, were quickly reintegrated into that scholarly community. In some cases, the universities and other institutions later celebrated and honored them for their work.[13] Then, by the late 1950s, people stopped talking about that disheartening bit of these men's pasts and joined a kind of group amnesia that was common in the German sciences and other parts of society after the war.[14]

That silence persisted until the late 1960s and early 1970s, when university students revolted against American imperialism, but also against their parent's generation, the silences about their Nazi pasts, and the roles that the universities and other research institutions played in it. That led to the public condemnation most notably of ethnologist Wilhelm Emil Mühlmann for his Nazi past—some twenty years after he (and many others) had successfully negotiated the postwar silence to re-create their careers.

Then, just as those debates had settled down in the late 1970s and 1980s, international scholars turned their critical inquiries to the sciences of anthropology, archaeology, and ethnology. Across Europe and the United States, led often by faculty in postcolonial and subaltern studies, large numbers of scholars began asking how these and other sciences had facilitated the rise and augmented the power of European empires.

Many indeed began characterizing these sciences as "handmaidens of colonialism," and many came to regard anthropologists, and thus also German ethnologists, as having been important agents of empire—even in moments when that was not the case.

Given those critical trends, it is hardly surprising that the directors of ethnological museums in the former West Germany were anything but enthusiastic about American doctoral students digging into the history of their institutions in the early 1990s. Such research might have caused them all kinds of political problems. In Berlin, for example, where the Berlin Museum für Völkerkunde had once had a monopoly on ethnological collecting in the German colonies, too much inquiry might remind people that many of the African artifacts that had just returned from their decades-long odyssey through the Soviet Union and East Germany, might easily be denounced as colonial booty rather than celebrated as the returning "Berlin collections."

Such revelations could put a damper on the excited unpacking and the plans to display some or all of these things in the near future. So, in order to avoid scrutiny, West German museum directors and curators developed extensive strategies of delay, deflection, and outright denial of access to discourage researchers from working with the records of what had once been research institutions.

The irony is thick; but it is made all the thicker by the fact that East Germans, such as Lothar Stein in Leipzig, did not share those fears and were happy to open their doors to me and others who were interested. Neither Germany's colonial history nor its Nazi past was a problem for his museum. There were no secrets to expose, because East Germany had been founded on an argument, even a conviction, that it represented the first victims of capitalism, imperialism, and fascism. Consequently, East German narratives of the German past began with the assumption that scientists in Imperial Germany, like most European elites, were bourgeois supporters of imperial conquest. Moreover, within that historical and political framework, ethnologists who had not fled National Socialism or had clearly suffered in internal exile, were assumed by East German scholars to have been at least partly culpable for its crimes.

For scientific integrity, East German scholars looked not to people like Franz Termer, who claimed to have muddled through the years of neglect under National Socialism, but to individuals such as Julius Lips, a committed Social Democrat and director of the Museum für Völkerkunde in Cologne. Lips and his wife, Eva, had sought exile in the United States soon after the Nazis assumed power. They gained jobs and pursued research in

US universities while also writing anti-Fascist reports on events in Europe. After the war they returned to work in East Germany, in Leipzig.

Given this alternative narrative of the German past, it is not surprising that the first dissertation on the interconnections between German colonialism and ethnology appeared in East Germany in 1966, decades before a West German wrote a comparative study.[15] Moreover, given those different twists on a shared past, it also is no wonder that by the 1990s, connections between ethnology and colonialism were old news in Leipzig, even if they were still taboo topics in West German museums.

There was, however, one concern that Stein shared with his colleagues in the West. Ethnological museums had become increasingly isolated over the course of the twentieth century. Their stagnation was plain for many to see. If the Berlin Museum für Völkerkunde in Dahlem had managed to retain and even regain many of its old collections by the end of the Cold War, still, it had become a much different institute than the one Bastian had founded. Bastian's museum had been closely tied into Berlin and Germany's leading intellectual and political circles. It was a magnet for young talent, a critical complement to the universities, as well as a formidable, internationally recognized research center. Before 1920, Bastian's museum was unquestionably the leading institute of ethnology in Germany, and most of Germany's interwar ethnologists were trained in part either in Bastian's museum or in one of Germany's other leading ethnological museums, such as Leipzig's Grassi Museum.

By the 1990s, however, everything had changed. Although the Dahlem Museum Complex sat at the center of the sprawling Free University, students who were keen to sign up for classes in material culture did not find them taught, as one might have expected in the past, by university professors who also worked in the Museum für Völkerkunde. That was true for ethnology classes as well. They were led by university academics who thought seldom about the nearby museum. Much the same was true across the rest of Europe and in the United States.

By the 1970s, in fact, an ever-growing gap had developed between what people came to call "museum anthropology" and the ethnological institutes and anthropology departments that had been created in universities. Many students, as well as university faculty in West Germany and other states, shifted their interests away from the history of cultures toward a focus on current, extant cultures in the world. As that trend took shape, many came to regard the kinds of science and public relations pursued in ethnological museums as a tiny and, for some, dubious, subset of what ethnologists did or should do.

As part of those shifting attitudes, research monies for ethnological museums declined precipitously during the postwar era. Fewer and fewer museum ethnologists could engage in research trips, which reduced the research portfolios of the museums and added to their isolation. At the same time, less and less funding was available for research with the objects in the museums' collections. The growing division between ethnological museums and ethnological institutes on German universities continued into the 1990s. It impoverished both.[16]

Sadly, the static Schausammlungen rejected by Bastian at the turn of the century and condemned by Konrad Theodor Preuss in the 1920s had only aided the critics. Preuss's concerns were never addressed. During the postwar era, no effort was made to usurp the dominance of the kinds of displays that he had called "fashionable trends" set by art historians and art museums. Instead, those trends had become permanent conditions even in the new buildings.

Initially, during the first decades after World War II, before the museum complex in Dahlem was completed, Berlin's ethnologists simply lacked the space to do anything but set up small displays with representative objects. Most considered those efforts, like so many of their efforts across the twentieth century, temporary, expedient, and ephemeral. A few of the ethnologists who created those displays in Berlin took some small solace in the fact that they no longer had the cross-town division between the public displays and research collections after the war.

Yet, if all the postwar collections were united in Dahelm, and if the new displays set up for the general public in 1973 were done in a manner that had not been possible for decades, the museum's ethnologists knew even then that not all was well. Gerd Koch, for example, let this slip in his essay on the South Seas section of the Berlin Museum für Völkerkunde for its one-hundredth-anniversary volume.[17] While his section of the museum had 48,080 well-organized objects in the study collection at that time, they were able to display only 3,006 for the public. That, he hoped out loud, was a short-term solution. Yet it became, as we now know, a permanent condition, because the space he and his predecessors had sought over generations, and that the central museum administration had promised them across a series of political regimes, never became available. As a result, the problems Preuss had pointed out with Schausammlungen in the 1920s not only persisted but continued to grow well into the 1970s, as Schausammlungen increasingly became any museum's reason for being. This trend dramatically undermined innovation and continued to undercut the

FIGURE 5.8. The sculptures from Santa Lucía Cotzumalguapa as a high point in a new Schausammlung in 1970. Staatliche Museen zu Berlin, Ethnologisches Museum.

eminence the Berlin Museum für Völkerkunde had once held as a research institution.

Even in 1973, almost fifty years after Preuss's complaints about the dominance of art and art historians in the museum world, Koch explained somewhat defensively in his essay: "these ethnographic objects have been selected in order to give the visitor a representative image of the cultural regions of Oceania and Australia. The exhibit is not constrained by the formal concept of 'art.'"[18] Despite his claims, it certainly looked that way to many people. These were lovely displays.

Moreover, in a fit of rationalization that echoed back to the interwar period, Koch argued that their public displays were less important than the bigger project, which he hoped he and the other ethnologists would be able to continue soon:

> If, during these decades, the phase of traditional collecting has also been completed for Oceania, scientific inquiry should be focused now on the concentration of "cultural documents" [in the collections]. The systematic publications of the collections and the resulting research should be the most important future task. At the same time, public relations work that includes contact with the different regions of Oceania should be further developed. It is on these foundations that one must fulfill the task of serving the historical scholarship on those peoples who hitherto lack a pronounced sense of their own cultural history and whose traditional cultural assets [*Kulturgüter*] have been saved in the museum from their ultimate demise.[19]

That fascinating statement captures the conundrum of "museum anthropology" and ethnological museums toward the end of the twentieth century. In almost the same breadth in which Koch defends a mode of display the art world pressed on the museum before he was born, he denies that victory of form over substance, and then he turns to arguing that the museum's most important work takes place behind the scenes, among the 90 percent of objects that few people will ever see.

What makes Koch's rationalization most fascinating, however, is that somehow, across the institutional transformations of the past century, the notion that ethnological museums were engaged in a project of historical preservation, that they were meant to act as surrogates, preserving the historical records produced by cultures all around the world, in some case the only records of cultures that had been in the throes of radical change, had persisted across generations, multiple locations, and a series of different political regimes. In the museum's back rooms, far away from the Schausammlungen and the general public, people still knew this to be true.

The kinds of public displays forced on museum ethnologists since the 1920s, Koch explained, had never been central to the museum's mission. They were the poignant and irritating remnants of that old Faustian bargain. Ethnologists' most important work in the museums was preserving and caring for the collections that they were forced to keep behind closed doors. Research with the collections was also essential, but over the years, after Koch and the others who wrote those anniversary essays in 1973 retired, less and less of that could be done than they anticipated.

Yet again, much of the drama took place behind the scenes. Despite Preuss's complaints and Koch's revelation, most people who entered the Berlin Museum für Völkerkunde after 1926, 1973, or during the unpacking of the Leningrad collection in the early 1990s, never understood that there were treasure troves hidden behind the walls and in the basements. Even today, very few visitors understand that there are cabinets, shelves, and rooms filled with records of human history just out of sight of the ever more titillating, wonderfully entertaining, and digitally enhanced displays. Very few have any sense that the vast collections of material culture in these museums continue to hold long-hidden clues into what Bastian had called Weltanschauungen, and which many today would call ontologies— how people understood and understand the world and their place in it.

The question that was slowly buried in the storage depots, ad hoc arrangements, and temporary installations that became permanent over time, the question that drove the creation of German ethnological museums in the first place but was usurped by museum men such as Wilhelm von Bode, the question that matters most for us today, is how to unlock the potential of these collections. As Berlin ethnologists unpacked and restored the Yup'ik Flying Swan mask in the mid-1990s, an answer emerged.

Treasure Troves

Over the last few decades, ethnological museums began to be recognized as more than dusty chambers of curious relics: they are modern treasure troves, vessels that have transported vast amounts of human history into the present. If the 1970s and 1980s were a kind of nadir for museums, an increasing transnational interest in material culture, visual culture, and exhibitions during the 1990s made them exciting to many people again. Museums in general underwent a boom that is still under way, and the stature of ethnological museums eventually rose along with the others. At precisely the same time, increased indigenous activism brought the histories of non-Europeans and the scholarship about them into the limelight, which made ethnological museums everywhere sites of public activity and debate and brought critical inquiry to the state of these institutions, to their modes of display, and to the very fact of their existence. Most important, these transnational political movements threw light on the objects behind the scenes, the collections that museum ethnologists had always known were more important than their Schausammlungen, but which had been kept for so long out of sight and, for most people, out of mind.

As curators, ethnologists, and indigenous activists and scholars alike have engaged during the last decades in debates over the contents of these museums and the purposes of these institutions, they have begun to transform them into working spaces that, one might argue, are returning to Bastian's original vision of pursuing a total human history.

One early success story took place in Berlin in 1997, when four Yup'ik elders arrived at the Berlin Museum für Völkerkunde (which changed its name to Ethnologisches Museum in January 2000), eager to see the treasures produced by their ancestors and contribute to the production of knowledge about human history. They arrived with a videographer, a translator, the mayor of St. Mary's, their Alaskan town, and cultural anthropologist Ann Fienup-Riordan. The anthropologist, who had long worked with their community, had discovered the collections just a few years earlier, during a research trip to Berlin. She had traveled there to take stock of the Museum für Völkerkunde's collection of Yup'ik masks for an exhibition she was planning in Anchorage, Alaska. Arriving as the museum's ethnologists were still unpacking, cataloging, and refurbishing objects from the newly arrived Leningrad/Leipzig collections, she got much more than she expected: she was "stunned to find museum staff busily unpacking this extraordinary Yup'ik collection, second only to Nelson's Smithsonian collection in Washington D. C. in size and scope, yet with accession records still handwritten in old German script and almost completely unpublished."[20]

Fienup-Riordan quickly realized that the Berlin museum held "arguably the finest assemblage of ethnographic objects from southwestern Alaska anywhere in the world." As a result, she spent her time not only photographing masks for her exhibit but also documenting the scope and size of the collection for the Yup'ik community. Over the next two years, she planned a second trip to the museum with a "team of Yup'ik tradition bearers and community leaders" to explore those collections more thoroughly.

Their goal was to "turn fieldwork on its head." As Bastian had anticipated, Jacobsen had created his collection at a critical moment in Yup'ik history. When he arrived in Alaska, the region still had been "largely untouched by the onrush of Euro-American colonial expansion." Yet, as this Yup'ik delegation knew very well, dramatic changes followed "close on the heels of his departure. . . . Missionaries, teachers, miners, and assorted entrepreneurs began active efforts to change the face of life along the Bering Sea coast." Much did change as a result.

The Jacobsen collections thus offered the Yup'ik delegation a unique window into the world of their ancestors before that radical transition. The group that arrived to take advantage of this sudden opportunity, some

of whom were over eighty years old, came eager to peer through that window and to engage in a model action of knowledge production based on reciprocal relations with the museum's curators. What they sought "was not so much the collection's physical return to Alaska, but the return of the history and pride that it embodied."²¹

The Yup'ik delegation, historians in their own right, did that in part during their interactions with the objects over an intense three weeks of "visual repatriation." The point of their venture—their travel to Berlin, their engagement with the objects, the recordings they made of the elders' commentary in Yup'ik, its translation into English and its later bilingual publication, as well as the translations of the German accession records— "was not to reclaim museum objects." The goal was "to reown the knowledge and experiences that the objects embodied." Yet that knowledge production also occurred as they interacted with curators and other members of the Berlin staff who eagerly worked with them, learning about the use of some objects, the origins of others, the distinctions between tribes that produced the items displayed on the workshop tables, and their differing worldviews. This was the kind of interaction Franz Boas had dreamed about back in the 1880s; the kind of exchange he had sought as he first began working with the Jacobsen collections, and as he later traveled to British Columbia in an effort to glean more information about the roles some of the objects played in their respective communities.

The process of joint knowledge production is what most matters. These 1997 meetings in the Berlin museum created a space for both the Yup'ik elders' engagement with the objects and their articulation of ideas, knowledge, and memories brought out by the encounters. The publications that followed were part of the process as well. Those texts became vehicles for sharing histories and experiences beyond the museum, the subsequent exhibitions, as well as German and Yup'ik communities. The knowledge the elders shared in those publications, Fienup-Riordan later remarked, "constitutes a 'return' not only in allowing an essential aspect of the objects Jacobsen collected to come home to Alaska but in providing elders with what they viewed as an empowering opportunity to share what they know, enriching us all in the process." ²² It was a masterful achievement that set a precedent worthy of much emulation.

That achievement was made possible by what Fienup-Riordan termed "Jacobsen's gift." After her initial interactions with the collections, she became intrigued with Jacobsen—the imperfect collector, equally imperfect husband, and complex human being. He had many limitations. His praise of the "nation of artists" he encountered along the coast of British Columbia was interspersed with derogatory remarks about some of the

FIGURE 5.9. The Yup'ik Flying Swan mask after restoration.
Staatliche Museen zu Berlin, Ethnologisches Museum.

"insolent people" he encountered. She found racist comments in his letters, and questionable actions recorded there as well. While Jacobsen purchased much of what he acquired, she learned that he also worked his way through graveyards, and as he traveled among Alaskans, he often failed to take the time to understand their rules and regulations, their modes of comportment, and their notions of reciprocity. In many cases, his trading relations took place within "grossly unequal colonial relationship with all the cards stacked on Jacobsen's side."

Still, "when Yup'ik elders visited Berlin and saw the things Jacobsen had collected, their reaction was gratitude and pride." While they never sought to lay claim to the objects, they left "with their mental suitcases filled to overflowing with new stories and experiences. They had repossessed what was truly valuable, and the museum could keep the rest."[23]

In the case of the Flying Swan mask, their position was made possible in part because such masks were made for single uses. Once used, they were meant to be discarded and then remade for the next use, the next time, for example, one needed to encourage birds to return to the coast with their nutritious eggs in the spring.

And, for the Yup'ik delegation, there was so much more to touch and to see than the beautiful masks that had held pride of place in the public displays: tools, such as harpoons, knives, and ivory thimbles; clothing ranging from decorative headdresses to boots, gloves, and parkas; dolls fashioned from antler, ivory, and wood; baskets, clay pots, wooden buckets, and "bentwood" containers; nets, net sinkers, and flotation devices; bladder water containers and the ivory funnels made to fill them; different types of bows, and varieties of arrows made for hunting and war. There were things from all walks of life, collected just as Bastian had instructed. It was a cornucopia of memories and knowledge, all tied up in the physical articulations of Weltanschauungen.

It is indeed an astonishing collection. Still, "working to collect the remnants of peoples thought to be on the edge of extinction," Fienup-Riordan remarked, "Jacobsen likely never imagined what a gift the objects he collected would be to the descendants of their makers." Nor, probably, did he imagine that this moment in the museum more than a century later would allow those descendants to offer us all a "return gift" as they interacted with the collections and shared their knowledge with the curators and later those who read the various publications.[24]

By all accounts, this was one of the most successful joint projects of its kind. It led to multiple publications, enhanced revitalization efforts in Alaska, and offered one model for future cooperation. At the same time, it taught the ethnologists in the museum many things as well, not the least of which was the value of such interactions and the possibilities inherent in bringing the collections back into circulation. Peter Bolz, the head of the American section of the museum, not only stressed how the productive the interactions between the Yup'ik and the museum ethnologists had been for the museum's staff but also how proud Bastian would have been of this action on the one hundredth anniversary of his death—much prouder, we might add, than during the christening of the first Schausammlung on the anniversary of his birth.

Bastian had always argued that ethnological museums should be well-funded sites for the joint production of knowledge about human history. Yet Bastian would probably not be surprised that little funding for this interaction came from Berlin or Germany. The Yup'ik elders' visit had to

rely on other gifts from North America. The National Science Foundation's Arctic Social Science Program, the Anchorage Museum of History and Art, the Rasmuson Foundation, The Rockefeller Foundation, and the Calista Elders Council made these interactions possible. The Museum für Völkerkunde, the city of Berlin, and the Prussian Cultural Heritage Foundation played the most minor roles, and they failed to follow up with any kind of comprehensive program to build on this success.

That is a disgrace. So much more would be possible if even a fraction of the hundreds of millions of euros that have been directed into the Humboldt Forum in central Berlin were reallocated to the collections, to collaborations, to expanding and improving the staff, and to research with the collections that remain exiled in Dahlem. So much more could be achieved if the funding were shifted from the support of yet another glitzy Schausammlung to unlocking the potential inherent in the half million objects hidden behind the scenes. The Berlin Museum für Völkerkunde was once the greatest museum of its kind. The Berlin Ethnological Museum could be that again, if the objects that have been lost for decades in boxes and depots were freed from their exile, brought back to life, and allowed to participate in knowledge production.

So much more could be achieved if we returned to the principles behind Bastian's vision and used it as a guide for future action. I am not advocating a return to the chaos of the nineteenth-century museum or Bastian's exaltation as a kind of guru. Rather I am arguing that his vision had merit. Bastian, for example, never envisioned his museum as a place for representing non-European others. Neither should we. Nor did he see it as a location for the mere illustration of arguments about human cultures or human history. Although that is what it became as it was forced to conform to more general trends in the museum world.

The point behind Bastian's museum was to create an institution for the production of knowledge about human history, and we would do well to return to that goal. Bastian focused his immense energies on collecting material culture because he recognized that all objects produced by people are historical texts that contain within them clues about the worldviews of the people who produced and used them. He also focused his energies on those things that were most in danger of disappearing, and in many cases the objects he managed to acquire for his museum are the only such records left by people living in specific times and locations. Therein lies their greatest value. We are foolish if we ignore it.

The Yup'ik visit to Berlin offers us one example of how such objects, preserved in the museum for over a century despite the many twists in

their histories, have been, and can continue to be, reactivated. It is one example of how the collections can be brought to tell their tales of the human past and how that can lead to the production of knowledge about human histories. It should inspire us to do more, to build up more such working relations, to fund more research into the collections, to free all of the collections from their cold storage.

Imagine working groups following the Yup'ik example with all the collections. Imagine their taking place publicly in the vast edifice in the city center. Imagine the public being privy to the production of knowledge, and not simply told of the results. Imagine modes in which laypeople could also participate. Here too Bastian offers us some guidance if not precise instructions.

Remember that one of Bastian's central goals was to create a space in which the collections he accumulated could be arranged geographically in large cases made of glass and steel, flooded with natural light, so that the objects were suspended in space in a way that mimicked their distribution around the globe. His goal was to create a space in which people, as they moved through those collections, could see not only individual objects but also across and through collections. Through that process, they might also ascertain relationships, similarities, and differences. The point was never to emphasize individual objects, to identify highlights for the masses to crowd around as they crowd around the *Mona Lisa* in the Louvre or the Rosetta Stone in the British Museum seeking the celebrities within the collections. The point was to take in the totality of the collections and allow understandings to emerge.

Is such a thing even possible? We are no longer dependent on natural light or those heavy steel cabinets, but we are deterred by our underestimation of publics and our unwillingness to abandon Schausammlungen. We should not be. It is time to set the collections free and to rethink the accepted notions of spatiality in museums. That is the first step forward.

Not all museums need to work in the same way, and not all ethnological museums need to fulfill the same goals or use their collections identically. The exceptional collections in Berlin's Ethnological Museum, however, do offer us some exceptional possibilities. Imagine, for example, entering a room in which the entirety of the museum's stunning collections of Hopi artifacts from the southwest United States were arranged geographically and chronologically so that one could move through the collections and look across everything as Bastian advocated. Imagine each of the over seven hundred kachina dolls offering viewers all the extant information about its origins, purposes, as well as its history in a way Bastian never

could. Visitors could pause to learn more about the origins and history of any given object, while at the same time moving about in the displays and engaging all of them from multiple directions, looking across shifting spatial and chronological relationships with every step. What would we learn as we did this alone or with others? We do not know, because these objects have never been displayed together in this or any other manner. They have only ever been stored together. We do not know what dialogues would take place or what knowledge might emerge if they were all brought out into the light. We do not yet know what the objects might teach us to see. But we should find out, and the sooner the better.

Given the breadth and size of the collections in the Berlin Ethnological Museum, it should be an institution that leads rather than follows. Bastian set out to create such an institution by attracting talent as well as funding and collections. It is high time for this institution to be well funded again. It is high time that it again boast a staff on a par with the people Bastian assembled in the 1880s and with networks akin to those he developed as he continually traveled around the world. It is also time to reverse the trends that led to the division of Bastian's pursuits into a series of academic fields and the estrangement of ethnological museums from universities. That was all part of the tragedy.

Bastian never meant to develop a unique field called ethnology; the point was to pursue a total history of humanity through whatever means necessary and possible. To that end, Bastian and his counterparts combined anthropological, archaeological, ethnological, and linguistic methods. They studied geographies and geologies, they worked in combinations of fields; they developed specializations while also engaging in joint efforts with each other and with their counterparts at other institutions and while recognizing that the project of producing a total history of humanity would likely never be completed in their lifetimes. No one expected to locate a tidy list of what Bastian called elementary ideas. The goal was simply to get as close to them as possible and, through a vast, comparative analysis of Weltanschauungen, to better understand what has been general and particular in the human condition. Those remain worthy goals, and we should stop the bickering, redirect the funding, and pursue them.

Harnessing Humboldt

AFTER TAKING POSSESSION of their *iwi kūpuna* (ancestors' remains) in October 2017, Halealoha Ayau and his team traveled from Dresden to Berlin. There are Hawaiian human remains in Berlin as well; a number of Hawaiian objects in the Berlin Ethnological Museum came from burial sites; and some, such as *Kihawahine*, have human remains integrated into them. The human teeth in *Kihawahine*'s mouth make her a fundamentally different kind of object from the other religious items in the Arning collections, not to mention the clothing, fishing hooks, jewelry, and other quotidian things he acquired. As Halealoha Ayau has sought repeatedly to explain to museum officials, publics, and a wide array of scholars, many Hawaiians believe that placing an object with the deceased creates a permanent bond between them, so that the object is forever the possession of the deceased. Consequently, funerary objects can never be regarded as abandoned things. Rather they are intimately connected to the human remains in a grave, and they must be kept with them. From the Hawaiian point of view, *Kihawahine*'s origins in a grave site, as well as the human remains in her mouth, made her removal and then her separation from the other human remains at the site especially upsetting.[1]

As a result, during their appointment with the curator in charge of the Berlin Ethnological Museum's Pacific collections, Halealoha Ayau and his team asked to see *Kihawahine* along with the other Hawaiian objects they had come to see. They also hoped to learn more about the extent of the Hawaiian human remains elsewhere in Berlin, since those too had been separated from the collections of material culture long ago. Pathologists and physical anthropologists ended up with the bones and skulls while ethnologists integrated the objects into the Berlin Museum für Völkerkunde's collections. Consequently, not everything Arning collected

is in the same institution today. Many of the bones and skulls, for example, are held by the Berlin Society for Anthropology, Ethnology, and Prehistory, a private foundation. The Hawaiians wanted to figure this out. Their questions were thus pretty basic: they wanted to know what Hawaiian artifacts and human remains were in the city, where they were located, and who was in charge of the institutions that held them. They also wanted to know how to initiate a discussion about the repatriation of human remains and funerary possessions and some of the sacred objects associated with them.

Such simple questions, however, seldom yield straightforward answers. So, Greg Johnson suggested that I accompany them to the museum. His hope, as I understood it, was that I could help them negotiate the German language, the Ethnological Museum's bureaucracy, and the structures of the Prussian Cultural Heritage Foundation. That was a tall order, and I was not much help. The foundation is notoriously complex, the bureaucracy around the museums is Byzantine, and the last few years of debates around the planned Humboldt Forum had been intense, often heated, and seldom reasonable. Moreover, the national government, the Land Berlin (Berlin is one of the Federal Republic's sixteen states as well as the capital city), the Prussian Cultural Heritage Foundation, and the foundation created for the construction of the Humboldt Forum building were all involved in the project, and they worked as much at odds with each other as together. The collaboration had not been a particularly harmonious one.

Everything about the process of rebuilding the old Berlin Palace on Unter den Linden had been controversial: from the initial act of spending over 12 million euros to tear down the former East German Palace of the Republic between 2006 and 2008 to its replacement with a new version of the old palace that for many Germans smacks of Prussian imperialism and the worst kind of German nationalism. Moreover, the decision-making process that led to the demolition of the East German building and the creation of the new one was just as opaque as the funding sources that paid for it. The new building had cost over 600 million euros by 2017, during a time when the city of Berlin was frequently short of funds and institutions such as the Ethnological Museum had been sorely neglected. It is hard to determine the costs of the content planning, but they would push the total costs much higher.

Recasting the new palace as the Humboldt Forum was a predictable sleight of hand—a way to legitimate the building and its contents by creating an association between the cosmopolitan science of Alexander von Humboldt and the imperial Prussian past. It was not a particularly clever

or original effort. Alexander von Humboldt was not a proud Prussian; he spent much of his time in Berlin wishing he could return to Paris. Still, promoters of the palace project followed a tried and true method, harnessing the Humboldt brothers' cosmopolitan reputations and their promotion and pursuit of Bildung in order to make the nationalist symbolism of the new building more palatable.

Germans all over the world have used Alexander von Humboldt's name to do precisely the same thing. It is small wonder, for example, that so many German schools in places such as Guatemala, Mexico, and Venezuela became Humboldt schools supported by self-proclaimed Humboldt associations during the postwar era. While National Socialism had tainted the German label, transforming once highly regarded and respectable German institutions abroad into suspect ones during and after World War II, Humboldt's name remained free of that. The chief associations with Humboldt remained Bildung, international science, and in the Latin American case the "second discovery" of the new world. In short, the naming of the new palace was anything but a novel act of political subterfuge, and efforts by its supporters, particularly the *Gründungsindendanten* (founding directors), to extend that Humboldtian cosmopolitanism to everything they hoped to do in the new palace were terribly transparent. It is no wonder so many people called foul.

Particularly controversial was the founding directors' defense of the decision to place the Ethnological Museum under the auspices of the Humboldt Forum and to exhibit some of its collections together with exhibitions devoted to Berlin, Humboldt University, and collections from the Asian Art Museum. The decision-making process that led to the integration of the Ethnological Museum's collections into the Humboldt Forum has its own complex history, and a series of pundits have continually recast, rewritten, and rationalized that history over the last fifteen years. In particular, Horst Bredekamp, a well-regarded art historian and one of the founding directors, has attempted to transform a random story into a logical, well-thought-out process in which the Humboldt Forum, much like the Kunstkammer that was once located in the original, nineteenth-century palace, would almost naturally include the ethnological collections. It is a reassuring teleology, but it does not make a lot of sense. Moreover, it did not fool many critical observers who participated in public condemnations of both the edifice and the decision to fill it with artifacts produced by non-Europeans.[2]

As I noted at the outset of the book, the most trenchant critiques of Bredekamp and the other founding directors' defense of the Humboldt

Forum, however, focused on their persistent unwillingness to deal directly with the legacies of German colonialism and imperialism. In addition to the criticism of the character of the neo-Prussian building or the implications of placing Berlin's ethnological collections within it, those initial debates stimulated even more heated discussions about the origins of the collections and the degree to which they are tainted by the hidden histories of Germany's colonial past.

As art historian Bénédicte Savoy argued in the summer of 2017, when she withdrew from the Board of Experts charged with channeling and shaping the character of the Humboldt Forum, neither the board nor the founding directors, to whom Cultural Commissioner Monika Grütters had assigned overall curatorial responsibility for the Humboldt Forum, were willing to deal with that "unmasterable" colonial past.[3] They were unwilling to engage the fact that there was, as she put it, blood on some of the collections. Many of the collections, she reminded everyone, were assembled during the age of empire. Some came directly from German colonies, some percentage were clearly stolen, seized during warfare, or coerced rather than purchased. She argued that the board needed to deal with that legacy and engage the realities of the collecting histories rather than use the objects to fashion a grand image of a lost cosmopolitan culture. And, to that end, funds needed to be allocated for basic research into the collections, to determine which objects had been obtained legitimately and which could be considered ill-gotten gains, and thus which should logically, and morally, be returned to the descendants of the people who had produced them.

Basically, Savoy joined a host of other activists and protesters while pointing her finger at her colleagues, particularly at the three founding directors—Horst Bredekamp, the director of Prussian Cultural Heritage Foundation Hermann Parzinger, and the newly arrived and highly celebrated director of the British Museum, Neil MacGregor. As she condemned their unwillingness to engage these colonial questions, she essentially declared that these three emperors were wearing no clothes. After she did that, the floodgates opened; public debates grew ever more heated; and open discussions about the history of the objects became more pointed, even trenchant.

Unfortunately, hyperbole inundated those debates about the colonial connections, and there was little evidence that the founding directors took their critics seriously; their responses showed little indication that they even understood the implications of their critics' concerns. As someone who wrote a book on the history of German ethnological museums during

the period in which they acquired the vast majority of their collections, I couldn't help but notice how frequently participants in those debates mis-represented and misused the history of the collections. A striking number of people on both sides of the debates (those who only wanted to under-score the cosmopolitan connections with the old palace and the collec-tions, and those who wished to focus only on colonial and postcolonial questions of guilt) have seemed keen to instrumentalize the ethnological collections and their history for their own purposes.

Perhaps that is why history seemed to be repeating itself: a giant edifice that transforms scientific collections into a municipal display? A building deemed inadequate before it is complete? Ethnologists and their efforts subordinated to the dictates of bureaucrats and politicians? Bildung usurped by Schausammlungen and edification by entertainment mixed with didactic displays? The gift shops and cafés are new, so too is the emphasis on gastronomy, staging, and events. The rest, however, is strikingly familiar to the historian of German ethnology—the division of the collections between a Schausammlung in the city center and the rest of the vast majority packed away with most of the ethnologists in the Dahlem suburb of Berlin; the folding of the Asian ethnographic collections into the Asian Art Museum; the promises of more space and better locations that lured the ethnologists into the deal and were then taken away—all of this echoes the debates from a century ago, during the age of Wilhelm von Bode, Felix von Luschan, and Konrad Theodor Preuss, about Schausam-mlungen, the division of collections, and the goals of ethnological muse-ums. Familiar too is the dramatic disjuncture between the extensive fund-ing for the municipal displays meant to impress visitors to the city's center and the limited monies allocated to support the Ethnological Museum's staff, their research, future collecting, and the kinds of collaborative work Halealoha Ayau's team hoped to initiate. In fact, the public debates' *lack* of attention to the vast majority of the objects in the collections of the Berlin Ethnological Museum has been deafening. So too has the German government's lack of attention to the pursuit of Bildung in the Ethnologi-cal Museum that the Humboldt brothers would have advocated and quite likely pursued themselves.

What Can Be Done?

I am not sure when the epiphany came; when I realized that the debates around the Humboldt Forum might be the key to unleashing the hid-den value of Berlin's ethnological collections, and perhaps even those

across the rest of Germany. Maybe it was already there as Halealoha Ayau emerged with his Hawaiian colleagues from a taxi in front of the now closed Ethnological Museum in Dahlem ready to talk. It was an impressive group. Maybe, however, it was the earnestness with which they looked at the books about the Pacific on the shelves of the curator's office where we met to talk about the collections. It might have been the way in which the group drew us together around the table after drinking coffee, stood up, had us clasp hands, and burst into a chant that lasted longer than the uninitiated might have imagined. It might have been the seriousness with which Halealoha Ayau questioned the curator about the collections, the locations of objects and human remains, and the reasons for Arning's collecting practices. Why, he wanted to know, had Arning and others separated funerary objects from the bones and skulls found in the same locations? From his perspective, that should never have happened. Perhaps it was because the curator was so forthcoming, so eager to work with them, making sure that objects they identified at the last minute could be seen. I did not expect that. There is no question that I felt privileged to have the chance to see them present the curator with a different ontology, to explain the ways in which they related to and communicated with the remains and culturally significant objects. But it was more than that.

During that meeting I saw a way out of the conundrum that is the Humboldt Forum and a means to resolve the tragic history of the Berlin Ethnological Museum. Working relations like those Halealoha Ayau and his team were trying to build are the future of German ethnological museums, and the best relations require openness to cultural difference as well as a keen understanding of the history of the collections. Through a combination of contemporary technology—new modes of communication, exhibition, and reproduction—new information, brought to the museums by indigenous participants, and a new generation of curators and directors, who are more willing to work with these indigenous groups and less insistent about guarding and hiding their collections and histories, the museums, perhaps for the first time, have the potential to achieve a good part of the Humboldtian goals that drove their creation. For the first time in a very long time, they have the chance to fulfill part of Bastian's vision.

After all, I thought to myself while contemplating the repatriation scene in the museum, the entrance to Bastian's museum was dominated by a giant statue of Buddha, the symbol of a religion Bastian had studied across decades in situ and contemplated his entire life. Why is that part of the museum's history being ignored? Just consider Arning's collections: the vast majority of what he acquired were everyday objects, collected

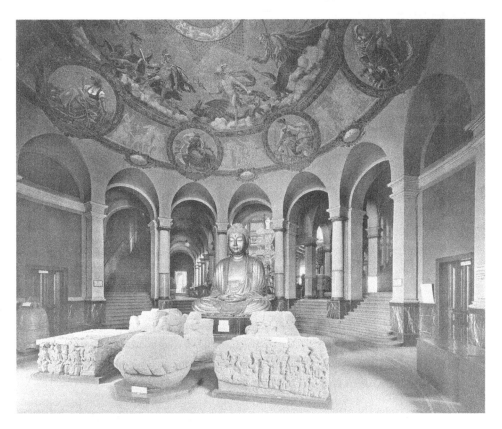

FIGURE E.1. The Buddha statue centered in the entryway to Bastian's museum.
European mosaics are above it, Latin American sculptures surround it.
Staatliche Museen zu Berlin, Ethnologisches Museum.

while he was working as a physician for the Hawaiian government, pub-
licly displayed in rooms where locals helped him to understand their
importance and uses. Even King Kalākaua participated in these discus-
sions. The king was so impressed with *Kihawahine* he had an artist make
a watercolor drawing of her before Arning transported her to Berlin.[4] It
was, in fact, those local Hawaiians who enabled Arning to preserve exten-
sive information about the individual objects that he transferred to the
Berlin Museum für Völkerkunde, and which remain extant in the Berlin
Ethnological Museum.

With the help of local Hawaiians and the Hawaiian government, in
other words, Arning saved a lot. For better or worse, the Berlin Museum
für Völkerkunde preserved histories that became hidden on the islands.
As a result, people like Halealoha Ayau and his colleagues can work with
the museum's ethnologists and others today. They can build new working

relationships and harness these objects to help all of us better understand German, Hawaiian, and human histories. It may be that some of those objects, such as *Kihawahine*, will return to the islands. But that cannot be the end of the story. Rather, as Halealoha Ayau has long argued, it is just part of the next chapter.

A central problem with the public debates about the collections in German ethnological museums has been that no one discusses the uncontroversial objects, their hidden histories, and their great potential. Nevertheless, the arguments that have taken place in the public debates underscoring the importance of pursuing research into the colonial collections could and should be extended to all of the collections.

It is hard not to wonder why the founding directors of the Humboldt Forum and their critics spent years ignoring the vast majority of the collections in the Berlin Ethnological Museum and their histories. In part, the answer is because most people have no idea what is in these museums, and even fewer understand the history of the collecting that brought those objects to Berlin and other cities in German-speaking Europe. Moreover, there is a tendency to think that the ethnologists who created those collections were driven by outdated goals and concerns. Yet that was not the case, and every now and then people notice that those nineteenth-century scholars still have much to teach us in the present.

In 1961, for example, Franz Termer, at the end of his career as the director of the Hamburgisches Museum für Völkerkunde, took it upon himself to translate parts of Bastian's 1876 Guatemalan travel narratives into Spanish. He did that because, after a scholar in Guatemala wrote to ask him who Adolf Bastian had been and what he had done, Termer returned to Bastian's volumes on Latin America and realized there was "much interesting material also about antiquities in it, that hardly a German colleague knows today, let alone the one who lives in the Bastian traveled countries of Latin America."[5] He knew that basically meant no one, and he realized that simply by pulling the dusty volume off his shelf and opening it up, he had just encountered lost knowledge worth resurrecting. By translating those pages into Spanish, he sought to give his Latin American colleagues access to that historical knowledge as well.

A few years after I published *Objects of Culture: Ethnology and Ethnographic Museums in Imperial Germany* (2002), I had a similar revelation. I had been asked to give a paper on the history of German Völkerkunde and Völkerkunde Museums at the Max Planck Institute for the History of Science in Berlin. To prepare the paper for circulation, I went to the nearby library of the Berlin Ethnological Museum to dig out a citation

from a Bastian essay written in 1877, with the innocuous title "Ethno-logical Considerations." The early 2000s was at a moment when histo-rians of all kinds were excited about globalization and transnationalism. In Germany, a number of historians were challenging their colleagues to place the German past into a global context, and to think about the ways in which German history was part of world history. I too was thinking a lot about those topics, and as I found that old Bastian essay in the dusty library stacks and began scribbling down the page numbers, I inadver-tently started to read it. A little while later, I found myself sitting on the floor engrossed and flabbergasted at how much Bastian had already been thinking about Germans' history as part of a total world history, how he had already thought about the flows of people across space and time, and how his history had already been, from the outset, the kind of transna-tional history many of my colleagues were urging us all to pursue. In short, I was stunned by Bastian's global vision; I was taken aback by the degree to which he and his assistants had already been engaging the questions of my age long before I was born. Moreover, I was overcome by the recogni-tion that I could have written a completely different and probably much better book, if only I had been paying attention to those things a few years earlier.

Such insights into the breadth of human history, however, can be gleaned not only in those old texts written by Bastian, his colleagues, and their many students but also in the objects they collected. It is high time to release them. As Bastian made crystal clear over the course of his life-time, he knew the power of objects. He also knew that display, knowl-edge, research, and science should not be divided. That is why that first guidebook to his 1886 museum opens with such a salvo, a resounding call to understand the potential in the collections and their use in a vast com-parative analysis.

The problem, however, as Bastian also knew, is that the objects' poten-tial cannot be released if they are packed away, and the dirty little secret is that the vast majority of the objects in the Berlin Ethnological Museum, like most of its counterparts in the Western world, have been packed away for decades, and in many cases, for the better part of the twentieth century.

The tragedy of these collections is that Berlin's ethnologists have waited for generations to get them out and working, passing down, in many cases, the hope that a new day would come, a day in which buildings would be created with sufficient space to exhibit the breadth of the collections and funds would be allocated to support the staff needed to care for and work with them. That hope, however, was dashed again and again. Even when

the first self-standing ethnological museum building opened its doors in Berlin in 1886, it was already too small for the collections. The chaos that ensued is well documented, and by now that failure is a well-known story. But the part of the story that so many people seem to be missing is that the decade-and-a-half-long discussions around the Humboldt Forum, with all the promises that were made to Berlin's ethnologists and then rescinded, with all the debates about public displays planned for the Humboldt Forum, the facilities promised to hold the rest of the collections, and the minor role assigned to research in both the private planning and public discussions before the public debates became especially heated—these are as old as the museum itself.

What is new, of course, are current, twenty-first-century questions of repatriation and the emphasis on guilt that drives much of the criticism hurled at the Humboldt Forum. *Vergangenheitsbewältigung*, the reckoning with the past, remains a leitmotif of postwar German history, and in many ways the emphasis on colonialism and the call for repatriation in the debates around the Humboldt Forum have been part and parcel of a much longer effort to come to terms with the German past. Yet the question of repatriation is not new in global debates about ethnological collections. They are just now being revisited in Germany in ways that, unfortunately, too often hide the complexities in the histories of ethnological collecting and obscure the ontologies tied to objects that, once recognized, make simple political arguments untenable.

I said this at the outset of the book and I will say it here again: the question that should concern us is not repatriation yes or no, but what should be done with these collections today? Repatriation is only one, small part of the answer. Anyone interested in the complexities that dominate this question and its answers would do well to read Chip Colwell's recent book, *Plundered Skulls and Stolen Spirits: Inside the Fight to Reclaim Native America's Culture*. Colwell began his career as an anthropologist at the Denver Museum of Nature and Science in the years after the Native American Graves Protection and Repatriation Act of 1990 changed the legal contexts in which US museums operated. As a result, he waded into an explosive context. As he explains, literally "hundreds of [American Indian] tribes have confronted 1,500 museums over the fate of more than 200,000 Native skeletons and 1 million grave goods and sacred objects." Determined to find common ground with those tribes and the members, Colwell approached his job with naïve enthusiasm. He wanted to do the right thing. That, however, proved to be anything but straightforward.

His revelation is worth quoting at length:

after my first days on the job, I learned that common ground is so elusive because every object contains within it the seeds of conflict that have germinated over the decades between religious freedom and academic freedom, spiritual truths and scientific facts, moral rights and legal duties, preserving historical objects and perpetuating living cultures. When I followed the biography of each object, I saw the bright line between right and wrong fade to shades of gray. I learned that sometimes it was tribal members who stole objects and sometimes curators who wanted to give things back. Sometimes it was Indians who worked for museums and non-Indians who worked for tribes. Sometimes keeping an object in a museum destroyed it, while allowing it to naturally decay gave it life. As I was learning [one] summer morning [during a negotiation], some of the hardest fights are those *within* a tribe [his emphasis]. Repatriation, I discovered, is a tangled web.[6]

It is not as if the vast majority of curators who work in German ethnological museums today do not know this. They do. In fact, it was so odd for me, even upsetting for me, as someone who began working with these people decades ago, to read quips in German newspapers about the need for provenance research—written as if provenance research is a new idea: as if many German curators had not devoted much of their careers to researching their collections. Many did, and many of them helped me with my dissertation research in the 1990s. Many of them have also written extensively about their findings since then. Indeed, many still are currently, quietly, doing what they can with shamefully small budgets and within stunningly opaque bureaucratic structures to work with repatriation claims and reach out to non-European communities.

With good reason: because that is where part of the future lies, even if the debates about colonialism and repatriation tend to obscure the inherent potential and the incredible importance of the half million objects in the Berlin Ethnological Museum for our understanding of world histories. The fact of the matter is: this and other ethnological museums are filled with unique historical traces, material objects that are also texts. On this point Bastian was right. While those "texts" contain vast amounts of information about human history, they are more than that. The objects are varied, their histories numerous, and they have much to teach us about different ontologies, about different worldviews, and ultimately about the human condition.

The upshot is this: Bastian's museum can be saved. It does not have to end as the institute Wilhelm von Bode wanted, as another soulless Schausammlung dressed up with an espresso bar. Yet to save it, priorities have to change: funding has to be redirected away from the Humboldt Forum as a municipal display—a statement of self-aggrandizement—and toward restaffing the museum with experienced, motivated curators, supporting basic research with the collections, reconnecting that research to the universities, funding working relations with indigenous groups that are willing, like the Yup'ik elders of the 1990s or Halealoha Ayau's team in 2017, to build working relationships while unpacking the treasures in the museum and releasing their secrets about human histories. Bastian left that task for future generations. Now is the time to pursue it in earnest.

Introduction. Kihawahine: *The Future in the Past*

1. Halealoha Ayau long worked with Hui Mālama I Nā Kūpuna ʻO Hawaiʻi Nei, a leading group in indigenous repatriation worldwide, as its executive director; he was accompanied by Kaleikoa Ka`eo, a Hawaiian studies professor and renowned sovereignty activist; Noelle Kahanu, a museum studies professor; Keliʻikanakaʻoleohaʻililani, a representative of the Edith Kanakaʻole Foundation, who was the group's lead chanter and ritual protocol expert; and Kamanaʻopono Crabbe, a cultural protocol practitioner and CEO of the Office of Hawaiian Affairs, which supported the trip.

2. Big Island Video News, "Germany Returns iwi kupuna to Hawaiʻi (Oct. 26, 2017), http://www.bigislandvideonews.com/2017/10/27/video-germany-returns-iwi-kupuna-to-hawaii/.

3. "Ethnographie von Hawaii, Conferenz vom 11. Februar 1887, 3 Uhr Nachmittags, in der Aula des Museums für Völkerkunde," *Zeitschrift für Ethnologie* 19 (1887): 129–38.

4. Bastian, "Über Ethnologische Sammlungen," 42.

Chapter One. *Hawaiian Feather Cloaks and Mayan Sculptures: Collecting Origins*

1. He remarked on that poverty in a letter to the Prussian king, which has since been lost. Meuß, "Die Beziehungen König Friedrich Wilhelms III. und König Friedrich Wilhelms IV. zu Kamehameha III. von Hawaii."

2. Ibid.

3. Kaeppler, "Feather Cloaks, Ship Captains and Lords."

4. Schasler, *Die Königlichen Museen von Berlin.*

5. Meyen, *Die Kunstkammer und Sammlung Völkerkunde im Neuen Museum.*

6. Bastian, *Der Mensch in der Geschichte.*

7. Ibid., xvi.

8. Ibid., xiv.

9. Ibid., x.

10. Ibid., xi, xiii, xv.

11. Ibid., xv, xiv.

12. Ibid., 12–13.

13. Ibid., 9.

14. Ibid., 10.

15. Bastian, *Die Voelker des Oestlichen Asien*, vol. 2:4.

16. Ibid., 7.

17. Ibid., 72, 74.

18. Ibid., 86, 90.

19. Ibid., 139–40.

20. Ibid., 143.
21. Steinen, "Gedächtnissrede auf Adolf Bastian," 240.
22. Ibid., 236, 242–43.
23. Ibid., 243.
24. Ibid.
25. Bastian, *Die Culturländer des Alten America*, vol. I.
26. Ibid., 14.
27. Ibid., 34.
28. Ibid., 38.
29. Fischer, "Adolf Bastian's Travels in the Americas," 192.
30. Bastian, *Die Culturländer des Alten America*, 47.
31. Ibid., 53.
32. Ibid., 69.
33. Haas, "Wilhelm Reiss und Alphons Strübel."
34. Bastian, *Die Culturländer des Alten America*, 84.
35. Fischer, "Adolf Bastian's Travels in the Americas," 193.
36. Adolf Bastian, *Die Culturländer des Alten America*, 279.
37. Ibid., 284–85.
38. Ibid., 286.
39. Ibid., 325.
40. Ibid., 333.
41. Ibid., 373, 383, 391.
42. Bastian, "Die Monumente in Santa Lucía de Cotzumalhuapan."
43. Fischer, "Adolf Bastian's Travels in the Americas," 201.
44. Steinen, "Gedächtnissrede auf Adolf Bastian," 248.

Chapter Two. The Haida Crest Pole and the Nootka Eagle Mask: Hypercollecting

1. I have kept the translations of Jacobsen's language (as for others quoted here) as close as possible to the German he used in his letters.

2. Jacobsen to Bastian, September 8, 1881; September 18, 1881 in Staatliche Museen zu Berlin, Museum für Völkerkunde, "Ewerbung der Sammlungen Jacobsen, vol. II" (EMB Jacobsen).

3. Jacobsen, *Captain Jacobsen's Reise an der Nordwestküste Amerikas*.

4. Jacobsen to Bastian, May 27, 1882, in EMB Jacobsen.

5. Jacobsen, *Captain Jacobsen's Reise*, 37–44.

6. Jacobsen to Bastian, October 4, 1881, in EMB Jacobsen.

7. "Wie ich in Verbindung mit Hagenbech kahm!" in Jacobsen Nachlass, Museum am Rothenbaum (MARKK), Hamburg (JN Hamburg).

8. Jacobsen to Bastian, January 20, 1882, in EMB Jacobsen.

9. Jacobsen to Bastian, May 15, 1883, in EMB Jacobsen.

10. Bastian, *Der Völkergedanke im Aufbau einer Wissenschaft von Menschen*.

11. Bastian to GVKM, June 1, 1881, in Geheimes Staatsarchiv Preussischer Kulturbesitz Rep. 76, Ve. Sekt. 15., Abt. XI., Nr 2, Bd. III.

12. This would translate as Auxiliary Committee for the Increase of the Ethnological Collections of the Royal Museums of Berlin.

13. BGAEU to the GVKM, May 25, 1884 in EMB, "Erwerbung der Sammlungen Jacobsen," vol I. 869/84.

14. Geheimes Staatsarchiv Preussischer Kulturbesitz Rep. 76, Ve. Sekt. 15., Abt. XI., Nr 2, Bd V.

15. Schulze to Bastian, 9 June 1881, in EMB Jacobsen.

16. Cole, *Franz Boas*, 94–98.

17. Kasten, "Masken, Mythen und Indianer."

18. Boas to von Luschan, 23 November 1886 in Luschan Nachlass, Staatsbibliothek Berlin.

19. Cole, *Franz Boas*, 222.

20. *Führer durch die Sammlungen des Museums für Völkerkunde* (Berlin: W. Spemann, 1887), 8.

21. Ibid., 7–11.

22. Bastian, *Führer durch die Ethnographische Abteilung* (Berlin, 1877).

23. Bastian to the GVKM, December 19, 1879 (777/83) in EMB "Die Gründung des Museums," vol. I (1872–93).

24. Bastian to Puttkamer, August 17, 1880, in Geheimes Staatsarchiv Preussischer Kulturbesitz, I. HA Rep. 76 Ve. Sekt. 15. Abt. III. Nr. 2 Bd II.

25. *Führer durch die Sammlungen des Museums für Völkerkunde* (Berlin: W. Spemann, 1887), 90, 115, 210, 213–14, 221.

26. *Führer durch die Sammlungen des Museums für Völkerkunde* (Berlin: W. Spemann, 1892), 8.

27. *Vossische Zeitung*, June 1900.

28. *Vossische Zeitung*, July 6, 1900.

29. Bastian, *Die Heilige Sage der Polynesier*, vi–vii.

30. Bastian to Lucanus, November 25, 1903, in Geheimes Staatsarchiv Preussischer Kulturbesitz, Rep. 89 H, vol. III (20491), S. 49–51.

31. Bastian November 17, 1900; Luschan, November 14, 1900; Grünwedel, November 15, 1900; Steinen, November 26, 1900; Müller, November 15, 1900, in EMB "Erweiterungsbau des Königlichen Museums für Völkerkunde," vol. I.

32. Von Bode Denkschift, February 1907 in EMB, "Erweiterungsbau des Königlichen Museums für Völkerkunde," vol. III, 441/07.

33. Westphal-Hellbusch, "Zur Geschichte des Museums," 27; Bode, *Mein Leben*, 369.

34. 46. Sitzung des Berliner Abgeordnetenhauses, March 27, 1912, in EMB, "Erweiterungsbau des Königlichen Museums für Völkerkunde," vol. IV, 133/12.

Chapter Three. Benin Bronzes: Colonial Questions

1. Luschan to Grünwedel, July 25, 1897, in EMB, "Die Erwerbung ethnologischer Gegenstuande aus der Benin-Expedition" (MfV Benin), vol. 1, 937/97.

2. Luschan, *Die Altertümer von Benin*, 1.

3. Luschan to Meyer, August 6, 1897, in MfV Benin, vol. I.

4. Correspondenz-Blatt der deutschen Gesellschaft für Anthropologie, Ethnologie, und Urgeschichte, XXIX, no. 8, August 1898.

5. Luschan to Brinckmann, August 13, 1897, in MfV Benin, vol. I.

6. Luschan to Meyer, August 12, 1897; Heger to Luschan, August 14, 1897, in MfV Benin, vol. I; Luschan, *Die Altertümer von Benin*, 8.

7. Luschan to Baessler, November 9, 1899, in MfV Benin, vol. III.

8. Luschan to Dorsey, November 23, 1898, and February 18, 1899, in MfV Benin, vol. II.

9. Luschan to Graf Linden, November 28, 1898, in MfV Benin, vol. II.

10. Luschan, *Die Altertümer von Benin*, 15.

11. Ibid., 21–23.

12. Ibid., 23–24.

13. Ibid., 1.

14. Du Bois, *The World and Africa*, 5.

15. Luschan, *Völker, Rassen, und Sprachen*, 68, 111–112.

16. Ibid., 326.

17. Ibid., viii.

18. Luschan, "Ziele und Wege der Völkerkunde in den deutschen Schutzgebieten."

19. Luschan, "Sammlung Baessler."

20. Jacobsen to Bastian, May 15, 1883, and October 8, 1883, in EMB Jacobsen.

21. Schöne to Gohsler, March 14, 1885, in Geheimes Staatsarchiv Preussischer Kulturbesitz Rep. 76, Ve. Sekt. 15., Abt. XI., Nr 2, Band VI.

22. Weule to Linden, January 27, 1904, in Museum für Völkerkunde zu Leipzig, KB 3–4: 487.

23. Thilenius to Luschan, March 27, 1906; Luschan to Thilenius, March 30, 1906; Jacobi to Thilenius, March 11, 1911; MARKK D 2.23, "Sammlungen aus der deutschen Schutzgebieten."

24. 1906 Luschan Gutachten, in Staatliche Museen zu Berlin, Museum für Völkerkunde, "Erweiterungsbau des Königlichen Museums für Völkerkunde," vol. 3, 564/06.

25. Bastian, 24. Juli 1900 PAAA, 37869 Band 5, 75–6.

26. Luschan to the GVKM, October 12, 1903, in Staatliche Museen zu Berlin Museum für Völkerkunde, "Erweiterungsbau des Königlichen Museums für Völkerkunde," vol. 2, 1901–1906 (1286/1903).

Chapter Four. Guatamalan Textiles: Persisting Global Networks

1. Georg Thilenius, Auszug aus dem Protokolle der Kommission, January 26, 1911 in MARKK, Vermehrung IV.

2. Corinna Raddatz, unpublished manuscript on the Elmenhorst collection in MARKK. For an extensive discussion of these collections, see Köpke, *Herz der Maya*, and Köpke/Schmelz, *Elmenhorst & Co.*

3. R. Burkitt to Termer, October 12, 1938, in MARKK, Franz Termer Nachlass, TER, 102 "Korrespondenz" (TER 102).

4. Termer to Norle (Nora), October 27, 1938, in TER 102. Termer's spellings for place-names are retained throughout.

5. Termer to Norle, November 19, 1938, in TER 102.

6. Termer to Norle, November 27, 1938, in TER 102.

7. Termer to K. Sapper, November 15, 1925, in TER 101.

8. Termer to K. Sapper, November 15, 1925, in TER 101

9. Termer to K. Sapper, November 20, 1925, in TER 101.

10. Termer to K. Sapper, December 10, 1925, in TER 101.

11. Termer to K. Sapper, May 20, 1926, in TER 101.

12. Termer to K. Sapper, January 5, 1926, in TER 101.

13. K. Sapper to Termer, August 22, 1926, in TER 101.

14. K. Sapper to Termer, August 11, 1928 in TER 101.

15. Chinchilla Aguilar to Termer, December 4, 1963; Termer to Chinchilla Aguilar, February 25, 1964, in TER 22.1. In particular, he stressed the importance of Carl Gustav Bernoulli, from Switzerland, an early explorer of the Mayan cities of Copán, Palenque, and Tikal; Karl Hermann Berendt, an ethnologist and linguist who had helped Bastian obtain the stone slabs from Santa Lucía Cotzumalguapa, and Edwin Rockstroh, a professor of mathematics at the Instituto Nacional in Guatemala City, who led the effort to map the border between Guatemala and Mexico and located many of the ruins others made famous with their excavations.

16. Undated 1939 Termer Manuscript, in TER 103.

17. E. P. Dieseldorff to K. Sapper, September 19, 1932, in MARKK, Sapper Nachlass, SAP 2.5.

18. Termer to K. Sapper, November 24, 1925, in TER 101.

19. Termer to K. Sapper, Sept 7, 1928, in TER 104.

20. Termer to K. Sapper, November 9, 1938, in TER 102.

21. Termer to K. Sapper, November 19, 1939, in TER 104.

22. Meissner to Termer, August 2, 1939, in TER 103.

23. Termer to K. Sapper, February 3, 1941, in TER 104.

24. Termer, "Erwin Paul Dieseldorff," 88.

25. Termer to K. Sapper, February 27, 1936, in TER 104.

26. Termer to Hans Plischke, November 27, 1938, in TER 104.

27. Termer to C. L. Nottebohm, December 23, 1938, in TER 104.

28. Termer to Plank, February 4, 1939, in TER 103.

29. Termer, "Boas zu 50 jährigen Doktorjubiläum," 319.

30. Termer to K. Sapper, October 14, 1941, in TER 104.

31. Termer to K. Sapper, December 30, 1942, in TER 104.

32. Termer to K. Sapper, January 28, 1945, in TER 104.

33. Termer to Leuzinger April 8, 1949, in TER 1001–1 Nr. 334.

34. Termer to D. Sapper July 10, 1949, in TER 1001–1 Nr. 334.

35. Termer, Bericht,October 3, 1945 in TER 1001–1 Nr. 334.

36. Mann to Termer, January 24, 1961, in TER 22.2.

37. Mann, "Kafee-Pflanzer—Im Lande des ewigen Frühlings," memoir, in the possession of Regina Wagner.

38. Elly von Kuhlmann to Termer, October 20, 1962, and December 11, 1962, in TER 22.1.

Chapter Five. The Yup'ik Flying Swan Mask: The Past in the Future

1. Krieger, "Abteilung Afrika," 126–29; and Westphal-Hellbusch, "Zur Geschichte des Museums," 51–52.

2. Irene Kühnel-Kunze, Bergung—Evakuierung—Rückführung, 61–76.

3. Westphal-Hellbusch, "Zur Geschichte des Museums," 58.

4. Schade, "Kriegsbeute," 199–25.

5. Schorch, "Two Germanies," 171–185.

6. I am grateful to Philipp Schorch for his help with this story of the Leningrad collection.

7. Höpfner, "Die Rückführung der 'Leningrad-Sammlung,'" 163.

8. Krieger, "Abteilung Afrika," 119.

9. Preuss, "Die Neuaufstellung des Museums für Völkerkunde," 69–72.

10. *Bericht über die Tagung der deutschen Ethnologen zu Frankfurt a. M. vom 19. bis 21. September 1946* (Hamburg: Hamburgisches Museum für Völkerkunde, 1947), 9.

11. Fischer, *Völkerkunde im Nationalsozialismus*.

12. Ibid.

13. Geisenhainer, "Rassenkunde zwischen Metaphorik und Metatheorie," 83–102; Kulick-Aldag, "Hans Plischke in Göttingen," 103–114.

14. Hauschild, *Lebenslust und Fremdenfurcht*.

15. Winkelmann, "Die Bürgerliche Ethnographie im Dienste der Kolonialpolitik." Gothsch, *Die deutsche Völkerkunde und ihr Verhältnis zum Kolonialismus*.

16. Haller, *Die Suche nach dem Fremden*, 196–203.

17. Koch "Abteilung Südsee," 141–74.

18. Ibid., 161.

19. Ibid., 174.

20. Fienup-Riordan, *Ciuliamta Akluit*, xviii.

21. Ibid., xviii. Fienup-Riordan, *Things of Our Ancestors*, xii.

22. Fienup-Riordan, *Ciuliamta Akluit*, xxiii.

23. Fienup-Riordan, *Yup'ik Elders at the Ethnologisches Museum Berlin*, 33–35.

24. Ibid., xiii.

Epilogue: Harnessing Humboldt

1. See *inter alia*, Ayau and Keeler, "Injustice, Human Rights, and Intellectual Savagery. A Review," 80–98.

2. Bredekamp and Schuster, *Das Humboldt Forum*.

3. Häntzschel, "Kunsthistorikerin über das Humboldt-Forum."

4. It is unclear if King Kalākaua knew of *Kihawahine*'s origins in a stone-lined hole on the coast. However, there is no question that the acquisition of *Kihawahine* from a burial site violated an existing criminal law under the Hawaiian Kingdom's Penal Code that protected places of sepulchure (1860). Any official's failure to enforce this violation of the law would amount to his aiding and abetting the crime of removing the contents of a burial site (human skull) and two funerary possessions including *Kihawahine*. Participation of a government official would not legitimate the acquisition.

5. Termer to Ernesto Schaeffer, September 1961, in TER. 22.3.

6. Colwell, *Plundered Skulls and Stolen Spirits*, 4, 8.

Citations in the text are limited to direct quotations. An extended bibliography is included below for readers who would like to pursue topics in more depth.

Cited Published Sources

Akluit, Ciuliamta. Edited by Ann Fienup-Riordan. *Things of Our Ancestors: Yup'ik Elders Explore the Jacobsen Collection at the Ethnologisches Museum Berlin*. Seattle: University of Washington Press, 2005.

Ayau, Edward Halealoha, and Honor Keeler. "Injustice, Human Rights, and Intellectual Savagery: A Review." In "Human Remains in Museums and Collections: A Critical Engagement with the 'Recommendations for the Care of Humans Remains in Museums and Collections' of the German Museums Association." Edited by Larissa Förster and Sarah Fründt. *Historisches Forum* 21 (2017): 80–98.

Bastian, Adolf. *Die Culturländer des Alten America*. Vol. I. Berlin: Weidmannsche Buchhandlung, 1878.

———. *Führer durch die Ethnographische Abteilung*. Berlin, 1877.

———. *Die Heilige Sage der Polynesier: Kosmogonie und Theogonie*. Leipzig: F. A. Brockhaus, 1881.

———. *Der Mensch in der Geschichte: Zur Begründung einer psychologischen Weltanschauung*. Leipzig: Otto Wigand, 1860.

———. "Die Monumente in Santa Lucia de Cotzumalhuapan." *Zeitschrift für Ethnologie* (1876): 322–26.

———. "Über Ethnologische Sammlungen." *Zeitschrift für Ethnologie* 17 (1885): 38–42.

———. *Die Voelker des Oestlichen Asien*. Vols. 1 and 2. Leipzig: Otto Wigand, 1866.

———. *Der Völkergedanke im Aufbau einer Wissenschaft von Menschen und seine Begründung auf ethnologische Sammlungen*. Berlin: Ferd. Dümmlers Verlagsbuchhandlung, 1881.

Bode, Wilhelm von. *Mein Leben*. Berlin: Nicolaische Verlagsbuchhandlung, 1930.

Bredekamp, Horst, and Peter-Klaus Schuster, eds. *Das Humboldt Forum: Die Wiedergewinnung der Idee*. Berlin: Wagenbach, 2016.

Cole, Douglas. *Franz Boas: The Early Years, 1858–1906*. Seattle: University of Washington Press, 1999.

Colwell, Chip. *Plundered Skulls and Stolen Spirits: Inside the Fight to Reclaim Native America's Culture*. Chicago: University of Chicago Press, 2017.

Du Bois, W. E. B. *The World and Africa*. New York: International Publishers, 1965.

Fienup-Riordan, Ann. *Things of Our Ancestors: Yup'ik Elders at the Ethnologisches Museum Berlin; Fieldwork Turned on Its Head*. Seattle: University of Washington Press, 2005.

Fischer, Hans. *Völkerkunde im Nationalsozialismus: Aspekte der Anpassung, Affinität und Behauptung einer Wissenschaftlichen Disziplin*. Hamburg: Dietrich Reimer Verlag, 1990.

Fischer, Manuela. "Adolf Bastian's Travels in the Americas (1875–1876)." In *Adolf Bastian and His Universal Archive of Humanity: The Origins of German Anthropology*. Edited by Manuela Fischer, Peter Bolz, and Susan Kamel, 191–206. Hildesheim: Goerg Olms, 2007.

Geisenhainer, Katja. "Rassenkunde zwischen Metaphorik und Metatheorie—Otto Reche." In *Ethnologie und Nationalsozialismus*. Edited by Berhard Steck, 83–102. Gehren: Escher Verlag, 2000.

Gothsch, Manfred. *Die deutsche Völkerkunde und ihr Verhältnis zum Kolonialismus: Ein Beitrag zur kolonialideologischen und kolonialpraktischen Bedeutung der deutschen Völkerkunde in der Zeit von 1870 bis 1945*. Baden-Baden: Nomos Verlagsgesellschaft, 1983.

Haller, Dieter. *Die Suche nach dem Fremden: Geschichte der Ethnologie in der Bundesrepublik, 1945–1990*. Frankfurt am Main: Campus Verlag, 2012.

Häntzschel, Jörg. "Kunsthistorikerin über das Humboldt-Forum: Ein unlösbarer Widerspruch" [Interview with B. Savoy]. *Süddeutsche Zeitung*, Feuilleton, November 21, 2017.

Haas, Richard. "Wilhelm Reiss und Alphons Strübel und die Sammlung aus dem Gräberfeld von Ancon, Peru." *Baessler-Archiv*, NF 38 (1985): 77–97.

Höpfner, Gerd. "Die Rückführung der 'Leningrad-Sammlung' des Museums für Völkekunde." *Jahrbuch des Preußischer Kulturbesitz*, 29 (1992):157–71.

Hauschild, Thomas. *Lebenslust und Fremdenfurcht: Ethnologie im Dritten Reich*. Frankfurt am Main: Suhrkamp, 1995.

Kasten, Eric. "Masken, Mythen und Indianer: Franz Boas' Ethnographie und Museumskunde." In *Franz Boas: Ethnologe, Anthropologe, Sprachwissenschaftler*. Edited by Michael Dürr, 79–102. Berlin: Staatsbibliothek, 1992.

Koch, Gerd. "Abteilung Südsee." Hundert Jahre Museum für Völkerkunde Berlin. *Baessler-Archiv*, N. F. 21 (1973): 141–74.

Königlichen Museen zu Berlin. *Führer durch die Sammlungen des Museums für Völkerkunde* (Berlin: W. Spemann, 1887, 1892, 1895).

Köpke, Wolf. *Herz der Maya*. Hamburg: Hamburgisches Museum für Völkerkunde (2010).

———, and Bernd Schmelz. *Elmenhorst & Co.: 150 Jahre Hamburger Sammlungen zu den Maya aus Guatemala*. Hamburg: Hamburgisches Museum für Völkerkunde, 2011.

Kulick-Aldag, Renate. "Hans Plischke in Göttingen." In *Ethnologie und Nationalsozialismus*. Edited by Berhard Steck, 103–14. Gehren: Escher, 2000.

Luschan, Felix von. *Die Altertümer von Benin*. Berlin: Georg Reimer, 1919.

———. "Sammlung Baessler: Schädel von den Polynesischen Inseln; Gesammelt und nach Fundorten beschrieben von Arthur Baessler." *Veröffentlichung aus dem Königlichen Museum für Völkerkunde*, 12. Berlin: Georg Reimer, 1907.

———. *Völker, Rassen, und Sprachen*, 2nd ed. Berlin: Deutsche Buch-Gemeinschaft, 1927.

———. "Ziele und Wege der Völkerkunde in den deutschen Schutzgebieten." *Verhandlungen des Deutschen Kolonial Kongresses* (1902): 163–74.

Jacobsen, Johan Adrian. *Captain Jacobsen's Reise an der Nordwestküste Amerikas 1881-1883 zum Zwecke ethnologischer Sammlungen und Erkundigungen nebst Beschreibung persönlicher Erlebnisse für den deutschen Leserkreis bearbeitet von A. Woldt.* Leipzig: Max Spohr, 1884.

Kaeppler, Adrienne. "Feather Cloaks, Ship Captains and Lords." *Bishop Museum Occasional Papers* 24, no. 6 (1970): 92-114.

Krieger, Kurt. "Abteilung Afrika." *Hundert Jahre Museum für Völkerkunde Berlin, Baessler-Archiv,* N. F. 21 (1973): 101-40.

Kühnel-Kunze, Irene. *Bergung—Evakuierung—Rückführung: Die Berliner Museen in den Jahren 1939-1959.* Berlin: Gebrüder Mann, 1984.

Meuß, Johann Friedrich. "Die Beziehungen König Friedrich Wilhelms III. und König Friedrich Wilhelms IV. zu Kamehameha III. von Hawaii." *Hohenzollern-Jahrbuch* 16 (1912): 65-72.

Meyen, A. *Die Kunstkammer und Sammlung Völkerkunde im Neuen Museum.* Berlin: Selbstverlag, 1861.

Preuss, Konrad Theodor. "Die Neuaufstellung des Museums für Völkerkunde. Allgemeine Bemerkungen." *Jahrbuch der Berliner Museen* 47 (1926): 69-72.

Schade, Gisela. "Kriegsbeute—oder, Weltschätze der Kunst, der Menschheit bewahrt?' Beschlagnahme deutscher Kulturgüter durch die Sowjetunion am Ende des Zweiten Weltkrieges und ihre teilweise Rückkehr zwischen 1955 und 1958." *Jahrbuch Preußischer Kulturbesitz* 41 (2004): 199-25.

Schasler, Max. *Die Königlichen Museen von Berlin: Ein praktisches Handbuch zum Besuch der Galerien, Sammlungen und Kunstschätze derselben.* Berlin: Nicolai, 1865.

Schorch, Philipp. "Two Germanies: Ethnographic Museums, (Post)colonial Exhibitions, and the 'Cold Odyssey' of Pacific Objects between East and West." In *Pacific Presences Volume 2: Oceanic Arts and European Museums.* Edited by Lucie Carreau, Alison Clark, Alana Jelinek, Erna Lilje, and Nicholas Thomas, 171-85. Leiden: Sidestone Press, 2018.

Termer, Franz. "Boas zu 50 jährigen Doktorjubiläum." *Forschungen und Fortschritte* 7, no. 22/23 (1931): 319.

———. "Erwin Paul Dieseldorff." *Forschungen und Fortschritte* 17, no. 7/8 (1941): 88.

Steinen, Karl von den. "Gedächtnissrede auf Adolf Bastian." *Zeitschrift für Ethnologie* 37, no. 2 (1905): 236-49.

Westphal-Hellbusch, Sigrid, "Zur Geschichte des Museums," *Hundert Jahre Museum für Völkerkunde Berlin, Baessler-Archiv,* N. F. 21 (1973): 1-99.

Winkelmann, Ingeburg. "Die Bürgerliche Ethnographie im Dienste der Kolonialpolitik des Deutschen Reiches (1870-1918)." Dissertation, Humboldt-Universität zu Berlin, 1966.

Further Reading

Ankemann, Bernhard. "Die Entwicklung der Ethnologie seit Adolf Bastian: Festvortrag in der Festsitzung zur Feier des 100. Geburtstages von Adolf Bastian." *Zeitschrift für Ethnologie* 58 (1926): 221-30.

Baehre, Rainer. "Early Anthropological Discourse on the Inuit and the Influence of Virchow on Boas." *Études/Inuit/Studies* 32, no. 2 (2008): 13-34.

Bahnson, Christian. "Über ethnographischen Museen mit besonderer Berücksichti-
gung der Sammlungen in Deutschland, Oesterreich und Italien." *Mittheilungen
der Anthropologischen Gesellschaft in Wien* 18 (1888): 109–64.

Barth, Fredrik, Andre Gingrich, Robert Parkin, and Sydel Silverman. *One Discipline,
Four Ways: British, German, French, and American Anthropology*. Chicago: Uni-
versity of Chicago Press, 2005.

Bastian, Adolf. *Alexander von Humboldt. Festrede*. Berlin: Wiegandt & Hempel, 1869.

Berg, Hans. "Adolf Bastian and His Relationship to Southeast Asia." In *Adolf Bastian
and His Universal Archive of Humanity*. Edited by Manuela Fischer, Peter Bolz,
and Susan Kamel, 222–32. Hildesheim: G. Olms, 2007.

Blackhawk, Ned, and Isaiah Lorado Wilner, eds. *Indigenous Visions: Rediscovering
the World of Franz Boas*. New Haven: Yale University Press, 2018.

Boas, Franz. *Race, Language, and Culture*. Chicago: University of Chicago Press, 1982.

Bolz, Peter, and Hans-Ulrich Sanner. "Ethnologisches Museum: Neuer Name mit tra-
ditionellen Wurzeln: die Umbenennung des Berliner Museums für Völkerkunde."
Baessler-Archiv N.F. 49 (2001): 11–16.

———. "Das Ethnologische Museum im Humboldt-Forum: Die Frage nach dem Konz-
ept von außereuropäischer Kunst und der Präsentation der Amerika-Sammlungen."
Kunst und Kontext 9 (2015): 5–12.

———. "Das Ethnologische Museum: Rettungsasyl, Forschungszentrum und Ort der
Präsentation." *Berliner Geschichte* 18 (July 2019): 22–31.

———. "From Ethnographic Curiosities to the Royal Museum of Ethnology: Early
Ethnological Collections in Berlin." In *Adolf Bastian and His Universal Archive
of Humanity*. Edited by Manuela Fischer, Peter Bolz, and Susan Kamel, 173–90.
Hildesheim: G. Olms, 2007.

———. *Native American Art: The Collections of the Ethnological Museum Berlin*. Seat-
tle: University of Washington Press, 1999.

———. "Wie Mann die außereuropäische Welt in drei Räumen unterbringt: Die ethnolo-
gische Sammlung im Neuen Museum." In *Museale Spezialisierung und National-
isierung ab 1830: Das Neue Museum in Berlin im internationalen Kontext; Berliner
Schriften zur Museumsforschung* 29, 119–35. Berlin: Staatliche Museen zu Berlin,
2011.

Bose, Friedrich von. *Das Humboldt-Forum: Eine Ethnografie seiner Planung*. Berlin:
Kadmos, 2016.

Bredekamp, Horst. *Aby Warburg der Indianer: Berliner Erkundungen einer liberalen
Ethnologie*. Berlin: Wagenbach, 2019.

Brusius, Mirjam. "The Field in the Museum: Puzzling out Babylon in Berlin." *Osiris*
32, no. 1 (2017): 264–85.

———, and Kavita Singh, eds. *Museum Storage and Meaning: Tales from the Crypt*.
London: Routledge, 2017.

Bunzl, Matti. "Franz Boas and the Humboldtian Tradition: From *Volksgeist* and
Nationalcharakter to an Anthropological Concept of Culture." In *Volksgeist as
Method and Ethic: Essays on Boasian Ethnography and the German Anthropo-
logical Tradition*. Edited by George W. Stocking Jr., 17–78. Madison: University
of Wisconsin Press, 1995.

Buschmann, Rainer F. *Anthropology's Global Histories: The Ethnographic Frontier
in German New Guinea, 1870–1935*. Honolulu: University of Hawai'i Press, 2008.

———. "Oceanic Collections in German Museums: Collections, Contexts, and Exhibits." In *Pacific Presences—Volume I. Oceanic Art and European Museums*. Edited by Lucie Carreau, Alison Clark, Alana Jelinek, Erna Lilje, and Nicholas Thomas, 197–228. Leiden: Sidestone Press, 2018.

Charle, Christophe, Jürgen Schriewer and Peter Wagner, eds. *Transnational Intellectual Networks: Forms of Academic Knowledge and the Search for Cultural Identities*. Frankfurt am Main: Campus Verlag, 2004.

Cole, Douglas. *Captured Heritage: The Scramble for Northwest Coast Artefacts*. Seattle: University of Washington Press, 1985.

Edenheiser, Iris, and Larissa Förster eds. *Museumsethnologie—Eine Einführung: Theorien, Debatten, Praktiken*, Berlin: Reimer, 2019.

Essner, Cornelia. "Berlins Völkerkunde Museum in der Kolonialära: Anmerkungen zum Verhältnis von Ethnologie und Kolonialismus in Deutschland." In *Berlin in Geschichte und Gegenwart*. Berlin: Landesarchiv Berlin, 1982.

Etges, Andreas, Viola König, Rainer Hatoum and Tina Brüderlin, eds. *Northwest Coast Representations: New Perspectives on History, Art, and Encounters*. Berlin: Reimer, 2015.

Evans, Andrew. *Anthropology at War. World War I and the Science of Race in Germany*. Chicago: University of Chicago Press, 2010.

Fiedermutz-Laun, Annemarie. *Der Kulturhistorische Gedanke bei Adolf Bastian: Systematisierung und Darstellung der Theorie und Methode mit dem Versuch einer Bewertung des Kulturhistorischen Gehaltes auf dieser Grundlage*. Wiesbaden: Franz Steiner Verlag, 1970.

Fischer, Manuela, Peter Bolz, and Susan Kamel, eds. *Adolf Bastian and His Universal Archive of Humanity*. Hildesheim: G. Olms, 2007.

Franzen, Christoph Johannes, Karl-Heinz Kohl, and Marie-Luise Recker, eds. *Der Kaiser und sein Forscher: Der Briefwechsel Zwischen Wilhelm II. und Leo Frobenius (1924–1938)*. Stuttgart: Kohlhammer, 2011.

Glass, Aaron. "Drawing on Museums: Early Visual Fieldnotes by Franz Boas and the Indigenous Recuperation of the Archive." *American Anthropologist* 120, no. 1 (2018): 72–88.

———. "Indigenous Ontologies, Digital Futures: Plural Provenances and the Kwakwaka'wakw Collection in Berlin and Beyond." In *Museums as Process: Translating Local and Global Knowledges*. Edited by Raymond Silverman, 19–44. New York: Routledge, 2015.

Goschler, Constantin. *Rudolf Virchow. Mediziner—Anthropologe—Politiker*. Vienna: Böhlau, 2002.

Hoffmann, Beatrix. *Das Museumsobjekt als Tausch- und Handelsgegenstand. Zum Bedeutungswandel musealer Objekte im Kontext der Veräußerungen aus dem Sammlungsbestand des Museums für Völkerkunde Berlin*. Muenster: LIT Verlag, 2009.

Hog, Michael. *Ethnologie und Öffentlichkeit: Ein entwicklungsgeschichtlicher Überblick*. Frankfurt am Main: Peter Lang, 1990.

———. *Ziele und Konzeptionen der Völkerkundemuseen in ihrer historischen Entwicklung*. Frankfurt: Fischer, 1981.

Hoßfeld, Uwe. *Geschichte der biologischen Anthropologie in Deutschland: Von den Anfängen bis in die Nachkriegszeit*. Stuttgart: Franz Steiner, 2005.

Johler, Reinhard, Christian Marchetti, and Monique Scheer, eds. *Doing Anthropology in Wartime and Warzones. World War I and the Cultural Sciences in Europe.* Bielefeld: Transcript, 2010.

Kaeppler, Adrienne L., Markus Schindlbeck, and Gisela E. Speidel eds. *Old Hawai'i: An Ethnography of Hawai'i in the 1880s; Based on the Research and Collections of Eduard Arning in the Ethnologisches Museum, Berlin.* Berlin: Ethnologisches Museum, 2018.

King, Charles. *The Reinvention of Humanity: A Story of Race, Sex, Gender and the Discovery of Culture.* London: Penguin, 2019.

Klautke, Egbert. *The Mind of the Nation: Völkerpsychologie in Germany, 1851–1955.* New York: Berghahn Books, 2016.

Koepping, Klaus-Peter. *Adolf Bastian and the Psychic Unity of Mankind: The Foundations of Anthropology in Nineteenth Century Germany.* London: Queensland Press, 1983.

König, Viola, and Andrea Scholz, eds. *Humboldt-Forum: Der lange Weg 1999–2012.* Berlin: Reimer Verlag, 2012.

Kubach Reutter, Ursula. *Überlegungen zur Ästhetik in der Ethnologie und zur Rolle der Ästhetik bei der Präsentation völkerkundlicher Ausstellungsgegenstände.* Nürnberg: Gesellschaft für Sozialwissenschaftliche Forschung und Praxisberatung, 1985.

Jean-Louis Georget, Hélène Ivanoff, and Richard Kuba eds. *Kulturkriese—Leo Frobenius und seine Zeit.* Berlin: Reimer-Verlag 2016.

Lowie, Robert H. *The History of Ethnological Theory.* New York: Farrar & Rinehart, 1937.

Manner, Brent. *Germany's Ancient Pasts: Archeology and Historical Interpretation since 1700.* Chicago: University of Chicago Press, 2018.

Mühlmann, Wilhelm E. *Geschichte der Anthropologie.* Frankfurt am Main: Athenaeum Verlag, 1968.

Nyhart, Lynn K. *Modern Nature: The Rise of the Biological Perspective in Germany.* Chicago: University of Chicago Press, 2009.

Oswald, Margareta von, and Jonas Tinius, eds. *Across Anthropology: Troubling Colonial Legacies, Museums, and the Curatorial.* Leuven: Leuven University Press, 2020.

Penny, H. Glenn. *Objects of Culture: Ethnology and Ethnographic Museums in Imperial Germany.* Chapel Hill: The University of North Carolina Press, 2002.

——, and Matti Bunzl. *Worldly Provincialism: German Anthropology in the Age of Empire.* Ann Arbor: University of Michigan Press, 2003.

Peterson, Nicolas, and Anna Kenny, eds. *German Ethnography in Australia.* Acton: Australian National University Press, 2017.

Plankensteiner, Barbara ed. *Benin Kings and Rituals: Court Arts from Nigeria.* Ghent: Snoeck, 2007.

Reyels, Lili, Paola Ivanov, and Kristin Weber-Sinn, eds. *Humboldt Lab Tanzania: Objects from the Colonial Wars in the Ethnologisches Museum, Berlin—Tanzanian-German Perspectives.* Berlin: Reimer, 2018.

Rodseth, Lars. "Back to Boas, Forth to Latour: An Anthropological Model for the Ontological Turn." *Current Anthropology* 56 (2015): 865–82.

Scheffler, Karl. *Berliner Museumskrieg.* Berlin: Cassirer, 1921.

Schindlbeck, Markus. *Expeditionen in die Südsee: Begleitbuch zur Ausstellung und Geschichte der Südsee-Sammlung des Ethnologischen Museums.* Berlin: Reimer, 2007.

———. "Der Federmantel von Hawai'i in der Berliner Sammlung." *Baessler-Archiv* 58 (2010): 139–58.

———. "Das Humboldt-Forum im Schloss oder 'Anders zur Welt komen': Eine Ausstellung als Werkstattblick." In *Humboldt-Forum: Der lange Weg 1999-2012.* Edited by Viola König and Andrea Scholz, 95–102. Berlin: Reimer Verlag, 2012.

Schorch, Philipp. *Refocusing Ethnographic Museums through Oceanic Lenses.* Honolulu: University of Hawai'i Press, 2020.

———, and Conal McCarthy, eds. *Curatopia: Museums and the Future of Curatorship.* Manchester: Manchester University Press, 2019.

Smith, John David. "W. E. B. Du Bois, Felix von Luschan, and Racial Reform at the Fin de Siècle," in *Amerikastudien / American Studies* 47, no. 1 (2002): 23–38.

Steinmetz, George. *The Devil's Handwriting: Precoloniality and the German Colonial State in Qingdau, Samoa, and Southwest Africa.* Chicago: University of Chicago Press, 2007.

Stelzig, Christine. *Afrika am Museum für Völkerkunde zu Berlin, 1873-1919: Aneignung, Darstellung und Konstruktion eines Kontinents.* Herbolzheim: Centauras, 2004.

Stocking, George W. Jr. *After Tylor: British Social Anthropology, 1881-1951.* Madison: University of Wisconsin Press, 1996.

———. *Volksgeist as Method and Ethic: Essays on Boasian Ethnography and the German Anthropological Tradition.* Madison: University of Wisconsin Press, 1996.

———, ed. *Objects and Others: Essays on Museums and Material Culture.* Madison: University of Wisconsin Press, 1985.

———, ed. *The Shaping of American Anthropology, 1883-1911.* New York: Basic Books, 1974.

Tylor, Edward B. "Professor Adolf Bastian." *Man* 75–76 (1905): 138–43.

Vermeulen, Han F. *Before Boas: The Genesis of Ethnography and Ethnology in the German Enlightenment.* Lincoln: University of Nebraska Press, 2015.

Walravens, Hartmut, ed. *Albert Grünwedel: Briefwechsel und Dokumente.* Wiesbaden: Harrassowitz Verlag, 2001.

Warren, Stephen, and Ben Barnes. "Salvaging the Salvage Anthropologists: Erminie Wheeler-Voegelin, Carl Voegelin, and the Future of Ethnohistory." *Ethnohistory* 65, no. 2 (2018): 189–214.

Zimmerman, Andrew. *Anthropology and Anti-Humanism in Imperial Germany.* Chicago: University of Chicago Press, 2001.

Zumwalt, Rosemary Lévy. *Franz Boas: The Emergence of the Anthropologist.* Lincoln: University of Nebraska Press, 2019.

INDEX

Page numbers in italics refer to figures.

A NOTE ON THE TYPE

THIS BOOK has been composed in Miller, a Scotch Roman typeface designed by Matthew Carter and first released by Font Bureau in 1997. It resembles Monticello, the typeface developed for The Papers of Thomas Jefferson in the 1940s by C. H. Griffith and P. J. Conkwright and reinterpreted in digital form by Carter in 2003.

Pleasant Jefferson ("P. J.") Conkwright (1905–1986) was Typographer at Princeton University Press from 1939 to 1970. He was an acclaimed book designer and AIGA Medalist.

The ornament used throughout this book was designed by Pierre Simon Fournier (1712–1768) and was a favorite of Conkwright's, used in his design of the *Princeton University Library Chronicle*.

GPSR Authorized Representative: Easy Access System Europe - Mustamäe tee
50, 10621 Tallinn, Estonia, gpsr.requests@easproject.com

www.ingramcontent.com/pod-product-compliance
Lightning Source LLC
Jackson TN
JSHW020836140325
80782JS00001B/2